MONDO
James
Dean

Other books by
Richard Peabody & Lucinda Ebersole:

MONDO ELVIS
MONDO BARBIE
MONDO MARILYN

MONDO
James
Dean

A Collection of Stories and Poems about James Dean

Edited by

Lucinda Ebersole

&

Richard Peabody

St. Martin's Griffin ⚘ New York

Library of Congress Cataloging-in-Publication Data

Mondo James Dean / [edited] by Richard Peabody and Lucinda Ebersole.
 p. cm.
 ISBN 0-312-14121-1
 1. Dean, James, 1931–1955—Fiction. 2. Short stories, American.
I. Peabody, Richard. II. Ebersole, Lucinda.
PS648.D35M66 1996
813'.0108351—dc20 95-41109
 CIP

First St. Martin's Griffin Edition: February 1996
10 9 8 7 6 5 4 3 2 1

For Nancy Alvarez
—L.E.

For Sarah Payan and Alec MacKaye
—R.P.

Enormous thanks to our agent, Anne Edelstein, plus Keith Kahla, Dean Mudgett, and everyone at St. Martin's Press, for the Mondoing of America. We also owe a special nod to Glenda Pleasants, Kathleen Warnock, and the folks at the Writer's Voice. And we won't forget Michael Arnzen, John Crutcher, Robin Deiner, Janice Eidus, David Greisman, Michael Hemmingson, Kristin Kovacic, Fiona Mackintosh, Terri Merz, Katharine Meyer, and Gretchen Sinclair.

Contents

MONDO

James
Dean

Introduction

"That guy up there's gotta stop!"
—James Dean's Last Words

James Dean. The very mention of his name elicits a tiny sigh. Hollywood's little boy lost. The fair-haired rebel whom everyone made their cause.

James Dean was twenty-four in a silver Porsche 500 Spyder, customized with racing stripes and the words LITTLE BASTARD painted across the tail end. He was dead. It would be another two months before *Rebel Without a Cause* filled movie screens. The 1955 film would change the lives of a generation and make James Dean the ultimate icon of alienated American youth.

He was now immortalized. The quintessential teenager, filled with anger and angst, toughness and tenderness, sexuality and sweetness. The misunderstood boy who would give his best friend his jacket rather than watch him shiver. The misfit who, in a moment of turmoil, took the time to introduce his girlfriend to his distraught parents. The outsider with a code of honor.

His visual impact was staggering. One look at Dean and a generation adopted a new physical posture. Kids stood differently, dangled cigarettes from their lips, cooled off by rubbing cold drinks against their foreheads, embraced new haircuts, wore red jackets, customized the family sedan beyond recognition. Anything to get them closer to the man Andy Warhol once called "the damaged but beautiful soul of our time."

His death cult was larger than either Rudolph Valentino's

or Marilyn Monroe's. From 1955 to 1958, his studio received more mail addressed to him than to any living actor. All across America the wrecked Porsche Spyder was parked on vacant lots, and kids paid fifty cents just to sit behind the wheel where he died.

With all the adulation, James Dean was still just a shy Indiana farm boy. The quiet kid who read too much. In his glasses, he was the boy every woman wanted to mother. And in his inimitable T-shirt and Levi's, he was the boy every woman wanted to love. Every man wanted him for a best friend, and some boys harbored other secrets.

Despite all the biographies that have been written, all the images that have been projected and marketed, James Dean remains an enigma. The actor whose performances garnered posthumous Academy Award nominations—not once, but twice—is still a mystery to figure out. Nobody gets any closer.

Perhaps it is only in fiction that James Dean transcends his silent life. But that doesn't stop the writers in this collection, many of whom were born after Dean's death, from wrestling with just what makes James Dean tick—or rather, what about James Dean makes everyone care so much.

James Finney Boylan has a lot of fun grafting James Dean the actor onto that other Jimmy Dean (the singer) and creating one eternal sausage king. Michael Martone gives Dean's high school English teacher a voice. Edwin Corley, Bentley Little, and Robert Ready examine the sexual legacy of the star. Janice Eidus meets him as a playwright at an arts colony. David Plumb postulates a son. Louisa Ermelino transplants him to today's Afghan border. Jack Haldeman gives him pole position at the Indianapolis 500. Lewis Shiner reinvents Dean as a serial hero in a postapocalyptic UFO-western in the Arizona desert. Michael Hemmingson weaves a Goth-rock horror epic. And Miranda Schwartz links Dean to River Phoenix and *Beverly Hills 90210* star Luke Perry.

For some the movies of James Dean may seem dated, or they may know James Dean only as a spokesmodel of the consumer age. The temperamental actor's image sells glasses and khakis and his own personal line of artifacts and memorabilia. Dean is no longer too difficult to work with. Image is indeed everything. We know a rebel when we see one.

This bittersweet book ressurects James Dean. It is a guide-

book for disciples, for new initiates, for romantics, for wanna-bes—for everyone who has ever wanted to live fast, die young, and leave behind a good-looking corpse.

LUCINDA EBERSOLE
RICHARD PEABODY

Washington, D.C.

She thought she was James Dean for a day.
—Lou Reed

I placed a flower for Jim Dean of Indiana.
—Phil Ochs

James Dean

A i

Night after night,
I danced on dynamite,
as light of foot as Fred Astaire,
until I drove the road
like the back of a black panther,
speckled with the gold
of the cold and distant stars
and the slam, bang, bam
of metal jammed against metal.
My head nearly tore from my neck,
my bones broke in fragments
like half-remembered sentences,
and my body,
as if it had been beaten
by a thousand fists,
bruised dark blue;
yet a breath entered my wide-open mouth
and the odor of sweet grass
filled my nose. I died,
but the cameras kept filming
some guy named James,
kept me stranded among the so-called living,
though if anybody'd let me,
I'd have proved
that I was made of nothing
but one long, sweet kiss
before I wasn't there.

* * *

Still, I wear
my red jacket, blue jeans.
Sometimes I'm an empty space in line
at some Broadway cattle call,
or a shadow on a movie screen;
sometimes I caress a woman in her dreams,
kiss, undress her anyplace,
and make love to her
until she cries.
I cry out
as she squeezes me tight
between her thighs,
but when she grabs my hair,
my head comes off in her hands
and I take the grave again.
Maybe I never wanted a woman
as much as that anyway,
or even the spice of man on man
that I encountered once or twice,
the hole where I shoved myself,
framed by an aureole of coarse hair.
By that twilight in '55,
I had devised a way
of living in between
the rules that other people make.
The bongos, the dance classes with Eartha Kitt,
and finally racing cars,
I loved the incongruity of it.
They used to say that I was always on
and couldn't separate myself
from the characters I played,
and if I hadn't died,
I'd have burned out anyway,
but I didn't give Quaker's shit, man,
I gave performances.
I even peed on the set of *Giant*—
that's right—
and turned around
and did a scene with Liz Taylor.
I didn't wash my hands first.
All the same, I didn't need an audience.

That's the difference
between an actor
and some sly pretender
who manipulates himself
up on the tarnished silver screen.
I didn't *do* method; I did James Dean.
Since then, the posters, photographs, biographies
keep me unbetrayed by age or fashion,
and as many shows a night as it's requested,
I reenact my passion play
for anyone who's interested,
and when my Porsche
slams into that Ford,
I'm doing one hundred eighty-six thousand
miles a second,
but I never leave the stage.

Everybody Watching and the Time Passing Like That

Michael Martone

Where was I when I heard about it? Let's see. He died on that Friday, but I didn't hear until Saturday at a speech meet in Lafayette. I was in the cafetorium, drinking coffee and going over the notes I had made on a humorous interp I'd just finished judging. The results were due in a few minutes, and the cafetorium was filling up with students between rounds. I had drama to judge next and was wondering how my own kids had done in their first rounds. So, I was sitting there, flipping back and forth through the papers on my clipboard, drinking coffee, when Kevin Wilkerson came through the swinging doors. I saw him first through the windows in the doors, the windows that have the crisscrossing chicken wire sandwiched between the panes. He had this look on his face. I thought, "Oh my, I bet something's happened in his round." He looked like he'd done awful. But he'd probably flubbed a few words or dropped a line or two, or so I thought. I once judged a boy making his first speech who went up, forgot everything, and just stood there. Pretty soon there was a puddle on the floor and all of this in silence. The timekeeper sat there flipping over the cards. So I spoke up and repeated the last thing I could remember from his speech. Something about harvesting the sea. And he picked up right there and finished every word, wet pants and all.

They were corduroy pants, I remember. He finished last in his round, but you've got to hand it to the boy. I'd like to say the same kid went on to do great things. But I can't because I never heard. So I tell this story to my own kids when they think they have done poorly, and I was getting ready to tell Kevin something like it as he came up to the table. Kevin was very good at extemp. He's a lawyer now, a good one, in Indianapolis. He said to me then, "Mrs. Nall, I'm afraid I've got some real bad news." And I must have said something like nothing could be as bad as the look on your face. Then he told me. "Jimmy Dean is dead. He died in a wreck."

They'd been listening to the car radio out in the parking lot between rounds. That's how they heard. "Are you all right, Mrs. Nall?" Kevin was saying. Now, I'm a drama teacher. I was Jimmy's first drama coach, as you know. I like to think I have a bit of poise, that I have things under control. I don't let myself in for surprises, you know. But when Kevin said that to me, I about lost it, my stage presence if you will, right there in the cafetorium. Then everyone seemed to know about it all at once, and all my students began showing up. They stood around watching to see what I'd do. Most of them had met Jimmy the spring before, you know, when he came home with the *Life* photographer. They just stood watching me there with the other students from the other schools kind of making room for us. Well, if I didn't feel just like that boy who'd wet his pants. Everybody watching and the time passing like that.

But you were wondering where I was, not how I felt.

I suppose, too, you'd like to know how I met James Dean, the plays we did in high school, the kids he hung around with and such. What magazine did you say you're from? I can tell you these things, though I don't quite understand why people like yourself come looking for me. I'm flattered—because I really didn't teach Jimmy to act. I have always said he was a natural that way. I think I see that something happened when he died. But something happens, I suppose, when anybody dies. Or is born, for that matter.

I guess something is also gone when the last person who actually knew him dies. It's as if people come here to remember things that never happened to them. There are the movies, and the movies are good. It's just sometimes the people of Fairmount wonder what all the fuss is about. It isn't so much that the grave gets visited. You'd expect that. Why, every time you head up the

pike to Marion, there is a strange car with out-of-state plates, bumping through the cemetery. It's just that then the visitors tend to spread out through town, knocking on doors.

Marcus and Ortense, his folks (well, not his parents, you know), say people still show up on the porch. They're there on the glider, sun up, when Ortense goes for the *Star*. Or someone will be taking pictures of the feedlot and ask to see Jimmy's bedroom. Why come to the hometown? It's as if they were those students in the cafetorium just watching and waiting for things to happen after the news has been brought.

People are always going through Indiana. Maybe this is the place to stop. Maybe people miss the small town they never had.

I'm the schoolteacher, all right. I remember everyone. I have to stop myself from saying, "Are you Patty's little brother?" Or "The Wilton boy?"

That's small town.

The first I remember him, he was in junior high. I was judging a speech contest for the WCTU, and Jimmy was in it, a seventh grader. He recited a poem called "Bars." You see the double meaning there?

He started it up kneeling behind a chair, talking through the slats of the back, you know. Props. It wasn't allowed. No props. I stopped him and told him he would have to do it without the chair. But he said he couldn't do it that way. I asked him why not. He said he didn't know. He stood there on the stage. Didn't say one word. Well, just another boy gone deaf and dumb in front of me. One who knew the words.

I prompted him. He looked at the chair off to the side of the stage.

Couldn't speak without his little prison. So he walked off.

"Bars" was a monologue, you see. In high school, Jimmy did a monologue for me, for competition. "The Madman." We cut it from Dickens.

We took it to the Nationals in Colorado that year. Rode the train out there together for the National Forensic League tournament. As I said, it was a monologue. But it called for as many emotions as a regular interp which might have three or four characters. You never get more than five or six characters in a regular reading. But Jimmy had that many voices and moods in this single character. Could keep them straight. Could go back and forth with them. He was a natural actor. I didn't teach him that. Couldn't.

I know what you're thinking. You think that if you slice through a life anywhere you'll find the marbling that veins the whole cake. Not true. He was an actor. He was other people. Just because he could be mad doesn't mean he was.

You know the scene in the beanfield. Come to the window. There, you see that field? Beans.

They used mustard plants in the movie.

And here, we know that. Jimmy knew that too. Beans are bushier. Leave it to Hollywood to get it all wrong.

In the summer, kids here walk through the beans and hoe out the weeds. They wear white T-shirts and blue jeans in all that green. Jimmy walked, too, when he was here.

That's the town's favorite scene. Crops. Seeing that— those boys in the bushes, white shirts, blue pants. How could he have known how to be insane? Makes me want to seal off those fields forever. Keep out everything. You can understand that, can't you?

It was quiet then. Now the Air Guard jets fly over from Peru. I notice most people get used to it. At night, you can hear the trucks on I-69 right through your bed. I lost boys on that highway before it was even built. They'd go down to the Muncie exit and nudge around the barricades in their jalopies. Why, the road was still being built, you know. Machinery everywhere. Imagine that. How white that new cement must have been in the moonlight. Not a car on the road. This was before those yard lights the rural electric cooperative gives the farmers. Those boys would point their cars south to Indianapolis and turn out the lights, knowing it was supposed to be straight until Anderson. No signs. No stripes on the road. New road through the beanfields, through the cornfields. Every once and a while a smudge pot, a road lantern. That stretch of road was one of the first parts finished, and it sat there, closed for years it seemed, as the rest of the highway was built up to it along with the weight stations and the rest stops.

I think of those boys as lost on that road. In Indiana then, if you got killed on a marked road, the highway patrol put up a cross as a reminder to other drivers.

Some places looked just like a graveyard. But out on the unfinished highway, when those boys piled into a big yellow grader or a bulldozer blade or just kept going though the road stopped at a bridge that had yet to be built, it could be days before they were even found.

The last time I saw Jimmy alive, we were both driving cars. We did a little dance on Main Street. I was backing out of a parking slot in my Buick Special when Jimmy flashed by in the Winslows' car. I saw him in the rearview mirror and craned my neck around. At the same time, I laid on the horn.

One long blast.

Riding with Jimmy was that *Life* photographer who was taking pictures of everything.

Jimmy had on his glasses, and his cap was back on his head.

He slammed on the brakes and threw his car in reverse, backing up the street, back past me. He must have recognized my car. So out I backed, out across the front of his car, broadsiding his grille, then to the far outside lane where I lined up parallel with him.

He was a handsome boy. He already had his window rolled down, saying something, and I was stretching across the front seat, trying to reach the crank to roll down mine on the passenger side. Flustered, I hadn't thought to put the car in park. So I had to keep my foot on the brake. My skirt rode up my leg, and I kept reaching and then backing off to get up on one elbow to take a look out the window to see if Jimmy was saying something.

The engine was running fast, and the photographer was taking pictures.

I kept reaching for the handle and feeling foolish that I couldn't reach it. I was embarrassed. I couldn't think of any way to do it. You know how it is—you're so busy doing two things foolishly, you can't see through to doing one thing at a time. There were other cars getting lined up behind us, and they were blowing their horns. Once in history, Fairmount had a traffic jam.

The fools. They couldn't see what was going on.

Jimmy started pointing up ahead and nodding, and he rolled up his window and took off. I scrunched back over to the driver's side as Jimmy roared by. He honked his horn, you know. *A shave and a haircut.* The cars that had been stacked up behind us began to pass me on the right, I answered back. *Two bits.*

I could see that photographer leaning back over the bench seat, taking my picture. I flooded the engine. I could smell the gasoline. I sat there on Main Street getting smaller.

When the magazine with the pictures of Jimmy and Fairmount came out, we all knew it would be worth saving, that sometime

in the future it would be a thing to have. Some folks went all the way up to Fort Wayne for copies. But Jimmy was dead, so it was sold out up there, too.

I wasn't in the magazine. No picture of me in my car on Main Street. But there was Jimmy walking on Washington with the Citizen's Bank onion dome over his shoulder. Jimmy playing a bongo to the livestock. Jimmy reading James Whitcomb Riley. Jimmy posing with his cap held on his curled arm. He wears those rubber boots with the claw buckles. His hand rests on the boar's back.

Do you remember that one beautiful picture of Jimmy and the farm? He's in front of the farm, the white barn and the stone fences in the background. The trees are just beginning to bud. Tuck, Jimmy's dog, is looking one way and Jimmy the other. There is the picture, too, of Jimmy sitting upright in the coffin.

Mr. Hunt of Hunt's Store down on Main Street kept a few coffins around.

That is where that picture was taken.

In Indianapolis, they make more coffins than anywhere else in the world. The trucks, loaded up, go through town every day. They've got CASKETS painted in red on the sides of the trailers.

You wait long enough downtown, one'll go through.

See what you have made me do? I keep remembering the wrong things. I swear, you must think that's all I think about.

What magazine did you say you were from?

Jim's death is no mystery to me. It was an accident. An accident. There is no way you can make me believe he wanted to die. I'm a judge. I judge interpretations. There was no reason. Look around you, look around. Those fields. Who could want to die? Sure, students in those days read EC comics. I had a whole drawer full of them. I would take them away for the term. Heads axed open. Limbs severed. Skin being stripped off. But I was convinced it was theater. Look, they were saying, we can make you sick.

It worked. They were right.

I'd look at those comic books after school. I'd sit at my desk and look at them. Outside the window, the hall monitors would be cleaning out the board erasers by banging them against the wall of the school. The air out there was full of chalk. I flipped through those magazines, nodding my head, knowing what it was all about. I am not a speech teacher for nothing. I taught acting.

I know when someone wants attention. The thing is to make them feel things before anything else.

I taught Jimmy to kiss.

I taught Jimmy to die.

We were doing scenes from *Of Mice and Men*. I told him the dying part is pretty easy. The gun George uses is three inches from the back of Lenny's head. When it goes off, your body will go like this—the shoulders up around the ears, the eyes pressed closed. He was on his knees saying something like "I can see it, George." Then *bang*. Don't turn when you fall. After your body flinches, relax. Relax every muscle. Your body will fall forward all by itself.

Well, it didn't, not with Jimmy. He wanted to grab his chest like some kid playing war. Or throw up his hands. Or be blown forward from the force of the shot.

"Haven't you ever seen anything die?" I asked him.

"No," he said.

"It's like this," I said, and I got up there on the stage and fell over again and again. I had George shoot me until we ran out of blanks. It was October, I remember, and outside the hunters were walking the fields flushing pheasants. After we were done with the practice, we could hear the popping of shotguns—one two, one two. We hadn't noticed that with our own gunfire.

Hunting goes so fast, and that's what irritates me.

Jimmy was so excited, you know, doing things you couldn't do in high school. Dying, kissing. That's how young they were. Kids just don't know that acting is doing things that go on every day.

"Just kiss," I told Jimmy after he'd almost bent a girl's neck off. "Look," I said, taking one of his hands and putting it on my hip, "close your eyes." I slid my hands up under his arms so that my hands pressed his shoulder blades. His other hand came around. He stood there, you know. I tucked my head to the side and kissed him.

"Like that," I said.

I quieted the giggles with a look. And then I kissed him again.

"Do it like that," I said.

Even pretending, Jimmy liked things real. No stories, action. He was doing a scene once, I forget just what. The set for the scene called for a wall with a bullet hole. Jimmy worked on the sets too. I was going to paint the hole on the wall, and

Jimmy said no. We waited as he rushed home. He came back with a .22, and before I could stop him, he shot a hole in the plywood wall.

I tell you, the hole was more real than that wall. I remember he went up to the wall and felt it, felt the hole.

"Through and through," he said. "Clean through and through."

The bullet had gone through two curtains and lodged in the rear wall of the stage. I can show you that hole. If you want to look, I can show you.

Right before he died, Jimmy made a commercial for the Highway Safety Council. They show it here twice a year in the driver's education class. The day they show it, I sit in. The students in the class each have a simulator. You know, a steering wheel, a mirror, a windshield with wipers that work, dials luminous in the dark.

Jimmy did the commercial while he was doing his last picture. He is dressed up as a cowboy, twirling a lariat. Gig Young interviews him. They talk about racing and going fast. Then Gig Young asks Jimmy, the cowboy, for advice. Advice for all the young drivers who might be watching. And I look around the class, and they are watching.

It is the way he begins each sentence with "Oh."

Or it's the lariat, the knot he fiddles with.

That new way of acting.

What is he thinking about? Jimmy was supposed to say the campaign slogan—*The life you save may be your own*. But he doesn't. He looks toward the camera. He couldn't see the camera because he wouldn't wear his glasses. I can see what is happening. He is forgetting. He says, "The life you save may be"—a pause—"mine." Mine.

I guess that I have seen that little bit of film more times than anyone else in the world. I watch the film, and he talks to me, talks to me directly. I have it all up here.

He kissed me.

He died.

Leave his life alone.

I know motivation. I *teach* motivation. I teach *acting*.

Jimmy Dean: My Kind of Guy

Janice Eidus

Jimmy and I met at that really famous artists' colony, the one that's been around for a hundred years. I was there to paint landscapes; Jimmy, to write a play. He announced this at dinner, his first night there. He'd grown tired of film acting, he said. He described scenes he'd been forced to play all wrong in *East Of Eden* and *Rebel Without A Cause*, scenes he'd wanted to play tough but which the director had made him play sensitive, and other scenes he'd wanted to play sensitive but the director had made him go all steely and macho. "I want to be my *own* boss," he said, downing his third glass of red wine, "to write, direct, and star in my own play. And don't worry, it'll be a real work of art," he added, as though any of us at the dinner table that night would have doubted his artistry.

I was the only woman at the table. That was because out of the twenty or so of us in residence at the artists' colony at the time, there were five gay men, all of whom had major crushes on Jimmy, and all of whom had made beelines for Jimmy's table. "Jimmy is our idol," they'd informed me the night before his arrival, "with those soulful eyes, that perky nose, that rebel mouth. We believe that in his *heart*, he's one of us—whether he really is or not." The five of them, plus Jimmy, equalled six, exactly the number of chairs at the dinner table. But there was no way—on Jimmy's first night at the colony—that I was going to sit at one of the other tables, trapped next to Olga, for instance, the photographer known for her pictures of human fingers and toes. After all five of the men and Jimmy were comfortably seated, I squeezed in a seventh chair. I wanted Jimmy. I intended to have him. Not for eternity. Just for my stay at the artists' colony.

16

All week long, before Jimmy's arrival at the colony, the five men—each of whom I had become good friends with—had argued over which of them Jimmy would sleep with first. "Me first, definitely," insisted Gregory in a state of near rapture. "I'll win him over with my music." Gregory, a composer, was smug because his works had been performed by the New York Philharmonic.

"No, me first," argued Paul belligerently. Paul was a poet who wore round, clear-framed eyeglasses that slipped down his nose. "Remember, guys," he added, "I'm the film buff in this crowd. Jimmy and I will *bond.*"

They were all wrong, but I never said so aloud. It would be *me* first.

Jimmy Dean was ambivalent, ambiguous, tortured, talented, tormented, gorgeous, and noncommittal, and I always click with those guys right away. We see in each other the same swirling, relentless inner turmoil that devours our souls, the same wild desires that drive us so hard but that are too huge, too scary, even to name. "We have no skin," a former lover once said to me, "there's nothing between *us* and everything else." I don't know where that former lover is now, of course. I never expected to be with him forever. I never *want* forever—with anyone. I'm not that kind of girl. And none of them are that kind of guy. We know that perfection can't last. But we wouldn't exchange our one perfect moment together for a lifetime of anything less.

And I was right: When Jimmy's eyes met mine across the dinner table his first night at the artists' colony, we clicked, clicked, clicked, like a TV remote control gone wild. He just kept talking, though, like nothing out of the ordinary had happened, regaling us with some dishy anecdote about Natalie Wood, Sal Mineo, a bathtub, and a French poodle. He didn't miss a beat. I could tell that not one of the five men sitting at the table with us had any idea what had just happened. After we'd all finished our beef goulash—the colony chef's special, prepared in honor of Jimmy's arrival—I got up from the table and walked outside into the warm summer air, strolling purposefully through the dark woods back to my studio. All I had to do was wait. I sat in my chair in the center of the studio, staring at my own moody paintings hanging on the walls. Moments later, I heard Jimmy's knock on the door. The artists' colony rules strictly forbade residents from conducting love affairs on the premises, and even rebel-without-a-cause Jimmy followed the rules. So he and I hopped

onto his motorcycle and drove into town. We booked ourselves a cozy room in a charming Victorian-style hotel, where, within moments, we ended up naked, entwined, on top of a postcard-pretty four-poster bed.

And in that bed, all night long, Jimmy said all the right things—the things a girl like me just loves to hear. "I don't know who I am," he whispered, staring into my eyes and stroking my lips. His sultry whisper made me even more desirous. Our lovemaking grew wilder. He clawed my back, drawing blood. He cried out, "I'm in agony! I want *this*, but I want *that*, too. Hold me," he commanded, "tighter, tighter, even tighter, really tight. *Hurt* me," he said, flinging himself across the four-poster bed. "No, no, let *me* hurt *you*," he changed his mind. And then, "No! No, let's not hurt each other; let's just lie here and cuddle like two innocent schoolchildren, okay?" He grew insecure. He sat up. "You like this, don't you?" he asked.

"Oh yes," I answered. I grew nervous: "Jimmy, am I a good lover?"

"You bet," he sighed.

We knew how to drive each other crazy with lust, how to play on each other's fears, how to reassure each other tenderly, over and over, all night long.

After that, we spent every night together for the rest of my stay at the artists' colony. We always went back to the room with the four-poster bed, other than one Saturday night when, just for kicks, we went to a sleazy motel on the highway. By the time my residency had ended, I'd completed over a dozen landscapes, one of which—the most violent and ambiguous—I gave to Jimmy as a parting gift. Jimmy was scheduled to stay on at the colony for two more weeks. He kissed me at the bus station. "My play is almost finished," he said. I nodded, kissing his fingers in farewell one by one, wishing that Olga, the photographer, was there to capture with her camera my lips on his beautiful fingers.

Sometimes, after lovemaking, Jimmy had told me that his play was about a Brooklyn cabdriver named Antonio who yearns to be a boxer. Other times he'd said it was about a young girl named Antoinette who yearns for the love of a tough guy named Tony who won't give her the time of day. Honestly, it didn't matter to me what Jimmy's play was about, or whether he was even writing a play. It also didn't matter to me that—after I'd left the artists' colony and had returned to my gloomy Manhattan

studio, where I began a series of black-on-black urban streetscapes—Jimmy began to spend his nights on the four-poster bed with Gregory and Paul, and even with Olga on one or two occasions. Jimmy and I hadn't had that kind of relationship: it hadn't been about possession, till death do us part, meeting the in-laws, houses with picket fences, children, and grandchildren. The only thing that mattered to me then—the only thing that matters to me still—is that Jimmy Dean was my kind of guy.

The Idol

Bentley Little

"There! Did you see it?" Matt stopped the VCR and rewound the tape for a second. "Watch carefully."

James Dean, cooler than cool in his red jacket, backed away from the group of young toughs. "I don't want any trouble," he said. Realizing that the tire iron in his hand could be construed as a weapon, he cocked his arm and hurled it over the cliff.

Matt pressed the pause/freeze button on the remote, and the image stopped in midframe. Dean and the gang stared, unmoving, at the long piece of metal suspended in the clear blue sky. Matt hit the frame advance button, and the tire iron, very slowly, began to fall. He stopped the image just before the camera shifted to another angle.

"See. Right there. Right in those bushes."

I shook my head. "This is stupid."

"No, it's not. Hell, if we can find it, we'll make a fortune. Do you know how much shit like that goes for?"

Matt had taped *Rebel Without A Cause* the night before and was now trying to convince me that we should dig through the bushes down the hill from the Griffith Park Observatory to look for the lug wrench Dean threw in the film.

"Okay," he said. "Think about it logically. How many people know that that scene was filmed at Griffith Park? Only Southern Californians, right?"

"That narrows it down to two or three million."

"Yeah, but how many of them do you think ever tried this?"

"Lots."

"You're crazy."

"Look, after he died, fans scoured the country trying to find any scrap of memorabilia they could. They were selling napkins he'd touched."

"You really think people went scrambling through the bushes trying to find that piece of metal?"

"Yes, I do."

"Well, I don't. I think it's still there, rusting into the ground."

"Fine. Go look for it. No one's stopping you."

"You know I don't like to drive into Hollywood by myself." He turned off the VCR. "All you have to do is give me moral support. Just go with me. I'll do all the work. And if I find it, we'll go fifty-fifty."

"No deal."

"Come on."

"Are you deaf or just dumb? The answer is no."

He smiled, suddenly thinking of something. "We could invite the girls. You know, make a day of it: check out the observatory, have a little picnic. . . ."

It sounded good, I had to admit. Steph had been after me for the past few weeks to take her someplace new and exciting and creative instead of doing the same old dinner-and-a-movie routine, and this might fit the bill.

"All right," I agreed. "But I'm not helping you dig. And if you get arrested for vandalism or something, I don't know you."

Matt grinned. "What a pal."

He left the room to call Julie, and I picked up the remote and switched to MTV.

He returned a few moments later. "She can't go. Her grandpa's coming out from St. Louis this weekend, and she has to be there."

"Well—" I began.

"You promised." He knelt before the couch in a pose of mock supplication. "I won't bother you. You won't even notice I'm there. I'll just look through the bushes by myself, and you two can do whatever your little hearts desire. All you have to do is drive me there and back."

I laughed. "You're really serious about this, aren't you?"

"It's a great idea. Even if someone has thought of this before—which I doubt—I don't think they'd spend an entire day searching through the bushes to follow up on it."

"You may be right," I told him.

I called Stephanie from his apartment, but she said she couldn't make it, either. Finals were coming up, and she had some serious studying to do. She'd lost too much reading time already on account of me.

"That's fine," Matt said. "It'll be me and you."

"I'm just driving," I told him. "I'm not going to waste my time following you through the bushes."

"I know," he said.

We stood in the small parking lot just below the observatory, looking over the low stone wall, in the same spot Dean had stood some forty years before. Matt was carefully studying a map he had drawn, trying to figure out exactly where the tire iron had landed. He walked three paces back from the wall and pretended to throw something over the edge. His eyes followed an arc, focusing finally on a copse of tall bushes halfway down the hill. He pointed. "That's it. That's where it is."

I nodded.

"Remember that spot. Remember the landmarks next to those plants. We're going to have to recognize it from the bottom."

I nodded again. "Sure."

He laughed, a half-parody of a greedy cackle. "We're gonna be rich."

"Yeah. Right."

He made a note on his map. "Come on. Let's go."

We walked back up to the main parking lot in front of the observatory and drove down the winding road that led to the park below. We paid the dollar toll, splitting it, and pulled into a spot next to the playground.

Matt looked up the side of the hill, then down at his map. "The way I figure it, we go straight from here, turn left maybe thirty yards in, and keep going up until we hit the big palm tree."

"Right."

We got out of the car, unloaded our shovels from the trunk, looked around to make sure no one was watching us, and hurried into the brush.

I really had intended not to help him, but I'd had to change my tune. What was I going to do? Sit in the car all day while he went traipsing off into the woods?

Besides, it might be fun.

And we might actually find something.

He kept talking as we climbed, and I must admit, his excitement was catching. He was so sure of himself, so confident in his calculations, and I found myself thinking that, yeah, maybe we were the first people ever to search for this thing.

"I'm sure the movie people didn't collect it afterward," he said, hopping a small sticker bush. "You think they'd waste their time digging through acres of brush looking for a cheap, crummy little piece of metal?"

He had a point.

We climbed for over an hour. In the car, we'd made it to the top of the hill in five or ten minutes. But walking . . . that was another story. I'd read somewhere that Griffith Park covered several square miles, and I could easily believe it.

By the time we reached Matt's palm tree, we were both exhausted.

We stopped and sat under the tree for a moment. "Why the hell didn't we bring a canteen?" I said. "How could we be so fucking stupid?"

Matt was consulting his map. "Only a little farther. Maybe another fifteen or twenty minutes. A half hour at the most."

I groaned. "A half hour?"

He stood, brushing dead leaves off the seat of his pants. "Let's go. The sooner we get there, the sooner we'll be finished."

"What if it's not even the right place?"

"It's the right place. I went over that videotape twenty times."

I forced myself to stand. "All right. Move out."

It figured. The area where Matt thought the tire iron had landed was surrounded by thick, nearly impenetrable bushes, many of them covered with thorns. We jumped over some, slid under others, and a few we just waded through. My shirt and pants both had holes ripped in them.

"You owe me," I said as we traversed a particularly difficult stretch of ground. I stepped over a monstrous science-fiction-looking beetle. "You owe me big time."

He laughed. "I hear you." He grabbed a low tree branch above his head and swung over several entangled manzanita bushes. I followed suit.

"Shit!"

I heard his cry before I landed. I miscalculated, fell on my side, then stood, brushing off dirt.

We were in a small clearing, surrounded on all sides by a natural wall of vegetation. In the middle of the clearing stood a makeshift wooden shed.

And on the shed wall, carefully painted in white block letters was a single word.

GIANT.

"They found it. The fuckers found it." Matt dropped his shovel. He looked as though he had just been punched in the gut. "I thought for sure we'd be the first ones here."

I didn't want to rub it in, but I *had* told him so. "I warned you," I said.

He stood in silence, unmoving.

I looked over at the shed, at the white-lettered word—

GIANT

—and though it was hot out and I was sweating, I felt suddenly cold. There was something about the small, crude structure, about its very existence, that seemed creepy, that made me want to jump back over the wall of bushes and head straight down the hill to the car. The fanatic interest and postumous adulation that surrounded people like James Dean and Marilyn Monroe and Elvis had always disturbed me, had always made me feel slightly uncomfortable, and the shed before me increased that feeling tenfold. This was not part of a museum or a collection, this was some sort of . . . shrine.

And the fact that it was obviously homemade, that it was out here in the middle of nowhere, hidden in an impossible-to-get-to location, intensified my concern.

I did not want to meet up with the fanatic who had put this together.

Matt was still standing silently, staring at the shed.

I feigned a bravery I did not feel. "Let's check it out," I said. "Let's see what's in there."

"Okay." He nodded tiredly. "Might as well."

We walked across the short grass covering the clearing and stepped through the open doorway. After the morning brightness outside it took our eyes a moment to adjust to the darkness.

Matt's eyes made the transition first. "Jesus . . ." he breathed.

Hundreds, maybe thousands, of photographs were pasted onto the walls of the shed. The pictures were of women, some young, some middle-aged, some old.

All of them were naked.

They were in various poses, and at the bottom of each photo was a signature.

But that was not all.

In the center of the room, embedded in a large square chunk of stone, was the tire iron. The tire iron Dean had thrown. The bottom half of the tool, with its curved chisel end, was sunk deep into the rock. The top half, with its rounded wrench end, stuck straight up. The metal was immaculately polished and showed not a hint of rust.

Obviously someone had been taking care of it.

The chill I'd felt outside returned, magnified.

"Jesus," Matt whispered again. He walked into the center of the room and gingerly fingered the tire iron. "What the hell is this?"

I tried to keep my voice light. "It's what you've been hunting for all morning."

"I know that, dickmeat. I mean, what's *this?*" He gestured around the room.

I shook my head. I had no answer.

He climbed on top of the stone slab and straddled the tire iron. Using both hands, he attempted to pull it out. His face turned red with the effort, the veins on his neck and arms bulged, but the tool would not move.

"You know what this reminds me of?" I asked.

"What?"

"*The Sword in the Stone.* You know how all those knights tried for years to pull the sword out of the stone but no one could? And then Arthur pulled it out and became king of England?"

"Yeah."

"Maybe if you pull this out, you'll be the next James Dean."

"If I pull it out, we'll both be rich." He strained again, trying to loosen the unmoving piece of metal. He reached down for his shovel and started chipping at the base of the tool.

I watched him for a moment, then let my gaze wander back over the photos on the wall.

The nude photos.

I turned. Before me, level with my eyes, was a photograph of a gorgeous redhead lying on a bed, spread-eagled. Her breasts were small, but the nipples were gigantic. Her pubic hair proved that the red hair on her head was natural. The name scrawled across the bottom of the picture was Kim something.

The photograph next to that was taken from behind. A large bald vagina and a small pink anus were clearly visible between the two spread cheeks of the woman's buttocks. Not as visible was her face, blurred in the background and looking out from between her legs. Her name was Debbie.

Next to that was a picture of—

Julie.

I stared at the photo for a moment, unable to believe what I was seeing, unwilling to believe what I was seeing. Julie, Matt's girlfriend, was standing, her arms at her sides, her legs spread apart, smiling at the camera.

I looked away. The pose wasn't that intimate or that graphic. All I could see were her overdeveloped breasts and the thick triangle of dark-brown pubic hair between her legs. But I did not like looking at my friend's girlfriend naked. It seemed obscene somehow, my viewing of the photo an invasion of their privacy.

Matt was still trying to pull the lug wrench out of the stone.

I debated with myself whether I should tell him. On the one hand, he was my friend, my best friend, and I didn't want to see him hurt. On the other hand, this was something he should know about, something he would want to know about, no matter how unpleasant it was, and if I were really his friend I would tell him.

I cleared my throat. "Matt?"

"What?" He did not even bother to look up.

"There's something here you gotta see."

"What is it?"

I took a deep breath. "Julie."

He stopped yanking on the tire iron and jumped off the stone. All the color had drained out of his face. "What are you . . . ? You're not serious."

I pointed at the photo.

He stared at the picture, then looked at the surrounding snapshots. He took a deep breath, then reached out and grabbed the photo of Julie, ripping it off the wall. Beneath her photo was another, older, picture of a nude girl with a 1960s beehive hairdo.

"Fuck," he said quietly. He began tearing Julie's photo into tiny pieces, letting the pieces fall onto the dirt. There were tears in his eyes. "Fuck," he repeated.

I knew what he was feeling, but I tried to smooth it over. "Maybe she—"

He turned on me. "Maybe she what? How can you explain this, huh? What possible rational explanation could there be?"

I shook my head. There was nothing I could say.

A tear rolled down his cheek. "Fuck," he said, and the word caught in his throat.

I felt even worse now. I'd never seen Matt cry before, and somehow the sight of that was more disturbing, more intrusive, than having seen Julie naked. I felt as though I should reassure him, touch his shoulder, clap a hand on his back . . . something. But I had never done that before and did not know how to go about it, so I stepped out of the shed, leaving him alone with his pain. If I couldn't give him comfort, I could at least give him privacy.

I thought about Stephanie, and for the first time since we'd started going together, I was glad that she was a hardcore Christian. Her straitlaced morality had frustrated and irritated me in the past, and more than once we had almost broken up because of her unbudging commitment to virginity, but for once I was glad that she did not believe in premarital sex. I might not be getting any, I might be forced to relieve my sexual tension through masturbation, but at least I knew that Steph's picture was not on that wall.

Why was Julie's picture on that wall?

I had no idea. Maybe an an ex-boyfriend had posted it there. Maybe—

"It's right through here!"

I jerked my head toward the bushes.

"God, I've been waiting for this since I was ten!"

Two voices, female, coming this way.

There was a sinking feeling in the pit of my stomach. I hurried back into the little building. "Matt!" I hissed. "Someone's coming!"

"What?"

"Two women are coming this way."

He grabbed the shovels from the center of the room and smiled. There was something in that smile that put me on edge. "You mean we're going to catch them in the act?"

I waved him into silence. "We've got to hide!" I whispered.

"Why?"

I didn't know, but I felt it, sensed it, was certain of it. I

glanced quickly around the room. In the far corner was a small stack of boxes and packing crates.

"Come on!" I whispered. I led the way over to the boxes, climbed into one, and was grateful to see Matt follow suit.

The voices were close now, just outside the door.

"Do you have your picture?"

"Of course."

We ducked.

I heard them enter the shed. Their voices were silent now, but their shuffling feet were loud. It sounded like there were a lot more than two of them.

I peeked over the rim of the box, my curiosity getting the better of me. There *were* more than two of them. The number was closer to fifteen or twenty. There were the two girls I'd heard talking, both of whom were around sixteen or seventeen, and several other girls in their late teens. They were accompanied by four or five women in their midthirties.

I quickly ducked back down before anyone spotted me.

There were whisperings and shuffling noises, and a few nervous coughs and throat clearings. One of the older women spoke up. "You know what to do?"

"My mother explained everything to me," one of the teenagers replied.

"You are a virgin?"

"Yes."

"Good. When you are through, you may place your photo next to that of your mother."

Her mother.

Jesus.

The room grew quiet. Too quiet. I could hear Matt's deep breathing in the box next to mine, and my own breathing sounded impossibly amplified. I was terrified that we would be found out, though I could not say why the prospect of discovery frightened me so badly.

There was the sound of a belt being unfastened, the sound of a zipper. Something dropped onto the dirt, something soft, and it was followed by a low rustling noise. Someone walked into the middle of the shed.

Then there was silence again.

All of a sudden I heard a sharp gasp. A small moan of pain and an exhalation of air. Another gasp.

I had to know what was going on. Once again, I hazarded a peek over the rim of my box.

And immediately crouched back down.

One of the young girls, the prettiest one, was lowering herself onto the tire iron. She was squatting over the stone, completely naked, the rounded end of the lug wrench already inside her. Her face was contorted, physical pain coexisting with what looked like an underlying spiritual rapture.

The other girls and women were crouched on the ground before her, in a similar squatting position, intently watching her every move.

What the hell was going on here? I stared at the faded brown cardboard of my box, breathing deeply. Were these women part of a fanatic James Dean fan club or was this some sort of bizarre cult?

And what about Julie?

The girl gasped loudly, then moaned.

It was not a moan of pain.

The moans intensified, coming loudly and freely, the girl's breath audible in short heavy pants.

I thought of the photos on the walls, the thousands of photos. Had all of those women done this? They must have. The girl had said that her mother told her what to do. How had the rest of them found out about it? From their mothers?

How many women knew about this shack?

All the women in Southern California?

Goosebumps rose on my arms and neck. This was wrong, this was unnatural, and though I should have been aroused, I was frightened. I did not understand what was happening here, and I did not want to understand.

Julie

I found myself thinking of those secret societies of old, of horror movies and novels about the eternal mysteries of women and the secrets they could never share with men. I recalled—

Stephanie

—how, invariably, the men who did attempt to penetrate those mysteries were killed.

If Julie knows, Stephanie knows. They're best friends.

The thought burst into my consciousness. I had been assuming that Stephanie was not involved in all this, but maybe I was wrong. Maybe she was. Maybe her picture was here, too,

somewhere. Or maybe her mother's was. Both she and her mother had been born in Los Angeles.

But she was religious. She was a Christian. And a virgin.

The girl on the stone had been a virgin, too. Apparently, it was a requirement.

Julie had probably been a virgin when she'd come here.

I crouched lower in the box.

On the stone, the girl gasped her last. I heard her jump onto the ground, and then the shed was filled with the sounds of talking and laughing as the girl was congratulated.

"How do you feel?"

"I'll never forget when it happened to me. Greatest moment of my life."

"Wasn't it wonderful?"

"Could you feel His presence?"

The girl signed her photo with great fanfare and hung it somewhere on one of the walls.

Finally, after another twenty minutes or so, everyone left.

I stayed crouched in the box for another five minutes, just to be on the safe side, then slowly, painfully, stood. I reached over and hit Matt's box. "Come on," I said. "Let's get the fuck out of here."

I glanced over at the tire iron. Even in the diffused light of the shed, it glistened wetly.

I wondered where the girl had put her picture.

Matt stepped silently out of his box. Carrying his shovels, he walked out the door. I stood for a moment alone, glancing around the room at the overlapping layers of photos. Was Stephanie's here somewhere?

Had she fucked James Dean's lug wrench?

The chill returned, and I was suddenly acutely conscious of being alone in the small building.

I hurried outside.

We walked back to the car in silence. I opened the trunk when we reached the parking lot, and Matt threw the shovels inside. We did not speak on the drive home.

I saw Steph the next day and debated whether or not to ask her about the shed. The question of whether or not she knew of the place was torturing me; my mind had conjured up all sorts of perverse and gruesome scenes.

But in the end, I said nothing.

I decided I didn't really want to know.

A week later, I found the nude Polaroid in her dresser drawer.

She was in the bathroom, getting ready for our date, and I, as usual, was snooping. The photo was lying on top of a pile of panties, and I gingerly picked it up. I had never seen her completely naked, although only a few days before I had finally managed to get her top off in the backseat of my car, and I examined the picture carefully. She was seated, her legs in front of her, knees up, and the pink lips of her vagina were clearly visible.

She was shaved.

I heard the door to the bathroom open, and for a brief second, I considered confronting her with the photo. *Who had taken it? Had she taken it herself with a self-timing camera? Had some guy taken it? Had some girl taken it?* But, almost instinctively, I threw it back on top of her panties and hurried over to her bed, where I quickly grabbed a magazine and leaned back, pretending to read.

The door opened, and I looked up.

The dresser drawer was still open.

I'd forgotten to close it.

Steph noticed immediately. She looked at the drawer and looked at me, but I smiled, feigned innocence, pretended not to see, and she smiled back and surreptitiously closed the drawer.

She walked across the room and sat next to me on the bed. "I forgot to tell you," she said. "I'm going to have to cancel out on next Saturday."

"Why?"

"Something came up."

I threw aside the magazine. "But we've been planning to go to Disneyland for months."

She put an arm around me. "I know, but my mom and a few of her friends are having, like, a picnic, and I have to go."

My mouth was suddenly dry. I tried to lick my lips. "Where?"

"Griffith Park."

"Can I go?"

She shook her head. "I'm afraid not. It's only for us girls this time."

"I won't—"

"No." She smiled, reached over, tweaked my nose. "Jealous?"

I looked at her, looked at the closed drawer, thought for

a moment, and shook my head. "No," I said slowly. "No, I guess I'm not."

"The next weekend we'll do something special. Just us."

"Like what?" I asked.

"You'll see."

"You have something planned?"

She nodded.

"Okay," I said.

We kissed.

The 8 O'Clock Movie

Tino Villanueva

Boston, 1973—Years had passed and I assumed a
Different life when one night, while resting from
Books on Marlborough Street (where things like
This can happen), there came into my room images

In black and white with a flow of light that
Would not die. It all came back to me in different
Terms: characters were born again, met up with
Each other in adult life, drifted across the

Screen to discover cattle and oil, traveled miles
On horseback in dust and heat, characters whose
Names emerged as if they mattered in a history
Book. Some were swept up by power and prejudice

Toward neighbors different from themselves,
Because that is what the picture is about, with
Class distinctions moving the plot along. A few
Could distinguish right from wrong; those who

Could not you condemned from the beginning when
You noticed them at all. Still others married or
Backed off from the ranch with poignant flair,
Like James Dean, who in the middle of grazing land

Unearthed the treasures of oil, buried his soul in
Money, and went incoherent with alcohol. When the 40s

Came, two young men were drafted, the one called *Angel*
Dying at war. It's a generational tale, so everybody

Aged once more and said what they had to say along the
Way according to the script. And then the end: the
Hamburger joint brought into existence to the beat of
"The Yellow Rose of Texas," Juana and her child the

Color of dark amber, foreshadowing the Mexican-looking
Couple and their daughter, all in muteness, wanting
To be served. I climbed out of bed and in my head
Was a roaring of light—words spoken and unspoken

Had brought the obliterated back. Not again (I said,
From my second-floor room) . . . let this not be happening.
Three-and-a-half hours had flicked by. As the sound
Trailed off into nothing, memory would not dissolve.

FROM Farewell My Slightly Tarnished Hero

Edwin Corley

Early Saturday morning, both saddlebags stuffed with sandwiches and extra sweaters, we piled aboard the Harley and roared up Coldwater Canyon Drive, turned right on Mulholland, and snaked our way through the Santa Monica Mountains. We found ourselves on Cahuenga Boulevard West and at the entrance ramp to the Hollywood Freeway and Highway 101, which would take us all the way to San Diego and beyond, to San Ysidro, the gateway to Mexico. It was still early, and there was a nip in the air as it rushed through my hair. Behind me, Diana sat easily on the buddy seat; her years of horseback riding paid off in ease and grace on the Harley. Her hands held my waist loosely. They wore light cotton gloves. "Better than leather," I had told her. "Leather will freeze your fingers off in ten miles unless you have cotton on under them." Now, on the first Sunday in December of 1954, the California day would warm up as the morning shadows grew shorter, but right now both of us wore windbreakers and plastic goggles. With just over three thousand miles on the odometer, the bike was nicely broken in, and felt properly free in all moving parts without being too loose. Now, out of the city streets, I opened up the "snuff—don't snuff" baffles on the mufflers, and the deep song of the engine bounced off the concrete freeway walls and purred in my ear. Passing through Los Angeles, the pointed obelisk of the courthouse to our right, I found myself catching up with a highway patrolman on his own heavily-laden machine complete with radio antenna and windscreen. I

checked my speedometer, saw it was exactly on sixty, so let myself creep up alongside him and past. I gave him a wave, and from the corner of my eye saw him checking our speed, looking for signs of the bandit cycle clubs, and seeing none, wave back casually. We crossed the Los Angeles River, almost dry in its concrete bed, and turned right onto the Santa Ana Freeway. Soon we were in relatively open country, although the blight of the housing projects was starting to spread over the nearby hills.

I let her out to seventy now; that was actually the speed of the traffic flow, and the last thing you want on a bike is to have cars constantly passing you. I had learned a long time ago that the only way to ride a bike safely is to pretend it is a car. The hell with riding the shoulder so cars can get by in the same lane. That's just asking for some joker to brush you off the road with his rear fender. I staked out a claim in the exact middle of the lane, stayed far enough behind the forward car so I'd have time to stop if he jammed on his brakes, and tried to keep the ignorant bastards behind me from tailgating. That could be the most dangerous part of the ride, letting some guy get up close enough so he couldn't stop if you should go down. More guys have been run over after they successfully dumped their machines than have been killed by taking bad falls. My anti-tailgating maneuver was to signal for him to pass; if he didn't, I would slowly ease up on the throttle, until he would by Christ pass or else be going thirty miles an hour.

Soon we sped through Buena Park, home of the Walt Disney studios, and were approaching Anaheim, where the master of Mickey Mouse was building a huge amusement park called Disneyland. Now the sun was higher in the sky and the cars were fewer on the road, and the ride began to settle down into a kind of pleasant monotony. Every so often Diana would pinch my waist to let me know she was still alive, and once, as we roared along between two groves of orange trees, she leaned forward and shouted in my ear, "Oh, this is so wonderful! You miss all the sounds and the smells in a car!"

Past San Juan Capistrano, we turned down the hill toward the beach, past old San Juan Capistrano Mission, just as the bells were tolling the hour into the crisp morning air. The bike backfired several times as I eased up on the throttle and coasted down the hill into Capistrano Beach, and five miles farther along the highway I turned off into San Clemente and parked at a diner.

"Let's get a little coffee," I said. "And a word of warning:

if you want to wash your hands, this is the place. For the next thirty miles or so we're inside Camp Pendleton, and those Marines don't exactly have facilities for ladies."

"You make a terrific tour director," she said, nuzzling me as we went in. "I'll send all my business to you."

I sat at the counter and ordered coffee and Danish for both of us while she went to the john, and the combination of the beautiful morning and the delight of sharing this ride with her sent little goosebumps of pleasure springing up all over me. She came back and joined me and we sipped coffee and relaxed.

"Oh, Johnny," she said excitedly, "now I understand why you love riding so much. It's so different from being closed up in a car, or even riding in a convertible. You're right in there with the sound and the air and the wonderful odors of the countryside. It's almost like flying."

"That's part of it," I said. "The rest is the riding itself. It's not like a car, where you just shove on the gas and steer. With a bike, you become part of the machine. You steer by leaning your body. You can feel the road through the tires as if they were part of you. A lot of nuts have given riding a bad name because of the cruddy things they do. But I think those same guys would still be cruds if motorcycles had never been invented. They'd be riding cars, or pogo sticks, or something. It isn't the bike's fault, what the nuts do."

We finished our coffee and got back on the road. Riding through Camp Pendleton, we could hear the Marines blowing things up, back in the hills. Soon we were through the military reservation, passing San Luis Rey, and were slowed up by the dozens of little beach towns as we got closer to San Diego. Encinitas, Cardiff-by-the-Sea, Solana Beach, all fell behind, and then we were at Torrey Pines where I pulled off to a picnic area that overlooked the Pacific.

"Lunch," I said. Actually, the coffee an hour before had taken off the edge, but in the fresh air and surrounded by the rugged beauty of the sea and of mountains far to the east, we managed to do all right by the sandwiches and the thermos bottle of iced tea. "See?" I pointed, "Up there? That's Palomar Mountain, where the Palomar Observatory is. One of these days I'm going to head up there. They say the ride up the mountain from Rincon Springs is some trip."

"Good heavens," she said. "I think you study the road maps like you do a script."

"You're just about right," I said. "You can't take out a map and look at it while you're riding, so it helps to have most of the routes in your head."

"Do you think I could learn to ride?"

"I don't know why not. A lot of girls do. And you've got better balance and timing than most of them."

We cleaned up our mess and got back on the highway. Now we turned inland and soon were bypassing San Diego, its tall buildings sliding by on the right. We went through National City, past Chula Vista and at almost exactly 1:00 P.M. were creeping through the International Gate. We went across the long bridge over the dry bed of the Tia Juana River in second gear, and now the fetid odors and screeching sounds that swirled up around us were anything but pleasant.

"This isn't really Mexico," I told her. "No border town is worth a damn, and Tijuana is worth a little less than most. See those huts down there? They're made of cardboard and old tires. If a cloudburst ever comes up and fills this riverbed, they'll lose a couple of thousand peons pronto. And nobody will give a damn, that's the truth. The only reason for coming to a place like this is for the fights."

"I hope they're worth it," she said.

We turned left onto the main drag, filled with garish signs offering LAWYER, MARRIAGE AND DIVORCE, and SEXPOT GIRL SHOW. Every doorway was filled with slim, dark Mexican men in colorless sports shirts. They huddled in groups of three and four, and leaped forward to accost passing tourists with whatever specialty they had to offer. "Some of them have dirty pictures," I told Diana. "Some have Spanish Fly, or French Ticklers. All of them can take you to a girl, or set up an exhibition between a guy and a girl, two girls, a girl and a goat, or whatever combination you might want to ask for."

"Ugh," she said. "I didn't know people lived like this."

"You'd be surprised, honey," I said. "This is only what you see at one o'clock in the afternoon in broad daylight. Life is cheap down here."

I didn't tell her how cheap, though. I didn't tell her about the time I was offered a girl for three hundred dollars, a fantastic price in a town where five bucks was a top demand. When I wanted to know why she was so special, the pimp told me that I would be allowed to mount the girl as she was strapped on a kind of leaning board over a sunken tub. And that as I signaled that

my climax was approaching, she would be lowered, headfirst, into the water, and I could complete my orgasm into her twitching body as she drowned in two feet of water. In case I was afraid of being cheated, the pimp went on, I would be allowed to cut her throat to be sure she was truly dead.

I had a brief vision of Diana being tilted down into filthy bathwater, her silken limbs twisting in a final spasm, and it shook me so hard that I almost ran down an old lady with a cardboard box on her head. She leaped out of the way and shouted curses after us as I turned up the hill to the small hotel I usually stayed at. Six blocks from the rickety bull ring, it offered indoor parking which would protect my Harley from the thieving kids who roam the streets day and night.

"Here we are," I said, pulling up outside the Hotel El Presidente. "The boy will unclip the bags and bring them up to our room. Or rooms. Whichever you say."

She looked at me, and a little stab of fear passed through her eyes; then she said, "Don't they have a bridal suite, Johnny? With white sheets and a walk-in bathtub and mirrors on the wall?"

I nodded and kissed her as we went up the crumbling steps.

When we were in the room, I moved to hold her, but she pulled away and said, "Not now, dear. Let's go out and do whatever it is that visitors do. Let's buy junk and eat hot things and drink Mexican beer. Let's spend the day like tourists."

So we did. We started out by buying straw hats to keep the sun off; a plain, yellow ten-gallon job for me, and a colorful woven one for her, with little bells strung from the brim, and black and green stitching around the edges. She tied it on with a blue and white drawstring and cinched in her belt another notch, and damn it all if she didn't start looking a little like Delores del Rio!

Since the dollar was better than gold in Tijuana, we didn't bother to change any money, but paid for everything with U.S. bills and coins. We strolled the wide streets, stopping in the door-less shops that lined both sides and examining the onyx chess sets and leather boots and beaten copper jewelry. In one shop, I bought her a little Aztec idol who seemed to be all eyes and mouth. He had a chain coming out of his ears and she hung him around her neck by it.

We stopped at a street corner photographer and had our pictures taken together, standing next to a donkey and with colorful blankets over our shoulders. The pictures were gray and dingy, but I gladly paid a dollar for the two and we carried them by the corners, still slightly damp, as we strolled up the street.

Harsh, jangling music followed us, flooding out of every door and up from every cellar club. Since it was Saturday, and the Navy was in town, the clip joints were in full swing, and standing at every door was one of the brown, mustached men in his colorless sport shirt, saying, "Come on in, señor, the show is just beginning."

"What kind of show is he talking about?" Diana whispered.

"Girl show," I said. "Striptease. You know."

"I never saw one," she said. "Let's go in."

"You won't like it. It's all pretty crude."

"Well, if I don't, we can leave."

As luck would have it, we were outside the Bum Bum Club at that moment. While all of the joints operate wide open, the Bum Bum has a well-earned reputation for going a little further than most. "Okay," I said, taking her arm and leading her down the winding stone steps, "but remember, you asked for it."

Inside, the music was even louder. Three girls were on the arena stage, surrounded by tiny tables jammed up against its edge. I took a table farther back and when the waiter came, ordered two Mexicali beers.

Watching the girls, who wore G-strings and lace bras, Diana said, "I don't know what you were so worried about. This isn't so bad."

"Just drink your beer, honey," I said, "and hang on."

One music number finished, and as two of the babes scampered off, the third began to strut along the edge of the stage, and the sailors in the front row set up a shout of encouragement. She whipped off her bra, and her taut breasts bounced with each step. Although the G-string did a minimum job of covering her pubic area, it disappeared into the crack of her buttocks, and back there she might as well have been completely nude. The band struck up a driving tempo and the girl began swishing her behind in swirling circles, just inches above the faces of the men seated at the edge of the platform. They set up a yowl of anticipation, and when her posterior brushed against one swabbie's

nose he leaped up screaming, "I'm gonna eat it! I'm gonna bite it to pieces!" His buddies screamed with raucous laughter and pulled him back down in his chair. The girl shook her finger at him over her shoulder and continued her promenade around the stage, swishing her ass closer and closer to the perspiring faces. Eventually, she returned to the sailor who had shouted, and as the drums took over with a frenetic beat, she wiggled herself down with a screwing motion as if she were settling on a piano stool, lower and lower, closer to the bulging eyes and the dry lips licked by a nervous tongue, until suddenly there was a crescendo of music and she had pressed her bare behind directly on his face. His hands crept around her naked thighs and pulled her closer, and now the music was only a throbbing pulse of the brushes on the snare drum, and I knew suddenly that this was no gag, that that sonofabitch had his tongue right in there and working and you could see it on the girl's face as she tensed her legs and settled down farther. I felt a savage anger, and I got up and dragged Diana to her feet. Her eyes were wide and fixed on the sight across the room. "Come on," I said, and when she did not seem to hear me, I yanked her after me and headed for the door. "Goddamn it," I yelled, "I said come on. Let's get the hell out of here!"

The sunlight on the street blinded us for a minute, and as I waited to be able to see, I could feel my hands trembling. Diana caught my arm and pressed my hand against her burning face. "Why are you so mad, Johnny?"

"I'm not mad," I said. "I just don't like queers."

"Queers? But they weren't the same sex."

"What do you know about it?" I said, too loudly, and as she drew back with hurt on her face, I reached out and caught her hand. "Look, I'm sorry. I just don't like those kinds of shows. Let's start back, huh? It's almost seven, and we ought to get cleaned up and have supper."

We got a cab and rode out to the hotel. Without speaking about it, we came to an agreement that happened naturally; I waited in the bar while she showered and changed, and then I went up and she sat on the small balcony while I took a quick shower and got into my clean khaki pants and the extra T-shirt I'd brought along. Somehow she had managed to pack an uncrushable linen dress in the bags, and with her hair down and fresh lipstick, she looked beautiful in the soft light of the sunset.

We ate on the terrace, sticking to simple foods that I hoped

wouldn't disagree with us. With the meal, we had a white wine from Chile, and after it a Tia Maria for Diana and a double martini for me.

"Heavens," she said, sipping her liquor. "For a girl who never drank in her life, I'm rapidly becoming a lush."

"If Mama could only see you now," I said. It was the wrong thing to say. She gave me a sharp look and said little for the rest of the time we were at the table. Out by the pool, a string quartet struck up wheezing renditions of popular songs, and we wandered over and sat nearby. I ordered another drink and she had coffee. Twice, we danced, and her warm, full body felt just right in my arms. "I'm sorry," I said. "I didn't mean that crack. I know what it meant for you to come down here with me." She didn't answer, nor did she make any sound, but a hot tear burned its way down between our closely pressed cheeks.

A little after nine, when we had both passed enough yawns, I got up and held out my hand. She took it, slipped her arm through mine, and we went up to the room. Inside, she clung to me and I could feel her entire body trembling.

"You go out on the balcony," she said, "and don't come in until I call you."

I sat out there, in the chill evening, and listened to the shouting mob going by a few blocks away. The language was foreign, but the drive and the goals were the same as the mob on Sunset Strip. Money and position and someone to scratch the itches of desire. I put my feet up on the railing and half dozed until I heard her voice.

"Now, Johnny. Now."

When I went in, the lights were all out. But enough filtered in from the window to let me see her standing near the bed. Her body was white against the shadowed walls, and I could sense, rather than see, that her two hands were crossed over her breasts. My clothes made an obscenely loud rustle as I slipped out of them and moved slowly to her. Her hands came away from her body and reached for me and then we clutched at each other savagely as our lips pressed together. I let my hands slide down her back and then the globes of her buttocks were caught in my grasping fingers and under the soft flesh the muscles tightened as she pressed up against me.

"Oh, Johnny," she whispered, "I want you so."

"I want you, too, Diana."

"Johnny," she said, "I'm not Diana. I'm Sharon."

"I want you, too, Sharon."

"Yes, that's good. Touch me there. And there. Oh, oh, you know just what to do."

"Lie down here, Sharon. That's it. No, be careful, not too much there! I'm too hot."

"You're so big. Is it possible. How can it ever fit?"

"It will, when you're ready. Maybe not all the way the first time."

"Oh, sweet Johnny, don't worry. I'm not a virgin. Physically, that is. The horses took care of that. There won't be a horrible mess and you can even ease your conscience because how do you know for sure that horseback riding is all I really did? And you're not the only boy I ever petted with, either."

"You're some woman of the world, huh? Did any of your nice boyfriends ever try this?"

"What are you doing? Ooooooh!"

"Do you like it?"

"Oh, yes, yes! You make me feel like my body is one long string of nerves, and at the very end of them all, there is this little spot and your finger, rolling it back and forth and causing the spot to grow and swell until it is bigger than the world. Ohhh, yes, darling, yes. Let me do it to you."

"Not yet. First I want you to come. Have you ever come before?"

"I don't know."

"Then you haven't. Lie still, darling."

"Mmmm. It's starting to tingle."

"You're getting juicy. Listen."

"Oh, I'm so embarrassed."

"No, you're not. That's the way it's supposed to sound."

"Do you love me, Johnny?"

"You know I do."

"Really? Enough to marry me? Mmmm! Did you hear me, darling?"

"I heard you. How's that?"

"Ummmm. Delicious! Yes, right there. Oh, oh, darling, what's happening? No, no, right there, don't stop. Oh my God, I never felt like this before. What are you doing to me? I can't get my breath, I'm going to faint, help, I'm dying, I'm—Aaaaaah! Oh! Oh . . . I'm scared, darling. Hold me. Is *that* what it is? No wonder people do it all the time. Oh, did I scratch you, dear? I'm sorry. I just went wild. Nothing has ever felt like that. It was

wonderful, but it's over now, you can stop . . . Mmmmm. Why don't you . . . oh, Jesus, *here it comes again!*"

In the land of mañana, where clocks run slow and nothing ever happens on time, there is one thing you can set your watch by: four o'clock on a Sunday afternoon in the Plaza de Toros. When the minute hand of the big clock over the arena points at twelve and the little hand at four, you can stake your life on hearing the sharp blare of a trumpet, and the parade of matadors and their entourage will begin into the sand of the bull ring.

Sharon and I sat in the shady fifteen-dollar seats just alongside the *presidente* of the arena. We had slept late, exhausted by the long sequence of love play and the ultimate lunging of sex. I felt warm and pleased with myself. My old potency had come back in her arms, and there had been enough libido left over for an encore before lunch. As we climbed to the seats in the arena, she pressed close to me and whispered, "You awful man. I'm *raw!* But it feels good." Her fingers dug into the inside of my arm and when I turned to look at her, she gave me a deep, ecstatic smile.

The parade over, the men retired to their respective places and the first bull was released into the arena. He came out fast, and each matador in turn made a series of passes with the large cape. I only knew one of the matadors personally, Gabino Armaderiz, a twenty-six-year-old who was born on the ranch of Piedras Negras, where some of Mexico's finest fighting bulls are calved. He was fighting second on today's corrida.

"Why are they all fighting the bull?" Sharon asked.

"They're not, honey. This is to get some idea of the way he charges, of which horn he favors. You see, until today, this bull has never seen a man on the ground."

"Why not?"

"Because bulls learn too quickly. By the end of the fight, this bull will be so dangerous that it would be sure death to let him recover and fight another matador. You may find it hard to believe, but on some ranches in Spain, it's legal to shoot a *novillero* if he is spotted on the land."

"What's a *novillero?*"

"He's a would-be matador. They sneak onto the ranches to get practice in fighting the real bulls. The only thing is, the bull gets practice, too. That's why they make it rough on the *novilleros* if they get caught."

Now the crowd started booing, and the picadors were riding into the ring on their heavily padded horses. The bull spotted a nearby horse and charged it. The *pic* aimed his lance and drove it into the ball of muscle atop the shoulders and neck of the bull.

"What's he doing?" Sharon shrieked. "He's spearing the bull!"

"They have to weaken those back muscles," I said. "Otherwise, the bull would never get his head down, and the matador couldn't go over the horns with the sword."

The trumpet blared again, and the matador came out to place his own *banderillas*. "These do the same thing," I told her. "And they help correct against hooking."

"They look like little sticks with feathers on them," she said.

"Feathers—and barbs," I said. The crowd cheered as the matador did a skillful job of jabbing in the miniature spears. "Now comes the last act. See that little red cape? It's called a *muleta*. It's windy out there today, so he's wet it down to keep it from flapping. Now, every one of those passes he's doing has a name. The closer he works to the bull and the slower he works, the better it is. Notice, the bull is getting tired. And he's getting dangerous. Instead of reacting, he's starting to think. It's up to the matador to know the exact moment to complete his passes and line the bull up for what they call the moment of truth. That's when he goes over the horns with the sword. Now!"

The matador had killed well. The blade drove between the bull's shoulder blades, severing the great artery, and the animal dropped in his tracks. The man strode stiff-legged around the ring, and by petition from the crowd, waving their handkerchiefs, was allowed to cut an ear of the bull.

"The better the fight," I said, "the more they let him have. A really great matador might get both ears and the tail. Not very often, he gets a hoof, too. And very, very rarely, they award him the whole bull. That's only happened three times in the whole history of bull fighting."

"Look at the horses, dragging him off," Sharon said. "It's so sad. What do they do with him now?"

"He's too tough for steaks," I said. "They generally make dog food out of him."

"And you actually want to *fight* a bull?"

"Right. I think you have to test your courage every so

often. That's the entire principle of bullfighting. Courage is everything."

"You've got plenty of courage. Why do you have to prove it?"

"You just do."

None of the fights that day were particularly spectacular. Gabino Armaderiz did well enough with his second bull to cut two ears, and that was fun for us because, spotting us in the crowd, he had dedicated the animal to Sharon by tossing his hat over his shoulder to her. "Now," I whispered, "if you were the kind of girl who usually comes down to these fights, you'd put your hotel room key in the hat when you toss it back to him."

"I'd be delighted," she hissed back, "but where would we put *you*, darling?"

After the fights, we went to La Casita Café, on Fourth Street and had some of the juicy Mexican abalone and a couple of bottles of beer. When we were almost finished, Gabino entered and the crowd applauded him as he came over and bowed gracefully to Sharon.

"Exquisite," he said to me. "She is a flower of beauty."

He sat down and had a small whiskey with us, refusing food.

"My stomach," he explained, pressing it. "After a fight, the muscles are so tight from crawling away from the bull that food is an abomination. Later tonight, I will eat."

"Do you mean you're afraid when you fight?" Sharon asked.

"Always," he admitted. "All fighters are afraid; those who are sane, at any rate. What would it all mean if we were not afraid? It takes no courage to sit on a veranda, and that is why no one pays to watch a man sitting on a veranda. But to gather your bravery up in your hands and throw it into the face of death, yes! That is why men face the horns. That is why your *caballero* here will one day face them, to test his soul."

"I just want to see what it feels like," I mumbled.

Sharon was full of silly questions about bullfighting, and I could tell that he enjoyed answering them. At every opportunity, he shaded meanings so as to put me in the best possible light, and I knew he was going far out of his usual way to be pleasant.

"To see the best fights," he said, "you must come to Mexico City. The ring here in Tijuana is bush league. But in Mexico City, the great fighters come to make their reputations. *There* is

a *corrida!* Still, today's was not so very bad. I have seen some where the picador virtually murdered the bull with his lance to protect a cowardly matador. Forgive me, but your *touristas* do not know the difference. Such a picador would be driven from the arena in Mexico City."

Sharon said, "I'd like to see Mexico City. Who knows? Next year, if things work out."

"Aha," he said, "a honeymoon trip? Then you must be my guests. Johnny knows how to contact me. In the spring, eh? That is a good time for Mexico City."

Sharon looked at me, waiting for me to say something. My lousy friend! He'd really put me under the gun. I took a final swig of my beer and stood up. "Sorry," I said. "Never happen. No honeymoons yet. I'm still a growing boy."

Sharon looked away.

"It's getting late, amigo," I told Gabino. "The lady and I must return to Los Angeles very early in the morning. If you will forgive us?"

"Certainly," he nodded, springing up to draw Sharon's chair out for her. "Will you be here for the celebration of Christmas?"

"I don't think so," I said. "I have to go to New York for the premiere of a motion picture. But I'll get in touch with you before the season starts. I haven't forgotten your promise to train me for my *novillada.*"

"Nor have I," he said. "Adios, señorita."

"Good-bye," she said in a small voice. Outside, we caught a taxi and rode back to the hotel. She didn't want another drink, so we went right up to the suite. "Excuse me," she said and went into the bathroom and shut the door. I turned on the radio and listened to a San Diego station for a little while. Except for the music, the room was ominously quiet. I began to get itchy. Finally I went over and knocked on the bathroom door. There was no answer. I knocked again, and when there was no reply, tried the knob. It was not locked. "Hey, Sharon?" I yelled. Again no answer. I rattled the knob and, with rising panic, pushed against the door with my shoulder. It didn't budge. I drew back and gave it a good kick, smashing the heel of my shoe against the wood as hard as I could. There was a crunching sound and the door sprang open. "Sharon?"

She sat inside on the closed john, staring at me. Maybe she had been crying, but she wasn't now. As I half fell into the

room, she made no move. "Sharon's not here," she said. "Not anymore. Not to you."

"Look," I said, "I'm sorry. I was worried. You didn't answer me when I knocked. I thought—"

"That I had used your razor?" She shook her head slowly. "Never happen. Isn't that what you say to all your girls? You swordsmen? You cocksmen? You *liars?* Never happen! You aren't going to marry me, are you, Johnny? And you never intended to."

"How the hell do I know?" I said. "Marriage is a big step. Up to now I never figured on taking it. Now I don't know. Honey, I'm doing the best I can. But give me just a little time."

Coldly, she said, "No."

Paradise Gate was scheduled to open in New York City at the Astor Theatre on December 16, 1954. The first gala screening would be a benefit for the Performer's Workshop, with tickets going for a hundred bucks a whack. Half the name actors under contract to Argos were going to be on hand to act as ushers, in snappy uniforms with gold-plated flashlights. Fleming had ordered me to come to New York and cooperate with the publicity staff because, as he put it, "This is a New York type picture. Newman's a New York director and damned near everyone in it is a New York actor. If you can't deliver New York to the box office, we don't have a prayer in Kansas City."

Although I did not really want to be separated from Diana, her attitude to me since our trip to Mexico had me puzzled, and I figured a few days away from Hollywood might help me think. The long flight east was eased by a flask of twelve-year-old Scotch produced from Ira Winton's briefcase. Ira was a studio press agent, and had been assigned to me for the trip and the premiere. He was a skinny guy in his late twenties, with heavy horn-rimmed glasses, a blond crew cut, and a bitter sense of humor.

"Just think of it as taking medicine," he advised.

"What? The Scotch?"

"No, the interviews. Bitter medicine that will make Papa Fleming healthy in the bank book department. Publicity sells tickets, Johnny. Sad but true."

"I don't object to publicity about the picture," I said. "But where the hell do those complete strangers get off asking me personal questions that I wouldn't even answer for a psychiatrist? What business is it of theirs?"

"The public is like that. If you're a nobody, they don't want to see you or hear about you or give you the time of day. But when you're somebody, they eat you alive. They can't get enough. You'll see. It's the price you pay for being a star. They make you a star, and they have a price for it."

"Suppose I won't pay?"

"Who knows? A few have gotten away with it. Not many." He handed me the flask. "Here, have another blast. Now, one thing's going to make you mad, I know that already. But I might as well warn you now. They're going to want to know about you and Diana Cooper."

"Know what?"

"Whether there's anything serious between you. If you're thinking of marrying her."

I sipped the Scotch, and realized that I wanted to talk about her. Ira listened, nodding when indicated and refraining from comment.

"So, now I'm starting to see how wrong I figured her," I finished. "I feel about her in a way I never felt for any of the others. I don't know what love really is, I guess, but if this is it, I've got a good dose of it. Hell's bells, I miss her so much already that I'm almost tempted to go up and ask the pilot to turn the plane around."

"You could do worse," Ira said. "In this business, there aren't very many good ones around. But she's one of the best."

"Then why don't I jump at the chance to marry her?"

"Because you're scared of the responsibility," he said. "Just like I'm scared, and I'm working on my second time around, and like any man with brains in his head is scared. Marriage changes you, and maybe you're worried about what you might change into. If it was anyone else but Diana, I'd tell you, hell no, kid, you're too young to get hooked up with a full-time female. But I think she'd be good for you. You could sure as hell do a lot worse."

That was all of the conversation about her. Eventually we got on the ground at La Guardia, and there were about a million photographers with blinding flash guns, and reporters with microphones and, sure enough, the second question out of the darkness was whether or not I intended to marry Diana Cooper.

"No comment," I said.

"Does that mean you want the announcement to come from her?" another asked.

"Goddammit," I yelled, "no comment means no comment."

"Knock off that profanity," said one of the TV guys. "Now we'll have to edit the film to get rid of it."

"Isn't that tough shit?" I said. The radio and TV reporters started hollering at me and Ira grabbed my arm and started to lead me through the crowd. The newspaper writers were angry with the broadcast technicians and there were signs of a free-for-all developing as we pushed our way through the mob. One of the TV reporters grabbed my shoulder and said, "Listen, punk, you'll get yours. We'll be laying for you."

"Take your fucking hand off me," I said, "or you'll be laying on your back."

He jumped back and started to square off, but two of his buddies grabbed him and held him. There was a studio car waiting outside the terminal, and we piled in and headed over the Triborough Bridge into the city. The studio kept a suite at the Plaza, and I was whisked right by the desk without registering. By the time we got to the room, the phone was ringing, and sure enough it was Fleming who ate me out for five minutes. I promised him I'd try to be nicer to the press, but that I wasn't going to answer any questions about Diana.

"Very wise," he said, surprising me. I'd have imagined that any publicity she and I might get could only help *Chicken Run*.

The round of interviews went better during the next three days. At Ira's urging I dropped notes of apology to the TV reporters I'd upset at the airport, and was rewarded by some moderately accurate coverage on the late news programs. I made the rounds and looked up friends; lunched with Jerry Conklin who was putting on weight and who had a list of projects a foot long that wouldn't conflict with my studio commitments. One was so odd that I had to dig into it further.

"A nightclub act?" I said, over coffee. "What the hell's that?"

"All we do," he said, "is teach you to sing."

"So who wants to hear an eighty-year-old singer? Because that's how long it will take me to learn."

"Don't be ridiculous," he said. "Singing with a microphone is different. You don't need a voice. What you need is personality. And that you've got."

"So what? Why the hell would I want to sing in a night-club?"

"Because that's where the big dough is," he said. "How about twenty-five grand for a week at a joint in Vegas? I'm not kidding, Johnny, that's the way things are going. People are getting money in their pockets again. And a lot of that money is going to be heading for the only gambling action in this country, the only legal action, that is. Nightclub acts in Vegas are going to be big business any day now, and I want you to be ready. No big rush; we'll talk the next time I'm on the coast. I know a voice coach who'll have you chirping like a bird in six months."

"I think you're nuts," I said. "But what the hell? I'm starting to think the whole *world's* nuts. If I can get twenty-five thousand bucks a week for crooning 'Avalon,' who am I to say no? Just so it doesn't get in the way of my real work."

"Guaranteed," he said. The check came and he handed it to me. "Believe it or not, he grinned, "it's cheaper for you to pay it yourself. If I do, it'll just come back on your account, marked up forty percent."

I cursed a little, good-naturedly, and paid the bill. There wasn't anything new about this. I was getting used to paying bills. In Hollywood, the waiter just presented them to me automatically, unless there happened to be another, better-known, star at the table, in which case *he* got it. "The price of fame," Mickey Rooney growled at me one night when handed a tab for all the drinks the hangers-on had swilled down before he had joined the group. When I fought him successfully for the check, he looked at me with unconcealed interest and said, "Well I'll be damned. A real person hides behind those specs. You're all right, kid. Just don't let the bastards get you down."

In between interviews and meetings with Conklin, I went to the theater every night. Geraldine Page and Darren McGavin were appearing at the Cort in *The Rainmaker*, directed by Joe Anthony, and I sat in the third row, entranced by the production. Anthony had put together a magnificent supporting cast, including Cameron Prud'Homme as the father and Albert Salmi as the kid brother, but my eyes feasted on the magic Gerry Page brought to the role of the spinster sister. When McGavin put a tin funnel on her head and told her she was beautiful, she became beautiful, as if by magic. I went back after the performance and said hello to the playwright, N. Richard Nash, and then played the game

of "Do you know so-and-so" with Gerry. Although we had never worked together, we'd met several times at parties, and I was amazed, as always, to see again how gentle and unaffected she was.

"Oh, Johnny," she said, smoothing off her makeup, "while you're in town, you just *have* to get down to the Theatre de Lys and see *The Threepenny Opera*. It will actually change your life! There has never been anything like it in the world."

I promised to go and then, before we went out to have a drink with Darren McGavin, she dug down into her huge purse and pulled out a little booklet. "Look at this," she said, "I'm an *authoress*."

I looked at the cover, and saw I was holding a copy of *Off Broadway*, and the feature story was "Peanut Butter Sandwiches and Dreams," by Geraldine Page.

"Can I keep this?" I asked.

"Oh, sure," she said. "You'd be surprised, Johnny, how busy the Off-Broadway theater is becoming. And they're doing some really fine work now. But you be sure to see *Threepenny*, promise me."

"Cross my heart," I said. But I never did see it.

On December 15, the day before the premiere, I had lunch at the Theatre Bar with Tony Warden. When I asked how things were going, he said, "Not bad. I'm doing a *Kraft* next week, and one of the networks is talking to me about going on staff to work on something called *Playhouse 90*. Have you seen Jerry Newman since you got back?"

"No," I said.

"He's married now, you know. Some photographer, you probably know her, Dee Dee Aldiss. She works for *Life*."

"I used to know her," I said.

"That's right, she did that series on you when you went out West. And speaking of marriage, what's this I hear about you and that child star, what's her name?"

"Sharon Eisenberg?" I asked

"Who?"

"You know her as Diana Cooper."

"That's the one. The word is that you're pretty serious about each other."

"I guess we are, Tony. It's the first time, for me, anyway,

and I've been doing a lot of hesitating. You know the kind of life I've led. It's one thing to screw every cunt in sight, and another to settle down with a nice girl like Diana. I'm afraid, and that bothers me a lot, because I've never been afraid of anything else before. I don't know how to handle her. We went down to Mexico a couple of weeks ago, and it started out to be a wonderful weekend, except I ruined it at the end by not handling her right. Since then, she's been avoiding me. I get her old battleaxe of a mother on the phone and she tells me that Diana is out.''

"What makes you think you have to handle her, Johnny? Why not be yourself and let whatever happens happen? That's always worked for you in the past. As for Diana being out, I have a hunch that unless you're willing to lead her to the altar, she'll remain permanently out, to *you* anyway.''

"That's the feeling I get, too. Jesus, what a mess. What the hell am I supposed to do?''

Tony beckoned for another round of beers and Patsy brought them over. "Do what you want to do,'' he said. "What else is there?''

"I think I want to marry her.''

"Then get the hell back to Beverly Hills and do it before somebody else does. That is not exactly distress merchandise, you know. I bet she has them lined up around the block. I know Fleming was interested, before you showed up.''

"Tony, you're a good friend. Why is it that I live in California, but all my friends are in New York?''

"Because you're the forerunner, my boy. Take my word, in five years, we'll all be out there. Live television is on its way out. Film and this new videotape process will take over, and then if you want to work you'll have to do it in California. Don't get lonely. We'll all join you soon enough.''

We had a little too much to drink, switching to martinis in the late afternoon, and along about six, when it was already dark outside, we bundled up and strolled up to Broadway to look at my name in foot-high letters on the marquee of the Astor. Tony and I walked along the traffic island separating Broadway from Seventh Avenue, our hands jammed deep into our pockets, slushing through the dirty gray snow.

"How does it feel?'' Tony asked, nodding toward the marquee.

"I don't know," I said. "I honestly don't feel a thing."

Then I heard the featherly flick of a camera shutter, just inches away.

"Beautiful," said Dee Dee's voice. "Hold still for one more." The camera clicked again and she came up close to the fence, a stout, middle-aged man with her. "Johnny, this is Harry Fine of the *News*. We've been looking for you all afternoon."

"Nice to see you again, Dee Dee. But aren't you a day early? The premiere isn't until tomorrow."

"Oh, we'll leave that up to the critics," she said. "The story we're on is your reaction to the news."

"What news?" asked Tony.

"You're Tony Warden, I remember you," she said, clicking away as she talked. "What news? Don't either of you read the afternoon papers? Why, the news that Diana Cooper is getting married tomorrow. To B. J. Fleming, head of Argos Films." Her voice was as cold as the shutter click of her camera. "Oh, dear, Johnny, do you mean you didn't *know?* And to think I had to break the news! Hold still, love, for just one more." The Leica clicked again and as I started to stride off, Tony following hesitantly, she called after me, "Better luck next time, darling!"

Weather problems in Chicago delayed my flight for five hours, and now my dawn arrival was getting closer to 10:00 A.M. California time. I had called ahead from Chicago, and hoped that when we touched down in Los Angeles my Sunset Strip friend would have been able to open my garage and get out the Harley. I would have preferred the Porsche, but the extra keys were locked up in the house and I was afraid the cops might prevent any successful break-in.

We landed and during the taxiing to the ramp, I slipped off my seat belt and headed up to the door where the stewardess waited.

"Sir," she said, "you're supposed to remain in your seat—"

"So sue me," I told her.

"Oh, Mr. Lewis. I didn't recognize you."

"Sure, sugar," I said. "I'm in a hurry. I don't suppose you're staying at the Roosevelt tonight?"

"No," she said. "But you could reach me at the Sportsman's Lodge."

"Who would I ask for?"

"Linda Burke."

"Hang loose, Linda," I said. "I just might call you for dinner."

"I already have a tentative date," she said.

"That's your problem," I said, hating myself as the door was pulled open.

The ramp was already in place and as I ran down it I asked myself, What the hell are you doing? Lining up a girl for the night when you've just flown coast to coast to see your real girl, the one you love? *What's wrong with you?*

My friend was waiting for me inside the gate. "The Harley's out front," he said. "In the No Parking zone. There's probably a ticket on it."

"Who the hell cares? Here. Take these baggage checks and when you pick up my stuff, drop it off at the studio. No, wait a minute. Not there. Take a cab and dump the stuff in my garage. Here's twenty bucks. And thanks, kid." He was still babbling his thanks at having been asked to help when I took off down the corridor. A cop was just writing out a ticket when I burst out the door and started to get on the machine.

"Hold on, buddy," he said, "I'm sorry, you overstayed the three minutes parking. I got to give you this ticket."

"I'm in a real hurry," I said, pulling out my wallet. "Let me pay you the fine."

"None of that," he growled, and then looked at me closer. "Say, ain't you Johnny Lewis, the picture star?"

"That's me. Please, officer—"

"Okay, what the hell," he said. "Take off. I read about your girl marrying that big shot. But watch yourself on the freeway. There's been some rain on and off and the pavement's slick, especially in the low parts."

"Thanks," I said, and kicked the starter. The bike roared into life and I booted her into first, shot forward and lifted the kick stand at the same time. I was in third and still accelerating before I reached the turn at the end of the loading ramp.

I got on the San Diego freeway and barreled along at seventy, past Culver City and Mar Vista. In West Los Angeles, I turned off onto Santa Monica Boulevard, and headed for Beverly Hills. The sun was out, but there were rain puddles on the road. My travel-stained suit was splattered with mud and water thrown up by the skidding wheels. Twice, I felt the rear wheel going, and barely managed to keep from going into a slide.

I made it all the way to my turnoff at Beverly Drive, which would take me up to Laurel, and then went into the turn too fast for the road. The rear wheel went out from under and I just got my leg up as the machine dumped and screeched across the concrete, with the motor running away. I rode the sliding machine like a carpet for a few yards, then it dug in and flipped and threw me free and I landed on my back and shoulders and rolled into a storm drain. The Harley coughed and died, and some kids came running out of a nearby house yelling, "Hey, mister, are you okay?"

My jacket was torn down the back and I had a good case of road rash on both forearms, but I didn't seem to have any broken bones. I limped over to the bike and grunted as I lifted it up and examined it for damage. One handlebar was bent out of shape, and a footpeg had been doubled up, and all the paint was ground off on the left side of the gas tank, but she seemed to be all right. I kicked her over twice, and she caught then and seemed to be missing slightly in one cylinder, but otherwise all was in order. The kids looked after me as I roared up Beverly Drive, heading for Diana's house. There were cars parked bumper to bumper along both sides of Laurel, and I could see a big tent out on the back lawn. I pulled up near the driveway and sat there for a minute, goosing the engine with the throttle grip. Two photographers came over from a nearby car and started taking pictures of me. I wanted to belt them, but instead managed a smile and asked, "What's the story, fellows?"

"The ceremony's taking place right now," one of them said. The other just kept shooting away with his 4×5 press camera.

I put the bike in neutral and opened her up, *va-rooming* exhaust noises bouncing off the nearby houses with barking echoes. The cameramen had stepped back, fearful that I might run over them. The front door of the house opened and someone came running across the lawn. It was Marcel. "Here," he said, "you'll have to stop that. We can't hear a word of the . . . oh, Mr. Lewis. We didn't expect you."

"I'll bet," I said. "What's going on in there?"

"The ceremony is almost over," he said, folding both hands piously.

"Swell," I said, and opened the throttle until the engine threatened to come off the mounts. Marcel stepped forward as if

to stop me, and I kicked her into first and let off on the clutch and he let out a shriek and took off across the lawn, with me and the big Harley hot in pursuit. His foot slipped and he fell, crying out in terror, and I steered around him, goosing the bike as I went past to give him a faceful of grass and mud thrown from the rear wheel. Then I found myself near the edge of the house, and there was enough room between it and the privacy hedge for me to get through, so I roared into the backyard and crashed through the canvas of the caterer's tent. It ripped easily, and I was brushing along the edge of a row of folding tables that collapsed as the bike hit them, spilling dozens of pretty little Cornish hens and plates of potato salad onto the grass. Ahead of me was the huge, white wedding cake, on a cotton-draped pedestal, and high on its top, two little figurines of a white-gowned candy girl and a man in a top hat. I hit it head on, and cake flew every which way, amidst the shrieks of frightened waiters and the curses of two private policemen who started chasing me as I finished skidding through the mushy remains of the wedding cake. I tried to make a clean exit through the canvas side of the tent, but hit a pole instead and barely managed to stay erect. Then I ripped out into the open, and behind me the big tent quivered and settled slowly onto the ground, flat except where the writhing shapes of trapped waiters could be seen. I skidded around and made out through the gap between the house and the hedge, almost clobbering Marcel who had started into the walkway to see what was going on in the backyard. He dived into the hedge for safety, and I burst out onto the front lawn which was becoming filled with wedding guests and photographers. I brought the Harley to a stop near the front door and ignored the jabbering questions hurled at me by the reporters. Finally the door opened and Mrs. Eisenberg appeared, regal in her pearl-encrusted black dress.

"My son-in-law, the well-known B. J. Fleming, wanted to come out and beat you up," she said. "Except my daughter was afraid he might lower his dignity by touching your filthy hide. But unless you leave this instant, we will call the police and prefer charges and *have you put away!*"

"I was just going, old lady," I said. "The hell with all of you, and that goes double for your daughter."

I kicked the machine into gear and headed for Sunset Boulevard. The tears were so hot in my eyes that I could barely see the road.

* * *

Naturally, I was suspended from the studio while the lawyers munched their way through my contract to see if there was any legal way they could hang me by my balls over Fleming's overtime clock. But the upshot was that any more publicity might hurt *Chicken Run*, and it all faded away except for a $2,700 tab for damages that I had to pay to the caterer. Fleming was going to make me sit on my ass without working until my contract ran out, but Jerry Conklin put a stop to that, and it worked out that I would probably be used for loan-outs until some contract settlement could be made.

I *did* call little Linda Burke at the Sportsman's Lodge, and we ended up in the sack just as I knew we would, and when I realized my old impotency was back again and tried to get her to perform in the only way I could stay interested she backed into a corner, whimpering, and I finally had to put her in a taxi and send her home.

Christmas came and went and on New Year's Eve, the phone rang. It had been silent recently, as news of Fleming's displeasure had leaked through the film community. Only the rave notices *Paradise Gate* had received kept me from being exiled to that never-never land reserved for fallen angels and out-of-favor stars. I answered the phone, and it was Sandra Vidor.

"We're going to fuck in the New Year," she said. "Why don't you come over?"

"Why not?" I said. Fleming and Diana were off in Hawaii, on their honeymoon. I'd had two calls from Jean Billingham, neither of which I returned. My relations with the studio were still strained, since few on salary there wanted to be seen talking with me, and for the holiday season I had been more lonely than ever before in my life. My father called me and asked me out for Christmas, but I begged off, and spent the day lying in bed listening to the radio. Now, the promise of some action was enough to pry me out of my depression.

There was some talk around town that I might be going into Sam Merridith's production of the Pulitzer Prize novel *Texas*, but outside of vague hints in the columns, there was no confirmation of the rumors. Conklin advised me to lay low and let everything blow over. "After all," he said, "half the big names in Hollywood lost their wedding lunch, thanks to that goddamned machine of yours. You're not too high on the popularity list right now. But wait until the returns start coming in from

Paradise. You know, Ira Winton got fired on account of your shenanigans back here. So I hired him at two hun a week to handle you on a personal basis. He thinks there's going to be a big teenage following busting out any day now."

"Teenagers? What the hell do I care about a bunch of kids!"

"Don't knock it until you've tried it," he said. "It's the teenagers who are going to the movies these days. If they swing for you, you're in."

I grumbled a little through my new teeth, which were now all freshly capped by the dentist, but agreed to hang loose for a while. Now, at the low point of my loneliness, a New Year's Eve at Sandra's didn't sound too bad. I decided to use the Porsche, in case I would be bringing someone back with me who might not like the idea of straddling a bike in an evening gown, and about nine o'clock I headed over to Sandra's place. The bash was already in progress: the windows were open and bongo noises spilled out into the warm California air.

Sandra had used her weird props to turn the apartment into a funeral parlor, complete with coffin and embalming instruments. The beakers were filled with vodka instead of formaldehyde, and the swizzle sticks were contained in a genuine human skull.

It was the usual crowd of minor actors, of overgroomed girls who aspire to film success, of writers hoping to get further than the patch jobs they now did on work created by other men, of exceedingly handsome men who usually turned out to be fags and who discussed the sex lives of prominent actors with the authority of those who had spent most of their waking hours under the beds in question.

I spent much of the evening sitting by myself, talking briefly to those who dropped over to my solitary post near the piano. Luckily no one there could play, so the big Baldwin remained silent. As midnight approached, and as drunkenness had already taken charge of the party, Sandra got up on the piano and stamped her foot for silence.

"Let's get this fucking party under way," she said. "In exactly two minutes, the lights are going to go out. I want everybody in dresses on this side of the room, everybody in pants on the other side."

"Oh, Sandra," squealed one red-headed girl in slacks, "what do *I* do?"

"You stay on the pants side," she was told. "Next time you'll wear a dress. Now, is everybody in place? When the lights go out, they will stay out until dawn, because I'm pulling the fuse and throwing it away. So make sure you get lined up with the one on the other side you want to start the night with, because it's going to be darker than a well digger's asshole in here in just one minute from now. Get ready, 1955, here we come!"

I had my eye on a big blond on the other side of the room. She had come in late and had spent much of the evening close by Sandra. I knew without being told that she had probably been invited to be my companion, and as I looked up at her over my glasses, she nodded and pointed toward a vacant corner. I turned my head that way and nodded myself, and just then the party started chanting, "Eleven fifty-nine and fifty-one seconds . . . fifty-two, fifty-three, fifty-four, fifty-five, fifty-six, fifty-seven, fifty-eight, fifty-nine—"

The radio burst into chiming bells and as a cry went up of, "Happy New Year!" the lights went out. I scuttled over into the corner and in a few seconds sensed movement near me, and sniffed a rich perfume and then the big blond was in my arms. We clutched at each other, and kissed deeply, and a writhing tongue slipped into my mouth. I felt hard breasts thrusting against my chest, and as the kiss grew more passionate, a hand groped for my crotch and fumbled with my zipper. I stroked my own hand down over the heavy behind, ran it up the short dress, and froze suddenly with shocked surprise.

My big blond was all boy.

Before I could pull away, a match flared, and Sandra was huddled close up against us. "Naughty, naughty," she said to me. "You weren't supposed to find out so soon. Come on: I reserved the upstairs bedroom for us. You come too, Holly."

Holly was the little redhead in slacks. I followed them up the stairs, still numbed by my discovery. The match flickered out, and a hand reached back and found mine and drew me up the stairs, through an open door which then closed behind us and I heard a lock click. Another match was struck, and a candle was lighted, and soft light rushed out to the corners of the room.

"What the hell are you up to, Sandra?" I said. She handed me a glass and just then a champagne bottle went *pop*, and as I turned my big blond had opened it and poured some wine into my glass.

"I thought we'd swing the New Year in a new way," she said. "You know Holly. And this is Richard Devine."

"My friends call me Dick," said the big blond.

"What do you think you're pulling, you mixed-up broad?" I yelled. "You know I don't go that route."

"There's always a first time," Sandra said, giggling into her champagne.

"You've got the name," said Devine. "You might as well have the game." He snickered and stroked his blond wig. I felt sick to my stomach.

"Unlock the door," I told Sandra. "I'm getting the hell out of here."

"Later, darling," she crooned. "Have some more champagne." She poured some more into my glass from a second bottle. Involuntarily, I drank it down. "Who knows? You may like it."

"I know *I* do," chirped Devine.

I wanted to leave at that very second. But before I moved, I saw, in a haze of alcohol and a strange kind of fascination that clouded my brain, Sandra reach out for the girl, Holly, and in a frantic clutching they were wound up in each other's arms and kissing one another full on the mouth.

"Sit down, sweetie," said Devine, "and watch this. I mean, it really turns you on."

The two women fumbled with their garments and were naked as soon as they could rip the clothes from themselves. "Sandra," breathed the redhead, "let's sixty-nine."

"No good," said Sandra. "Neither one of us can concentrate that way. I'll do you, and then you can do me."

"All right," breathed the girl, "but hurry . . . hurry!"

As I watched, frozen in my voyeuristic fascination, Sandra lowered her head and began to kiss Holly's genitals. The act became more frenzied and deeper, and Holly threw her head back and began to make spastic hissing sounds. Her fingernails clawed at Sandra's shoulders and at her neck, leaving red welts. Sandra slipped her hands under Holly's writhing buttocks and lifted the girl's lower torso into the air as she pushed her own head tighter and deeper into the trembling flesh.

"See what I mean?" said Richard Devine, putting his hand on my knee. I brushed it off, but I could not take my eyes away from the two women. Now Holly was panting and snorting in a frenzy of rutting that reminded me of nothing so much as the

sounds the sow back on the farm made when Uncle Ray loosed the boar upon her. Her eyes rolled back in her head and as Sandra worked faster and deeper, with her two hands tightening on Holly's erect nipples, the redheaded girl let out a wail that sounded for all the world like she was dying.

"That's it!" she shrieked. "Don't stop. Eat me, chew me, swallow me up!"

"Oh, it makes me so *hot*," whispered Devine. He had his own hand up his dress and I caught a glimpse of his swollen organ.

"Aaaaaah," gasped Holly and her hands beat against Sandra's head in a wild frenzy. Then there was quiet in the room, except for Holly's rasping breath. Sandra raised her face into view and turned to look at me.

"Doesn't that give you ideas?" she said.

"I'll do you first," said Devine, reaching for my fly.

"I don't know," I whispered. I felt in a daze. I was unable to make any decision, unable to stand up and leave this nightmare of a room. The metallic sound of the zipper jarred against my ears, and then, as if from a very far distance, I heard Devine's husky voice saying, "Look at that. He's all ready for me."

And, as I sank back onto a pillow and inched my way out of my khaki pants, Devine pulled off the blond wig and I saw that he was completely shaven bald, and now his face had become very old under the garish makeup and behind the red lipstick. "I'll do you," he said, stroking my trembling legs, "and then you do me."

"Yes . . . yes," I said thickly. "I'll do you. . . ."

Jimmy the Arab

Robert Ready

". . . and James Dean is realistically unpleasant as
the slimy one"
—Richard Watts, *New York Post*, February 9, 1954

Come in. Yes, you've found me. I am real. Touch me, if you can believe this is still skin.

This evening is a big anniversary. And you've come a long way. I have had my share of pilgrims like you since he died and became his name. Most of you are American, some doing research, as you can see by that shelf of books and generally sensational magazines that have come here since he died. My keepers let you in as a matter of policy.

Yes, for sure, I am Bachir, in my childhood a blackmailing, homosexual, thieving Arab houseboy—his last role on Broadway.

What you may have from me is a meditation, not a story. These are the basic facts.

Forty years ago today, *The Immoralist* opened at the Royale in New York. He played me, with Geraldine Page as Marcelline, the wife, and Louis Jourdan as Michel, the husband. Billy Rose was the producer. The play was adapted for the stage by Ruth and Augustus Goetz from Gide's novel. It was about Michel, a French archeologist who comes to French Algeria in 1901 and realizes his homosexuality.

Our big scene, Jimmy's and mine, was when I, manipulative Arab sexual terrorist, danced for Michel, confounding him until I could steal Marcelline's sewing scissors. To look Arab, Jimmy wore a bathrobe, thick brown makeup, and sandals. The

photo in the books there shows him dancing, hands over his head like your average Arab belly dancer.

Almost as soon as the play opened, Jimmy gave his notice, quit, on Kazan's promise of *East of Eden.*

But Eden was here, Biskra, oasis city in Algeria, where I, now an ancient man, am under a final house arrest next to the last of the orchards that saved Michel's life. In the orchards were the men and the boys I told Michel about, men and boys there at night, under the stars of North Africa.

Algeria in the Maghrib is no longer under the Michels and Marcellines of another country.

But I am no more popular with the besieged revolutionary party than I would be with the Islamic party the government fearfully shuts out of power. Neither their Marx nor their Allah has much use for me. Both call me immoral, unnatural, an unfortunate enduring thing. But I am a character, and characters go on.

And you, American culture tourist who cannot forget James Dean, Bachir lives in your dream of the Arab, just as Jimmy lives in your dream of brilliant, unfinished, cursed youth. The religion of ancient Carthage demanded child sacrifice. The religion of America demanded the sacrifice of James Dean.

Didn't it?

Once, after independence was won in 1962, I, already an old man, escaped to New York, to the Times Square where he once walked with his hands in his overcoat in the rain, and to a James Dean festival in a movie theater near Lincoln Center. I saw him as Cal Trask, Jim Stark, Jett Rink. And he was still a kind of Bachir. His death freeze-framed his life into Trask and Stark and Rink, but the Bachir of him still grinned behind those simple hard names.

Let us call this immoralist thing JD and the Arabs, after the crèche scene your irreverent Christian kids still call JC and the Arabs. JD and the Arabs was about dancing, rebellion, finding the orchard where no archangel guarded the gate. It was about finding the immoral Arab who would release European man.

Jimmy was a Bachir at heart. At any moment, he could drop the wounded, needy act and stick his I-lost-my-momma-and-so-fuck-you middle finger into the face of your expectations of him. He wasn't going to be the man they wanted him to be—for men or for women.

He was a thief. In '54 Jimmy was in *Philco TV Playhouse*'s "Run Like a Thief," and in '55 he was in *U.S. Steel Hour*'s "The Thief." In 1954, the year he began to rise, we began to take back our country from those who had stolen it from us. He stole manhood away to a different place in the fifties, turned it on men, the way Jim Stark steals Cal Trask's last name and turns it inside out. Like the multisexual Byron his mother middle named him after, he stole sex, fame, and death.

Jimmy was a great thief, would have been greater, had not the fates used those same scissors to cut his Spyder's thread that day in Paso Robles. He was never what manly men had in mind, always what they had to fear—another thieving Arab in their midst, grudging even the fight he had no choice but to get into.

Though Michel couldn't accept himself, I was what Michel expected me to be, nothing more. By telling Michel to be Michel in the orchards, I was his image in the dark mirror, his way into himself at last. How convenient for him to find clarity for his European soul in the native Arab houseboy!

But Jimmy knew as he played me that there is no such clarity. That's why he said that in playing Bachir, he didn't know who he was. Marcelline, the unfortunate wife, got it right. She told Michel after I danced for him that Biskra was a very confusing place.

To one of Michel's taunts, Bachir says, "Yes, sir. I think so. I am very healthy and disgusting." I became even more disgusting by threatening to blackmail Michel about his homosexuality. I was not admirable, only slimy, the serpent in the crypt of the European archeologist's discovery in his North African land. It is a role given to James Dean in 1954 at the fall of the French empire and the rise of the American one.

Extremes meet where they must, and Jimmy the thieving, homosexual, blackmailing Arab was so "very healthy and disgusting" that he was the nightmare about dirty boys to the rest of that, Western, man's world. Bachir was the way James Dean could look through America and everything America offered ten years down the road from the war that left America its time of power.

Yes, you're right. My keepers do not like me to get excited, to get passionate again. I am memory to them, even though they condemn me. But I tell you this. Bachir was James Dean gone evil, gone sexual, gone into the Western dream of the Arab, into the orchards, gone to Eden and come back with awful knowledge

of just how little the keepers of the garden really understood about everything growing in it. Guerrillas came to live in the orchards, here and elsewhere, got ready for the century to come in North Africa and Indochina and America.

You will say that Bachir was just a thief, a blackmailer, a panderer, that the role he played has no honor or substance in the world, so why tease it up this way? But Jimmy and Bachir were once the same, just before James Dean became a hero. St. James of Compostela rode a white horse and slew the Moors of North Africa. James of New York ended up riding his white Porsche way far east of Eden, where, as Michel's Arab lover Moktir in the play tells him about the orchards, "we are all the same . . . Arab, Nubian, Frenchman, Jew—we are all the same."

The light goes down. The orchard is still sweet outside my window. But as you go, look at that switch plate, there by the door. That's right. It is I, Jimmy, Bachir, our hands over our head, dancing for Michel. It is hand painted, in tones you might call Algerian green. See how the switch sticks out of Jimmy's burnoose-bathrobe, like the scissors the thieving, homosexual, Arab houseboy took.

Flick the switch. Watch Bachir light up James Dean again.

James Dean

Reuben Jackson

indiana is no place to be colored.

(eyes on your every swagger.)

no homies to embrace
like sal mineo upside
griffith planetarium's darkness,

james dean's rose red lips
and jacket;

natalie wood further away than mars
and the anguished father jim backus played.

further than the pockmarked tombstone
where my camera and i cautiously gather
around the abbreviated screenplay
like smokers desperate for a light.

Kings of the Afternoon

Lewis Shiner

From somewhere beyond the ragged palm trees came the screaming of sea birds. He lay with his head in Kristen's lap, watching the lines around her mouth. Her voice, with its rounded European vowels, seemed to mingle with the hissing of the sea.

". . . I had crawled to the top of the hill," she said, "and the water was close behind me. All I could smell was the burning of the bodies, and I knew that all of California was finished. They found me there, not conscious, and I was in a dream."

Landon closed his eyes.

"In the dream I was sleeping," she said, "and I was wrapped in a sort of blanket, soft, silver colored. From a distance I seemed to be watching and the sun was up but making no shadows and nothing seemed to be lighted, you know, but sort of glowed. Someone was carrying me, I could feel the hands, and they took me to the edge of a water. I remember the dark of it, and a mountain out in the middle. There was waiting a boat, and other hands reaching up for me. The hands, you know, were not human, but like fingers made out of rocks, and the body too was rough and lumpy. I had not then even seen the men inside the saucers, but I knew what they looked like.

"A big sail the boat had, black and stretching, but there was no wind. The hands took me and the boat moved away from the land.

"The sea was thick and clinging and full of odd lights."

Landon stirred. A seagull stumbled across the beach toward them, its body coated with dark, glistening oil. The bird rattled its wings with a noise like gunfire. Landon sat up, watched the bird stagger and fall into the sand, one dark, empty eye fixed

on him. Landon pulled his Colt and fired. The impact flung the
bird into a ditch beside the highway.

He lit a cigarette, the match trembling in his hand. The
smoke hurt his lungs and he coughed as he stood up.

"Let's go," he said.

Along the sides of the highway abandoned cars lay rusting in the
sun. The sky was free of saucers and the wind carried the smells
of the sea.

Landon drifted into a doze, waking as Kristen pulled into
a weathered café beside the road. The big Pontiac convertible
skidded on the gravel and jerked to a stop between two plastic
execucars.

"Where are we?" he asked through a yawn. The heat had
glued his black sport jacket to his shoulders.

Kristen shrugged. "Here." A handpainted sign over the
door read DON'S CALIFORNIA-STYLE DINER and a card in the win-
dow added "YES WE'RE OPEN."

The smells of grease and cigarettes drifted through the
screen door. Landon opened it and stood for a moment framed
by the doorway, leaving his sunglasses on, making no effort to
hide the holstered Colt at his side.

A few executives lingered in back, sketching on their nap-
kins. Kristen led the way to a booth and Landon sat down, his
sweat-damp trousers squealing against the red vinyl. A boy in a
soiled apron took their order, then went back to a row of beer
mugs on the bar.

"Your eyes," Kristen said, "they still hurt . . . ?"

He nodded. A close call with a saucer the day before had
nearly blinded him, the road melting into a steaming gash in front
of him. He had fought the car off the road, tears streaming his
face, as the saucer whipped away, leaving a mile-wide path of fire
behind it.

Kristen, sitting with her legs stretched out on the seat,
touched his arm. She pointed toward the kid at the bar, who had
started to juggle the glasses he was supposed to be polishing. Lan-
don took off his sunglasses. The kid was no more than five eight,
wearing boots, a T-shirt, and dirty jeans. His hair was shaggy
and stood up like a brush on top, tapering into long sideburns.
Light flashed off tortoise shell glasses that hid his eyes. A cigarette
hung from his mouth.

The act was meant to be casual, but Landon sensed a des-

peration behind it, a hunger for attention and for something else as well. The executives had gone quiet, and there was a thump as one of the glasses hit the table on its way back up. Kristen suddenly caught her breath and then Landon saw it, too, fragments of the shattered glass hanging above the kid's head.

The kid stepped aside, catching the other two glasses, and the fragments pinged harmlessly on the linoleum. The kid casually dried his hands and reached for a broom to sweep up the mess. Landon noticed the red stain on the towel, the trembling in the kid's fingers, the odd sensuality of his gestures.

The kid brought their hamburgers, puncturing the beer cans with sharp, graceful stabs of the opener. Landon couldn't help but notice the way Kristen watched the kid. He put his sunglasses back on.

"Bring one for yourself if you like," Kristen said.

The boy nodded. He was older than Landon had thought at first, maybe early twenties.

"You have a name?" Landon asked.

"Byron," the kid said. He ate a potato chip off Landon's plate, then spun away.

"Hey," one of the executives said as he passed. "Bring me a beer, will you?"

Byron smiled at him. "Fuck off," he said casually. He brought a beer back to Landon's table as the executives lined up meekly at the counter, perspiring in their dark gray suits. A small man with sores on his face came out of the kitchen and accepted their plastic cards with a conciliatory smile.

"Assholes never tip anyway," Byron said. He turned a chair around and sat with his head resting on his folded arms. The executives filed out and Landon caught the odor of hot plastic as they started their electric cars.

"So," Byron said. "You cats are like . . . outlaws?" He kept looking back at Kristen's face, again and again. He rubbed the back of his thumb under his nose and said, "I seen your car."

"That's right," Landon said.

"I mean," the boy said, a sudden urgency screwing up his face, "it's like . . . if I . . . I mean" Then he spun out of the chair and out the front door.

"He's insane," Landon said.

"He is beautiful. Can we keep him?"

Landon shrugged and finished his beer. "If you want him badly enough."

As they started for the door the man with the sores said, "Ain't y'all planning to pay for that food?"

Landon turned so the light from the doorway glinted on his Colt. "Just put it on our bill."

"I never seen you before," the man whined. "I got to make a living, too. I'm on *your* side."

"Tell it to Robin Hood," Landon said. "I'm only in it for the money."

They found Byron leaning against the front of the building, one foot planted into the wall. He'd taken off his apron and had a red zip jacket over one shoulder. He lit a cigarette and said, "Where you headed?"

Landon pointed north. "New Elay."

The kid took the cigarette out of his mouth and said something to it, too quiet for Landon to hear.

"What?"

"Take me with you."

Landon didn't like the edge of hysteria in the kid's voice. Before he could say anything, Kristen stepped in front of him and got behind the wheel. "Get in," she said to both of them.

The land was gutted and torn for miles in all directions, rolling down to the oily Arizona coastline. Stucco crumbled from the walls of the shattered building, and vines tore the red tiles from the roof.

Behind a growth of acacias lay a burned-out neon sign that read MOTEL CALIFORNIA. Landon leaned against the sign, watching Byron. The kid walked in circles around the parking lot, sniffing the dusty air and squinting up at the sky. He squatted at the edge of the moss-filled swimming pool and tossed pebbles into the murky green water. The boy had been with them for two days now and hardly said a word.

"Come on," Landon said. "Let's see if we can find you a room."

They worked down the row of cabins until they found one with most of the furniture still intact. Landon kicked idly at a pile of rat droppings and poked into the corners with a broken chair leg. The air held the tang of mold, urine, sour linen. He wound a window open and let in the gritty ocean breeze. A cough gently shook his chest.

Byron stretched out across the bare mattress and locked

his hands behind his head. A smile stretched his cheek muscles into tight cords. "Now what?" he asked.

On the horizon were the executive office towers, massive, opaque, impenetrable. They'd passed the residence blocks on their way into New Elay, equally fortified and remote. The buildings in between, Landon saw, had taken their share of punishment from the saucers. Shattered glass and collapsed walls littered the sidewalks; glittering trenches of fused concrete cut the streets.

Kristen drove at high speed, weaving through the lines of plastic cars and fuming executives. Pedestrians, most of them in rags, stared at Landon with blank acceptance. A pack of children chased a dog with a mixture of malice and desperation. An old woman squatted to urinate outside an abandoned storefront.

Landon took a Peacemaker in a worn leather holster out of the glove compartment. Turning sideways in the car seat he showed Byron how to load and fire it. The kid wound his fingers slowly around the grip, his eyebrows contorted in an agony of concentration. Landon watched as the gun seemed to be absorbed into the boy's hand.

Byron stood up on the backseat of the convertible and took aim at one of the execucars. The driver turned pale and swerved across the road, glancing off the cars on either side of him. Byron rolled his head back and laughed at the sky.

They pulled up in front of a heavily barred store window. A pair of steer's horns were mounted above it. "A meat market?" Byron asked.

"Lots of cash, pal," Landon said. "The liquor stores are too dangerous now." He got out and looked back at the kid. Byron had taken his glasses off and was carefully putting them into the pocket of his red windbreaker. Without the glasses, the kid's moist, deepset eyes gave him an unearthly beauty. He vaulted over the side of the car, holding the pistol as if he'd been born with it.

"Just stay out of the way," Landon said. "No grandstanding. Point the gun but don't shoot it, all right?"

Kristen led the way in, carrying a Luger and a cloth sack. Standing in the doorway, Landon kept his own gun in casual view. He could smell the raw meat, his stomach reacting with reluctant hunger. The customers shifted quietly out of the way as Kristen emptied the cash box. Byron stood in the center of the room, radiating quiet menace.

Kristen signaled him, and Landon went back out to the

car. The crowd had more than doubled in size in the minute or so they'd been there. Up and down the block Landon saw people moving toward him. He started the car and began inching forward. Kristen pushed through the crowd and got in the passenger seat, holding the sack of coins in her left hand. Then she looked back and shouted, "Hurry up! What are you doing?"

Byron was halfway up the metal grille that covered the front window. "He's taking his trophy," Landon said. The kid swung onto a metal bracket and began to tug at the huge pair of horns.

"Son of a bitch!" he yelled, the horns giving way under him. He dropped ten feet to the sidewalk, landing in a crouch, one hand slapping the cement. The other still held the horns.

He vaulted into the back of the car, holding the horns over his head. Landon was astonished to see a few smiles and raised arms in the crowd. He leaned on the car horn, pumping the clutch, moving forward a foot at a time. The crowd stared at Byron.

Just as he began to make some headway a frail blond teenager stepped directly in front of the car. She looked hypnotized. Landon swerved, brushing her aside with the hood of the Pontiac. "Idiots," he said. "It's their money we just stole."

He could see Byron, framed in the rearview mirror, holding the horns over his head.

From the door of the cabin Landon could see Byron slumped in a corner, mumbling and nodding rapidly. A bottle of pills was open by his foot, and his hands played nervously over a pair of bongos. A girl was stretched out on the mattress, writhing slowly with some internal pain or pleasure. The sight of her soft breasts and rumpled brassiere, her long legs tangled in the sheets, gave Landon a pang of formless longing.

"So fucking high, man," Byron mumbled, eyes swollen nearly shut. "This shit, this shit . . . so goddamned high . . ." His fingers twitched and fluttered over the surface of the drums, coaxing out a shallow, frantic rhythm. "Spinning . . . falling . . . crashing . . . saucers crashing, and like . . ."

Landon turned away. "Where *is she?*" the kid screamed. Landon walked to the beach, the hot sand working in between his toes, foam spattering his black coat and trousers. Behind him he could still hear Byron railing against the saucers and screaming for his mother.

The day was clear enough that Landon could see shadowy mountains across Mojave Bay. Among the litter of plastic and rubber on the beach he found a bleached skull and the bones of a single grasping hand. A fit of coughing took him and he crouched in the sand until it passed.

From the distance came a low vibration, like pedal notes on an organ. The flat disk of a saucer dipped into the horizon and disappeared.

The motel driveway was crisscrossed with tire tracks. The smell of gasoline hung in the air. Byron's motorcycle was gone, and Landon had a sense of foreboding as he pulled up in front of Kristen's room.

"Where is he?" he asked, not getting out of the car.

She looked worn, the lines of her face all pointing downward. "Gone," she said. "With four, five others. On motorbikes. They are after the saucer, I think."

"What saucer?"

"On the radio, it was. They say one low along the coast was flying, maybe in trouble."

"Christ," Landon said.

The tracks turned south along the coast road. Landon swung the Pontiac around after them. Unless they stayed on the highway there was no chance of catching them. Landon let the landscape on either side of the road melt into a yellow blur.

Eventually he realized that he'd been hearing a low screaming noise for some time. It seemed to be coming from ahead of him. Finally he saw a faint glow off to the east and pulled over. He got out and slammed the door, the noise inaudible over the throbbing whine.

The source of light lay over the next dune. Landon put on his sunglasses and drew his Colt. The sound carried a pulsing resonance that he could feel in his belly. He went over the top of the dune, his left hand pressed against the side of his head.

A saucer perched on narrow stilts over the sand. Landon had never been so close to one before. Its sheer size was over-whelming, at least a hundred feet in diameter. The entire surface glowed with a milky light.

Five men on motorcycles circled the saucer. They wore long hair and sleeveless denim jackets, their faces sunburned and expressionless. As Landon watched they wrestled their machines over the same rutted circles in the sand, again and again.

The riders ignored Landon as he walked toward the single abandoned motorcycle parked under the edge of the saucer. He climbed a flight of stairs into the underside of the ship, holding his gun like a talisman in front of him. The ladder opened into a small corridor, and Landon found himself in a curving passageway that followed the outside wall. The roar of the motorcycles and the high-pitched whine had both faded once he was inside, and now he could hear the muffled tones of a human voice.

The luminous wall to his left suddenly gave out, and Landon looked into the control room of the saucer. The walls were covered with cryptic designs, and the air smelled like mushrooms. In the center of the floor was a raised platform; two figures were struggling behind it. Landon ran around the platform and pulled Byron off the alien creature, pinning his arms behind his back. Byron fought him for a full two minutes, the power of his anger seemingly endless. At last his strength gave out and Landon tied the kid's arms with his own jacket.

The gnarled alien watched the process with black, expressionless eyes. Landon caught himself staring at the creature, reminded of a crumbling sandstone sculpture. He forced himself to look away and wrestled Byron out of the saucer.

The other riders were still circling. The pitch of the saucer's whine climbed threateningly and Landon sensed it was about to explode. Byron struggled free, shrugged out of the jacket, and ran for his motorcycle.

"Leave it," Landon shouted, unable even to hear himself. It was hopeless. He ran for the shelter of the nearest dune. He got over it and slid down the far side on hands and knees. He burrowed into the loose sand and faced away from the saucer, coughing and gasping for air. In the last moment before the explosion he saw Byron's motorcycle silhouetted against the sky. It shot over the crest of the dune and tumbled gently into the sand at Landon's feet, throwing the kid harmlessly to one side.

Another motorcycle followed, and was caught in midair by the full force of the blast. There was an instant of total light, then absolute darkness. When Landon was able to open his eyes again, there was no trace of the machine or the rider.

He pulled Byron into a fireman's carry, wondering if they had been hopelessly irradiated. It made little difference. The boy made a few weak gestures of resistance, then collapsed across Landon's shoulders.

* * *

"Why?" Byron shouted, slamming a beer bottle into the wall. "What's stopping me? Who makes these rules that I'm breaking? The saucer men, that can't even talk? The police, that are too scared shitless to do anything? The fucking executives in their little toy cars? *Tell me!*"

The kid's anger seemed to have been building over the months, steadily, inexorably, since they'd first found him in the decaying café.

Three sullen girls sat on the floor near him, paying no attention to Landon at all. One chewed gum, another patiently put her hair in a high pony tail. "It's me," Landon said. "You're putting my life on the line when you push things so hard. Mine and Kristen's both."

"If you can't take the pressure," Byron said, his voice suddenly quiet, "maybe you're just too old."

Landon got up from the bed and pulled on his trousers. Kristen dozed in a narrow band of sunlight, relaxed now, an arm behind her head, displaying the muscles of her ribcage.

Landon slipped on his stained white shirt, combed through his thinning hair with water from a pan in the bathroom. Then, almost as an afterthought, he buckled on his holstered gun.

The fading sunlight drew him outside. A mosquito sang past his ear, and he idly waved it away. He took a pint of whiskey out of the car and stretched out on a lounge chair by the pool. Strange columnar mosses grew in the dark water, the beginnings of a new evolutionary cycle. Landon drank, shifting as one of the frayed vinyl straps gave way under his weight. The warmth of the whiskey met the heat of the sun somewhere in his abdomen and radiated away into space. A single bird whistled in the distance.

Gradually he became aware of a new sound, close to the scream of a saucer, but more prolonged. It grew into a siren, and Landon turned his head to see a police car moving toward him from the north.

He capped the bottle of whiskey and sat up, thinking of Kristen, vulnerable in the motel room. As he got to his feet he saw Byron leaning against the door to his cabin. He wore a black T-shirt, leather jacket, and jeans, his glasses hanging from one hand. A huge reefer dangled from his lips. He wore the Peacemaker strapped low on his leg, and his eyes were wary and exhausted.

Landon felt the pull of destiny, a movement of forces in planes perpendicular to his own. The approaching car, the tense, expectant figure of Byron, the murky pool at his feet, all seemed part of a ritual, a tension in the universe that had to be worked out.

The lower limb of the sun touched the ocean and the world turned red. Light from the police car streaked the evening as two men got out, carrying lever action rifles. Their khaki uniforms glowed ruddy gold in the dying sunlight.

Finally one of the cops said, "Put your guns in the dirt." Landon held himself perfectly still.

Suddenly one of Byron's girls walked out of the motel room. The contours of her body were clearly visible through her sweatshirt, contemptuous of the law, threatening civilization.

"Hold it," one of the cops said.

The girl knelt by the pool, dipping one hand in the fecund water. "Fuck you," she said, not looking up.

The cop raised his rifle, working the lever in short, nervous spasms. "Halt, I said!" His anguished voice reminded Landon of Byron. The girl ignored him, watching the spreading ripples.

The bullet took her in the head, scattering fragments of her skull and whitish brain tissue over the pool. Landon, only a few feet away, stared at her gushing blood in horrid fascination. He pulled out his pistol in a kind of daze and turned to see Byron with his Peacemaker already out. The kid opened up, cocking the pistol with the flat of his left hand as fast as he fired. The two cops seemed to wait for the shots to tear into them, spinning with the heavy impacts, dust splashing up over them as they hit the ground.

Kristen stood in the open door of her room, wearing a threadbare white cotton shift, still unbuttoned. Her lips formed an unspoken question, then she went back inside. Landon heard the sound of drawers opening and shutting, the rustle of clothes.

Byron spat the stub of his reefer into the dirt and picked up his glasses from where he'd let them fall. He turned the collar of his jacket up, rolling his shoulders in a protective gesture. As he got into his sportscar he held Landon's eyes for a long moment. Then he roared off onto the highway, his tires grazing the head of one of the dead policemen.

Landon left the girl's body by the pool and began loading his things into the Pontiac.

* * *

A few days later, swinging south toward Yuma, they passed by the old motel. Hundreds of people, most in their early teens, wandered through the ruins, their faces full of confusion and the gathering darkness.

On the last day of September Landon rode into town with Kristen for supplies. He waited in the car as the daylight faded, his feet propped up on the dashboard. Coughing gently, he closed his eyes and listened to the crickets and the evening breeze in the palms. The crunch of gravel startled him and he looked up to see what must have been fifty gray-suited executives surrounding him.

The fear that finally came over him was the result of the failure of his imagination. It had not begun to prepare him for what he saw. The men stood with easy authority, their meekness and submission gone without a trace. They carried heavy weapons that Landon had never seen before, intricate masses of tubing and plastic that conjured death and burning.

One of them stepped forward. He was empty handed, authoritative. "Where's the kid?" he said.

Landon shrugged. "We haven't seen him for a week."

Kristen came out onto the sidewalk and Landon watched the fear and puzzlement spread over her face.

Another gray-suited figure pushed his way through the crowd and addressed the empty-handed man. "We've searched the town, J. L. He's not here."

J. L. nodded and looked at Landon. "Where would he have gone?"

"Anywhere," Landon said, struggling for equilibrium. "No place."

The man turned to Kristen, still standing in the doorway. "What about you?"

Kristen stared back, wordless, hostile.

Another man pushed through. "They've located him, J. L. He's driving a sportscar up the coast, toward New Elay. Some foreign job, silver, with numbers on the side."

"Green's outfit is up there. Have them take him before he gets to town. It shouldn't be hard, in this light. And tell him to make it look like an accident. It'll save trouble in the long run."

"The saucers," Landon said.

"What?" J. L. said.

Landon pointed to the weapons, the communicators. "You

78

made a deal. You sold out the rest of the human race so you could keep on going the way you were. That's why your buildings and your cars never get hit by the saucers. Because you sold the rest of us out and now they let you run things. What did you give them? Women and young boys? Gasoline? Gray flannel suits?"

One of the junior executives reached over and slapped Landon across the mouth. J. L. shook his head and the man stepped back. "Get out of here," J. L. said. "We're through with you."

Kristen said, "You're letting us go?"

"Do you think," J. L. said, "that we couldn't have taken you any time we wanted? That if we want you again we won't be able to find you? We don't care about you. It's the kid that's dangerous. You're just a part of the scenery. Just part of California."

"California's gone," Landon said, tasting blood. "It's on the bottom of the ocean."

For the first time Landon saw a hint of emotion in the man. "No," he said. "Not as long as we have a use for it. As long as there's a coast, there'll be a California."

"The king is dead," Landon said. "Long live the king.

He was talking to the sunset. The men were gone, and Kristen sat on the hood of the car, smoking and looking out to sea.

From somewhere beyond the ragged palm trees came the screaming of sea birds.

Who Killed Jimmy Dean?

Stephanie Hart

It was the spring of 1954 when James Dean squinted into the California sky. The sun cowered behind a cloud. Triumph shone in his blue, deep-set eyes.

"Quite a trick, Jimmy." The young woman on the grass next to him smiled with more than a hint of irony. "You really think you control the solar system, don't you?"

Jimmy's laugh was a half-silent chuckle. "Get those orbs off me, Marnie. Stop trying to X-ray me. I'm not that transparent."

The young woman stretched luxuriously and moved closer to him. "Aren't you, James Byron Dean? I think you are." She loved the feel of his name on her tongue, calling him James or Jimmy depending on her mood at the moment. She was dressed in red overalls and a matching red baseball cap. She tossed off the cap and ran her fingers through her wavy, blond hair.

"I'm just a simple farm boy." James began to giggle. He hooked his thumbs under his suspenders and composed his face into what appeared to be a parody of innocence.

Marnie enjoyed watching him; their faces were almost touching.

"You're a swell girl, a remarkable girl," he went on. "How would you like to date a famous movie star?" Jimmy made a beckoning motion with his hand. "Come with me to the Hollywood hills, and I'll ravish you under the stars."

"I'm tempted, James, really I am, but we came out here to rehearse a scene, remember? I want you to get inside Cal's skin, realize him in all his possibilities."

James bit his lip and hunched his shoulders with an inimitable combination of desire and hostility.

"That's it, kid," Marnie said approvingly. "I can see Cal Trask emerging."

They were on the set of *East of Eden*, deep in the heart of the Salinas Valley in northern California. Behind them the rust-colored relic of a train promised a Hollywood journey into the early nineteenth century. Marnie was a twenty-six-year-old script and story editor from Los Angeles who had taken to helping James rehearse between takes. She hadn't like James Dean much at first. She found his flirting, his magnanimous pouting, supremely adolescent. She was annoyed by his rudeness on and off the set, his outright disdain for anyone who dared to interfere with his artistic reverie. She had begun to think this twenty-three-year-old rebel from Indiana had more braggadocio than talent when he suddenly bowled her over with his genius. It was during the shooting of a pivotal scene in which Cal was to appeal to his mother for $5,000 and, more insidiously, the love she had denied him. James's subtle balance of arrogance and fragility, his hooded gaze, the insistent whine in his voice, his slow motion turns around imaginary curves, the naked greed on his face, the raw pain, all in a tapestry of seconds, left Marnie awestruck. She told James how she felt, and he lapped up her praise like a famished puppy. When they weren't reading lines to one another, he would talk in a shy voice of his Indiana childhood; he told her about his mother's death when he was nine, how he still longed for her in a hall of nightmares, blaming himself for her dying. He told her how the glare of fame made him shrink into a shadow of himself like a lost little boy. And Marnie, who believed in the power of optimism, the sheer American will to create someone over again, determined to help James realize his singular talent as a man and an actor.

"Aren't you a little bit in love with the James Dean of the movie magazines?" She had asked incisively.

And James, chameleonlike, had emerged from his soft shell and grinned at her. "Maybe."

She could tell he liked her honesty.

One night they drove high into the Hollywood hills, and James took her to his favorite cliff, where they could look at the stars. He seemed to gather the darkness around him. "Wouldn't it be something to be able to touch that star?" he said. Then more softly, "Sometimes I feel, I don't know, so boxed up inside my-

self—the devil and angel in me kinda toying with each other. Way up there I could start all over again."

Marnie touched his shoulder lightly, and James snickered. "Best seduction ploy I've come up with yet, ain't it, honey? Save me from the great abyss."

"Knock it off, Jimmy. I'm not one of your little lovesick fans." They were friends with a hint of desire between. Marnie liked it that way. It left room for fantasy and expectation. And besides, on a primordial level she was afraid of Jimmy—afraid of what he might awaken in her.

James giggled appreciatively. "One point for you, girl." Then he began to tell her his dreams of becoming a great actor and a great director. He would blaze a trail of glory across the next few decades.

"You'll make it, Jimmy," Marnie reassured him.

On that warm day in April, Marnie and James had planned to rehearse a scene that had become James's nemesis. In the character of Cal Trask, he was supposed to be drunk and full of hope and self-inquiry; teetering on a roof outside his brother's girl's window, he had to ask her to help him plan his dad's birthday party. Then, hitting his head against a piece of wooden scrollwork, he was to demand of himself, "Why did I hit my brother so hard?" Take after take James was leaden on the set. He couldn't get the right balance of yearning and self-reflection.

"Life isn't worth living when I can't get a scene right," he told Marnie. "Everything I am is in my characters."

"Let's try it again," Marnie encouraged him.

James ran a hand through his resentful tufts of hair. "Damn it, Marnie, I can't. I just can't."

"Come on, kid, you're the master of complexity," she reassured him. You've got it in you."

James wasn't listening. A production assistant in a tight white sweater and peddle pushers that fit like a glove walked by. He simonized her with his eyes. The girl gave him an intense look, a promise of honey.

"We haven't got all day," Marnie said impatiently.

"Come on," James said, suddenly serious. He took her by the hand and lead her into the tall grass in front of the rusty train with the painted sign saying SALINAS. She felt she was in an exotic jungle with only James beside her. He was breathing hard.

"I've got to *really* get inside Cal's skin in order to play that scene, know his every thought, feel his heart beat. I've got to *become* Cal Trask."

Marnie began to laugh. Her eyes were shining. "Oh, I see, first you order the sun behind the clouds, and now you're going to negotiate with the calendar. She touched his cheek affectionately. You're something else, Jimmy."

It was as if all his energy were concentrated in what he said next. "Come back in time with me, Marnie. I can become the real Cal Trask. I can bring him to life."

"You're crazy," Marnie whispered.

"Trust me. We can do it together." His eyes were blue and pleading, "Will you?"

Marnie was mesmerized by his intensity. "Sure," she heard herself say, not believing but wanting to believe in the possibility of anything. James could give her that hope.

He pulled her up onto the mammoth train; they took off with a rush of movement; she could hear the call of the steam engine. Through the window she saw rows of vegetables unfolding before her, a panoramic spring of yellow and blue and gold; mountains lingered in the distance. She grabbed James's hand. "What's going on here? My God, it's beautiful."

"Ain't it," he said in a pronounced western twang that seemed both foreign and familiar.

A crystalline rain started to fall, but the sky kept a peppermint cleanness she could almost taste. Marnie felt a chill of fascination. "Is this really happening, James?" she asked the man sitting next to her who both was and wasn't Jimmy. "What's really going on here?"

"Name's Cal." He shrugged with elaborate casualness. "This here sure is a beautiful country."

They got off the train near a village square and followed the booming sound of a marching band. There were soldiers in brown uniforms with their rifles held tight against their shoulders. Marnie saw low stone buildings, abundant green trees, and American flags and banners everywhere. A man in a top hat and a sparkling red, white, and blue suit paraded as Uncle Sam. Marnie saw him tread over a newspaper. She ran over and picked it up and studied it carefully. It was dated April 6, 1917. The headline glared up at her: WAR ON GERMANY.

"This *is* happening!" a voice inside her screamed.

Cal walked beside her swinging his arms in time with the band. He stopped to offer her a piece of licorice and then jokingly took it back again.

"That's him," he said. "I want you to meet my Dad."

Adam Trask was just as Marnie would have imagined him, a tall gangling man with a square jaw and a biblical voice. He was tinkering fervently with the engine of a Model-T Ford. Cal's brother, Aaron, stood beside him, tall and lean with ingenuous, wide-set eyes.

"Nice to meet you, Mr. Trask, Aaron," Marnie said politely.

Cal was saying excitedly, "There's a pile of money to be made in beans, Dad. I'm gonna make you rich, honest."

Adam Trask stood up to his full height. And Marnie was struck by his graceful, Lincolnesque presence. He planted a big hand on Cal's shoulder. "Money's one of the devil's tools, son. I want you to be a good man. Good men don't make money off the war. Now take Aaron here. He wouldn't think of doing a thing like that, would you, Aaron?"

"No, Father." Aaron smiled beatifically. He looked sideways at his brother. There was a coldness in his gaze that made Marnie shiver.

Cal gave a low, animal wail. I was only figuring a way to help *you* out, Dad." Then a mask of contentiousness came over his face. "Never mind. I don't care if you get rich or not. I don't care what happens to you."

"You don't mean that Cal," Marnie said softly. Although his ominous smile frightened her, she wanted to defend Cal. "Cal loves you so, Mr. Trask, but he's afraid of love." She spoke slowly, carefully from a well of deep feeling. "Half the time he doesn't even know who he is or who he wants to be and—"

"Love," Cal cut in, rolling his eyes at the sky in an exaggerated gesture. "Who wants love. Ain't nothing in it." He snickered. "*Love, good*, and *bad*—them's just words anyway." He put his hands in his pockets and began to slink toward his brother. "Now take Aaron here, he's goodness itself. That's cause he's too scared to look evil in the eye."

"Stop it, Cal," Adam said sternly. "Stop it this minute."

" 'Stop it, Cal,' " Cal mimicked his father.

He put an arm around his brother and said in an enticing whine, "I gotta surprise for you, Aaron. Marnie and me are gonna take a little trip. You got the guts to come with us?"

"I've got more guts than you'll ever have," Aaron said confidently.

Cal laughed. "We'll see about that, won't we Aaron?"

Marnie shivered, sensing the shattering power of Cal's cruelty. "You don't have to do this," she told him. She wanted to wrap the cocoon of her will around him and monitor his impulses.

Cal kept his arm around Aaron, moving it back and forth with the sinuous gesture of a snake charmer. "Come on," he hissed.

"I won't let anything bad happen, Mr. Trask, I promise," Marnie called over her shoulder. Her heart was beating wildly as she followed the brothers out of the square, back onto the train, and down the California coast to the sultry fishing village of Monterey.

When they got there, she saw the sky had begun to curdle with rat-gray clouds. Even the mountains and the sea looked menacing. Cal led them down a narrow, unpaved street to a row of ramshackle houses. From the street, a snarl of wild bushes made it difficult for Marnie to distinguish the houses. Cal ushered them up to the porch of one of the houses and knocked on the door. A girl of no more than eighteen opened it and let them in. She had luminous eyes and unnaturally white skin.

"We're here to see Kate," Cal said harshly. "I'm Cal Trask. She knows me."

The girl lead them into a polished foyer. "Wait here," she said. Marnie felt herself melt into a deep, sumptuous carpet. The tinkle of soft jazz music, the smell of musk, infused her senses. "Come this way," she heard the girl say. A velvet curtain parted, and she entered a room with luscious apple-green walls and chairs upholstered with cushions in the same vivid color. Lamps with silken shades gave off a rose-colored light. In the corner she saw a bed with a creamy white-satin coverlet. She wanted to touch the satin, linger over its softness.

An unfamiliar voice coming from the other side of the room made Marnie turn. She saw a woman sitting behind a low oak desk. The woman wore black with only a touch of lace at her throat. She had delicate patrician features. Her white-blond hair was tied back in a bun. Marnie noticed a thin scar on the woman's cheek. She was horrified by her eyes: they were as impenetrable as glass. She sat so still, Marnie marveled that she was actually alive.

"Come to take another look at your mother, Cal?" the woman asked sharply.

"Yes, Mother," Cal answered in a low, bloodless voice, "but this time I've brought company." He shoved Aaron forward. "This is my brother, Aaron, the angel in our family. Isn't he handsome, Mother? Cal saw the slight, spastic motion of Kate's shoulder. He snickered. "Aaron, this is your mother, Kate, the madam of the toughest whorehouse in California. She's not dead, Aaron. She shot our father in the arm when we were little and ran away from us."

Marnie saw Aaron's face drain of color. He fell back in a swoon. She tried to support him, but he ripped himself away from her and seemed to fly out of the room.

Kate really came to life when Aaron had gone. She made a high cackling sound. "We *are* alike, Cal. She smiled, showing sharp white teeth; you have a talent for heartlessness."

Marnie saw Cal's rage had passed like a fever. "You shot my father," he said mournfully. You shot him. Why?"

"Because"—Kate flailed at him—"your father tried to box me in. He thought he could keep me prisoner in his net of kindness and understanding. He wanted to control me like this woman wants to control you."

Marnie felt her head begin to spin. She hadn't realized Kate had noticed her. "I am not trying to control Cal," she said fiercely. "And he's not like you. He's just jealous of his brother and angry and confused."

Kate leaned toward Marnie and whispered evilly. "And you think you can change him. Wipe all the badness out of him. Whitewash him into a minister of virtue."

"I don't want him to be perfect," Marnie hurled back at Kate.

Kate's smile lingered like an apparition. She chuckled. "You want to make him over into whom you think he should be."

Marnie heard Cal's voice behind her. "You got that right, Mother."

The truth singed Marnie like fire. Kate salted the wound with still more cruelty. "You like it here, don't you, honey? You'd like to lie on those sheets with my son and let him teach you all about love. That's what you really want from Cal."

Marnie felt the heat of her anger. "Don't you talk to me like that . . . don't you ever . . . you—you evil witch."

Kate placed her gloved hands under her small, pointed chin. My evil's in you and in my son, too.''

Cal stalked up to his mother with a look of undisguised hatred. "We're mean with our own meanness, not yours," he told her.

Marnie thought she saw a spasm of regret contort Kate's face. Then the hardness came back into her eyes. "I'll leave you two to celebrate your own brand of evil."

Marine and Cal were alone in the dimly lit room. Words failed them and they moved toward each other, making a home for themselves on the satin coverlet. Marnie smelled the scent of Cal's breath on her face, tasted his lips on her lips, felt his hands moving over her. Their clothes fell away, and they began to mold one another like moist, uncertain clay. Marnie felt an exquisite glow in her solar plexus; there were no shapes, no sounds, no colors. Only this concentric flame. She felt herself being born again into a wholly new shape.

Marnie was never sure how she arrived back in the present. Her journey back in time lived in her bones like a new life that had been imprinted on her, a dimension of herself, a raw force she could not deny. She and James became shy with each other as if their secret selves needed to find shelter in separateness. James acted masterfully well on the set; he performed the scene with his brother's girl with a Machiavellian tenderness that made even the director applaud. Marnie decided that Cal and Jimmy were locked in one skin, and the boundaries between them were only those of time and space.

The film ended, and she and Jimmy went their separate ways. Their good-byes were full of affection and promises to write. James was just becoming a stellar sensation in Hollywood. Marnie had become aware that his talent, his mirth, his irreverence were essentially his; she was not his puppeteer. In some way James felt lost to her. He showed her dozens of pictures he had taken of himself in the mirror to applaud his celebrity status. They all looked essentially the same. His handsome face decorated the cover of movie magazines. Marnie sensed he was moving further and further away from his realization of himself; she felt powerless to help him.

James did write to her from time to time when she went back to Los Angeles. Sometimes cobwebs of fear showed in his

letters. While filming *Rebel Without a Cause*, he was worried the director wouldn't bring out the best in him. He said he wanted to turn himself into the superman that Nietzsche envisioned, a man of energy, intellect, and pride. Marnie intuited turmoil between the lines. "I miss you," James added furtively at the bottom of the page, and she felt her heart tug in his direction.

Sometime later he sent her a picture of himself standing in front of a silver Porsche. He was dressed in white, and his hands were clasped tightly together in front of him. The next night she dreamed of a beautiful lone bird with golden wings setting itself on fire and then soaring up from its ashes to create a new life. In the morning she remembered the Egyptian myth of the Phoenix rising, the symbol of immortality.

On September 30, 1955, Marine read of James's death. In a collision with another car, he had driven his Porsche into the California sunset. She saw pictures of the wreckage: the rumpled accordion of steel that had been his death chariot. She couldn't associate Jimmy with that twisted metal jungle. In the underpinnings of her mind he was still alive for her: hovering, inviolate. She saw his picture everywhere in the months that followed. He was being idolized as a symbol of disconsolate youth. James Dean fan clubs cropped up like viruses; in death women lusted after Jimmy and men envied him. His films *Rebel Without a Cause* and *Giant* were released posthumously. He could be seen wielding a knife, lusting after oil, or loyally protecting a friend. Marnie thought of the angel and the devil that had warred in Jimmy; she wanted to smash this cardboard image of James Dean and find the James she had known.

One night driving in the Hollywood hills, something propelled her to stop and look at the stars. One shone so brightly that it drew her into its magnet. All at once she sensed that James was there—that he had chosen his position in the firmament—that now at last he was free to make himself into the person he wanted to be. "Good luck, Jimmy," she called into the bowl of the sky.

She thought she saw the star shine even more brightly. Then it disappeared into the night.

South of Eden, Somewhere Near Salinas

Jack C. Haldeman II

Natalie Wood looked up at James Dean and smiled.

Dean didn't notice. His eyes were locked on Bill Vukovich as he wrestled the Hopkins Special around the track at Indianapolis for his qualifying run. Dean didn't need a stopwatch to tell that Vucki was lapping at well over 140 mph. Yesterday it would have been good enough for the pole. But yesterday rain had cut the qualifying session short, and Vucki hadn't been able to run. Dean had managed to get his run in.

James Dean, at age twenty-four, had the pole position for the 1955 Indianapolis 500, driving the Baker House Special around the brickyard at an average speed of 140.045 miles per hour.

"Excuse me. Mr. Dean?"

James Dean sighed, ran his hand through his sandy hair, and brought his attention back to the reporter.

"He's the man you want, Miss Wood," said Dean, waving at Vucki as he took his cool-down lap. "No one has ever won the Indianapolis 500 three times in a row. This could be the year."

"My name's Natalie," she said. "And it's you that I want."

Dean laughed. "Fair enough, Natalie. And you can call me James or Jimmy." He looked over to see Vucki's time being posted. It was a new track record at 141.071 mph. Yesterday that would have bought him the pole.

"Okay, James," said Natalie, taking out a notebook. "What do you feel about dying on a race track?"

Dean fixed her with a hard stare, turning up the collar of his jean jacket and sliding down in his seat in the grandstand, propping his boots on the seat in front. He reached down and picked up his cowboy hat and set it low on his head.

"I thought you worked for a reputable publication," he mumbled.

"*The Saturday Evening Post,*" she snapped, "*is* a reputable publication. Readers want to know about the hot new driver."

"New driver? I've been racing since I was sixteen years old. My uncle brought me here when I was eight years old, and I knew then I was going to be a driver. I never considered doing anything else."

"And you're clearly very good at it."

Dean looked at her and nodded. "I am."

"Then you must occasionally think about death."

Dean unfolded himself and stood up. "I think that magazine sent the wrong person to write this article, lady. You're chasing a story that isn't there. I drive, and I drive fast. That's all there is to it."

"I don't believe that for a minute," Natalie said.

Someone called Dean's name from the track and he waved.

"I've got to go," he said. "My chief mechanic needs me."

"I'll just tag along," said Natalie. "Maybe I can learn something. I'll stay out of the way."

"Women aren't allowed in Gasoline Alley," said Dean. "It's tradition, like the jinx on green cars. Just not done."

"I think that's stupid, tradition or not."

Dean shrugged.

"You'll be at the reception tonight, won't you?" asked Natalie.

"I don't have any choice," said Dean. "My sponsors would have a fit if I didn't show up."

"Maybe we can continue the interview there."

"Maybe," said Dean. "Maybe not."

Natalie watched James Dean leave. The lanky race driver was going to be a tough interview, but she'd known that from the start. He had that kind of a reputation. Nice looking man, though. Very nice.

Down on the track, Dean threw his arm around Sal, his chief mechanic, and they started walking toward Gasoline Alley.

Sal Mineo was everything that James Dean wasn't, and they were best of friends. Dean was tall, and Sal was short. Dean had tousled sandy hair that was continually out of control, while Sal's heavily greased black hair was always combed in a carefully prepared pompadour. Where Dean was ruggedly handsome, Sal had a soft, innocent baby face that would probably make him look eighteen forever. The fact that he always had a couple of comic books stuffed in his back pocket didn't make him look any older.

But Sal, the only son of one of the best mechanics in the business, had been born with a spanner in one hand and a torque wrench in the other. He was a genius, as Dean knew well. There wasn't anyone alive who could do more with the 270 cubic inches of a Meyer-Drake engine than Sal. Before qualifying, the Baker House Special had checked out at 335 horsepower at the rear wheels, almost 5 horsepower greater than the competition.

"So what's up, Boy Wonder?" asked Dean.

"Not much," said Sal. "You looked like you needed to be rescued."

"I did."

"She's a cute one, that reporter," said Sal. "A real Lois Lane."

"I didn't notice," said Dean.

"Right," said Sal, giving Dean a light punch in the ribs. "And the Pope ain't Catholic."

They laughed together and kept on walking.

Dean hated the days between qualifying and the actual race. It was a circus of interviews, parties, and personal appearances, none of which had anything to do with racing, as far as he could see. As the pole sitter, his sponsors missed no opportunities to parade him in front of anyone with a camera or a microphone. He was expected to be polite and articulate. Sometimes, to his sponsors' surprise, he was.

But not at the reception that night. He'd shaken too many hands that day, and engaged in too many meaningless conversations with people he had absolutely nothing in common with. After he almost snapped at the mayor of Indianapolis, he knew he had to get away before he did something that would get him into serious trouble.

Dean looked around the large hall. Sal was over at a table, trying to make some moves on Deborah Drake, a photographer from *Life*. He was playing the little boy role to the hilt. Vucki was

surrounded by people. Dean found himself looking for Wilbur Shaw, who was always good to talk with. But Wilbur wouldn't be back this year, or ever. Dead in a plane crash.

Then he saw Natalie Wood, leaning against the far wall, drinking a soda. She was wearing a plaid pleated skirt and a light blue cashmere short-sleeved sweater. Penny loafers. She smiled at him, but made no move to come over. Dean liked that.

Someone grabbed him by the arm. "Jimmy, I'd like you to meet—"

"Sorry, Mr. Baker," said Dean, pulling away. "Gotta take a whizz."

He walked over to Natalie, took her by the hand.

"Let's get out of here," he said.

They slipped out a side door to a covered porch and down the stairs to the parking lot. Dean opened the passenger door to a small red two-seater convertible with the top down and Natalie got in.

"Nice car," she said.

Dean shrugged as he slipped behind the wheel. "Ford Thunderbird. Nice lines, but it's still nothing but Detroit iron. It'll move in a straight line, but can't corner worth a damn. I wouldn't have one, but they rented it for me while I'm in town." He paused and smiled at Natalie. "My sponsors like to keep up my image."

"They seem to be doing well in that respect," she said.

"It's all show business," said Dean, shaking his head, firing up the engine and pulling out of the parking lot, laying twenty feet of rubber in the process.

"Where are we going?" asked Natalie, fastening her seat belt and grabbing the dashboard.

"The brickyard," said Dean, pressing hard on the accelerator.

The reception had been held in a hotel outside of town, and on the back way into the track, Dean pushed the Thunderbird hard, its headlights illuminating the winding, tree-lined road.

"How fast are we going?" Natalie asked, the wind whipping her dark hair.

"Not fast."

"How fast?"

"Seventy-five."

"This road is awfully narrow," said Natalie.

"I'd be pushing one hundred twenty if we were in my Porsche," said Dean. "The D-Jag I'll be driving in Le Mans could take this at one hundred forty. This is nothing."

When they reached the dark track, a security guard waved them inside. They drove across the racetrack and parked in the deserted infield.

It was quiet. Light clouds drifted across the star-studded sky. They walked out on the track and stood on the brick surface.

"This is incredible," whispered Natalie, as if they were in a shrine. "All those empty seats."

"In a few days they'll be packed," said Dean, standing with his hands in his pockets, his shoulders hunched. "It looks like a mountain of people from down here, if you have time to watch."

"You'd really like to win this, wouldn't you, James?"

"Sure," said Dean, starting to walk slowly down the track. "Who wouldn't? I finished second to Vucki the last two years, and second is nowhere in this business. If I'm going to win, he's the man I have to beat."

"He's fast," Natalie said.

Dean nodded. "Maybe."

"He holds the track record here," she said.

"Vucki is a man with an obsession," said Dean. "Indianapolis is his whole life. He doesn't do any of the other races, just Indy. He wants it so badly, he takes chances that maybe he shouldn't take. They don't call him Wild Bill for nothing. Don't get me wrong, he's a friend, and I admire the heck out of him, but if he makes a mistake, I'll beat him. Or maybe something will break. In '52 he was leading with nine laps to go when his steering went. Anything can happen here."

"You take chances, too," said Natalie.

"I drive right on the edge," said Dean. "I know exactly what the car can do, and what I can do with it. I push it to that precise point. There's a difference."

"But what if something happens? If you're going that fast, there must not be much time to react."

Dean shrugged. "Things happen. You do the best you can to minimize the damage. I've been into the wall twice here. The first was at the end of this straight during the '52 race when I hit some oil. In practice last year a tie rod let go and I went into the wall in turn four. Turns out our backup car was faster than the original, so it all worked out."

"It sounds like practice can be as dangerous as the race," Natalie said.

Dean didn't respond. Manuel Ayulo had been killed in practice this year.

As they approached the end of the grandstands, the brick surface gave way to asphalt. Dean stood there, lost in thought. He closed his eyes and visualized all two hundred laps, and how the brick straight in front of the grandstands threatened to jar your teeth out and how it felt like glass when you went from the bricks to the asphalt, just in time to get set for turn one. Repeat two hundred times, in heavy traffic.

"Your parents must be proud of you," Natalie said.

Dean turned to her, his face hard. He balled his right hand into a fist and pounded it into his left palm several times, then turned and walked briskly back down the track. As Natalie caught up with him, he broke into a run, left her behind, and didn't stop until he'd reached the car. A few moments later Natalie, out of breath, came up. They sat next to each other on the hood.

"I'm sorry, James," she said. "I didn't mean—"

"My parents don't understand," he said evenly in a cold, level voice. "I doubt if anyone does, but them especially. They wanted me to be a lawyer or a doctor. Anything less amounted to failure in their eyes. I couldn't do it. I couldn't do anything to please them. Are you going to write about *this?*" he asked sharply, tears in his eyes.

"No," she whispered.

"I couldn't sit still in school, though I did well enough in class when I was there. I wanted to be moving. I wanted to be moving fast. Back then I *did* take chances, before I learned better. I wanted to live fast, and I didn't much care if I died young in the process. Now I want revenge. I want to be the best damn driver in the world. There's no way in hell they can ignore that." He turned his back to her, dried his eyes.

"Jimmy," she said, touching his back. He flinched.

"I know what you mean," she said. "My mother wanted me to be a model or an actress. She thought I was wasting my time with words. To her, journalism was not a fit career for a woman. Actually, more to the point, she felt women didn't need careers; what a woman needed was a husband. I need a husband like a frog needs a bicycle."

Dean laughed.

"Looks don't last," she said, gently touching the back of his neck. "I figured that out early on. But words will last as long as there are books and magazines. I won three awards for feature articles last year, and I'm damn proud of them. They mean nothing to my mother, but they mean everything to me. I quit living my life for her—or against her—years ago."

James Dean turned, and caressed the side of her cheek. They kissed, gently at first and then with a passion. They drew apart, looked at each other for a moment and then laughed.

"Your place or mine?" asked Dean.

"Mine," said Natalie with a smile. "Definitely mine. We'd never have a moment's peace at your place."

They stayed in bed until noon. James Dean missed two interviews and a personal appearance at the local Goodyear Tire store. Natalie Wood learned a lot about James Dean, none of which was suitable material for *The Saturday Evening Post*. He learned a lot about her, too. It was a mutually satisfactory exchange of information. Sal chased them down about one in the afternoon.

"Jimmy," said Sal. "Have you gone crazy?"

Dean was sitting shirtless in Natalie's hotel room, wearing only jeans, with his bare feet propped up against the radiator.

"Hardly," he said.

"Everyone's looking for you," Sal said, taking an offered cup of coffee from Natalie, who was wearing a terry cloth bathrobe and not much else. "What are you going to do?"

"Oh my, oh my, what *shall* I do?" said Dean dramatically, wringing his hands and giving Natalie a wink and a smile. Then he looked at Sal. "So is the car set, Boy Wonder?"

"You know it is, Jimmy." He looked a little shocked and hurt that Dean might think anything else.

"And that body panel I crunched coming into the pits. Got that fixed?"

"Lawson is the best body and paint man in the business."

"Then what I'm going to do is drive the hell out of it on Monday. Until then, if anyone asks you where I am, tell them that as far as you know, I've gone to a mountaintop to practice my bongos. They'll believe anything about me if it's strange enough."

And they did.

By the time James Dean arrived at the track Monday

morning, every reporter covering the event wanted an interview with the beatnik driver who played the bongo drums. He ducked them all. But he couldn't escape Clayton Baker III, the major sponsor of the Baker House Special.

"And where the hell have you been, Jimmy?" said Clayton, grabbing Dean's arm as the crew rolled his car out to the track. "I had you scheduled for meetings all over the place, and you disappear with some cock-and-bull story about drums."

"You want a driver or a puppet, Mr. Baker?" asked Dean.

"What?"

"If you want a driver, you've got the world's best. If you want a puppet, you've got the wrong man."

"I've lost a lot of face here, Jimmy. You've cost me a ton of money."

"Wrong," said Dean. "I've made you a ton of money. There's no way in the world you could have bought this kind of publicity. Now get out of my way. I've got a race to run." He turned and walked away, leaving the car owner standing alone and flustered.

Sal caught up with Dean. "I see you're still biting the hand that feeds you," he said.

James Dean didn't reply. Sal realized he was putting his game face on again, mentally preparing for the race, and walked quietly beside him.

It was this way before every race. Dean would slip into a cold and distant place, a place where nothing existed but the car, the track. The other drivers ceased to be friends or acquaintances; they were simply obstacles between him and the checkered flag.

Everything else slipped away while he focused his concentration. The pageantry flowed around him unnoticed. The invocation, the National Anthem, Dinah Shore singing "Back Home Again in Indiana," the traditional command by Tony Hulman of "Gentlemen, start your engines." All a blur until the engine kicked over and Sal tapped his helmet for good luck, saying "SHAZAM," as he always did.

Like a fuzzy picture suddenly made razor sharp, Dean became acutely aware of everything within the confines of the track. He put the Baker House Special into gear and pulled away from the starting grid, following the Chevrolet convertible pace car around the track for their warmup laps.

Dean was feeling the car out as he weaved from side to side to get the tires hot. He listened to the engine, checked out the steering, accelerated and decelerated a couple of times to see what it felt like with a full load of fuel aboard. Everything was fine. They picked up speed.

The pace car pulled off into the pit road. The crowd was on its feet, roaring. Dean put his foot into it as he pulled out of turn four and was flying as he led the other thirty-two drivers past the green flag.

He dived low and hard into the first turn, barely nosing out Steve Charnes, who was fighting him for position. As Charnes tucked in behind him, Dean hit the throttle, accelerating as he exited the corner, and pulled away.

This was the kind of racing Dean lived for. He was in the lead, with nothing but clear track ahead of him. He drove the Baker House Special to its very limit, waiting for the last instant to decelerate for the corners, barely tapping the brakes, feeling the g-forces pull at the tires and the weight of the car. He was dancing right on the edge and he loved it.

He felt alive, as he did at no other times in his life.

He led the first lap, the second, the third. On the fourth, he glanced at Nick Steel, who was holding a chalk-marked sign by the wall. The sign told him he was eight seconds ahead of the second place car and twenty-three seconds ahead of Vukovich.

On the tenth lap Nick's sign showed he was ten seconds ahead of the second place car and twelve seconds ahead of Vukovich. Two laps later Vukovich was in second place and closing. Five laps later, they were side by side going down the back stretch at full speed.

Dean knew they'd both have to decelerate to make turn three. It was all a matter of who lifted his throttle foot first. It hung that way for an instant, then Dean felt the limit of his car approaching and backed off. Vucki barely ducked under him on the inside, the back end of his car sliding dangerously close to the wall.

When they hit the straight in front of the grandstand, Vucki started pulling away. Dean nodded grimly. The man had either found something extra or was driving past the limits of his car. There was nothing to do but hang in there and see what happened.

By lap one hundred, the midpoint of the race, Vucki had stretched his lead over Dean to seventeen seconds. A few laps later it happened.

Dean couldn't see what started it. They were working their way through lapped traffic when the cars in front started spinning. Dean slowed, his eyes searching for a pattern in the spinning cars, a way through. It seemed to last forever, but it only took a split second as Vucki headed for a clear space only to have a sliding car close it off at the last instant. Vucki's car rode up on the other car's wheel and flew into the air, spinning crazily end over end as it vaulted over the fence and crashed outside the track, exploding in a churning ball of flame.

Dean wove through the scattered cars and fell in behind the pace car as the yellow came out. As they drove past the scene of the wreck, it was still burning.

He pulled into pit road, and as they were fueling the car, he looked at Sal. Sal shook his head. The door in Dean's head slammed shut.

Dean pulled out of the pits. From the outside, he looked as if he was totally concentrating on the job. Inside it was completely different. As he followed the pace car slowly around the track, he was drifting, visiting an all-too-familiar place.

He imagined he was in a mansion, standing alone in the middle of an incredibly large room. All around him were doors to other rooms, thousands of them. People stood in many of the doorways; friends, strangers. Natalie waved to him from her doorway, Sal sat cross-legged in his, reading a comic book. Wilbur Shaw's door was closed. And now, Vucki's door was closed, too, closed forever. As long as Dean stayed in the central room he was safe, invulnerable. He was convinced he could be hurt, but not killed, in this special place, this place he had visited far too many times. It was a fugue state, almost hypnotic. It was protective.

For the duration of the yellow flag, James Dean stood alone in the middle of the room, safe, untouched. The caution period was a long one, twenty-seven minutes. When the green flag started the race up again, he immediately snapped back. Nothing existed except the track, the car.

He drove spectacularly, right on the edge, but never beyond it. James Dean won the 1955 Indy 500 by almost a full lap.

The celebration in victory lane was subdued. Dean, his face smeared with dirt and oil, accepted the traditional bottle of

milk and the traditional kiss. As he posed with the trophy, he saw Natalie standing at the back of the crowd of reporters. Deborah, the *Life* photographer, had her arm around Natalie. It looked like they had both been crying.

Later, after a seemingly endless series of interviews, Dean slipped away and found Natalie.

"I'm sorry," she said as he came up to her. "I know he was your friend."

"I'm sorry, too, but things happen. It's over, and time to move on." His eyes were hard. "We need to think about Friday."

"What's special about Friday?"

"You're flying to France with me."

"I am?"

"Le Mans," he said. "Better start packing."

She did.

Natalie had never been to France before, and the strangeness of everything was a shock at first. After a few days she settled in, and was almost comfortable as they sat together at a table outside a creperie the evening before the race, sipping cider from earthenware cups.

"Are you worried, Jimmy?" she asked, breaking a long, uncomfortable silence.

"Only about Mercedes," he said.

"That's not what I meant."

"I know." He sighed, and sipped his cider, holding the cup with both hands. "But Moss is going to be hard to beat. He tore up the Mille Migle this year, and that's one tough road course. Those 300 SLs are fast, and he's one damn fine driver."

"Jimmy!" snapped Natalie. "Don't you ever think about anything but racing?"

Dean reached out and touched her cheek. "Sometimes I do."

She blushed. "Seriously," she said.

"I get offers all the time," he said. "Jaguar and Porsche both want me to run car dealerships. I've been approached to do television commercials and bit parts in movies. Sun Records wants to turn me into the next Tab Hunter, even though I can't carry a tune in a bucket. I turn them all down."

"Why?"

"All I know is racing, Natalie. I'd be lost without it. I can't

stand still. After Le Mans I'm headed back to Bonneville for a shot at the land speed record. Next year Jaguar wants me to drive Formula One for them. I could be the first American to win the World Championship."

A waiter set two small cups of coffee in front of them. Dean added sugar to his before even tasting it.

"Have you ever turned down a racing assignment, Jimmy?" asked Natalie, sipping the strong coffee.

"Once," said Dean. "Lee Petty wanted me to drive a stock car, but I don't see the point. Stock cars will never get off the ground. No one wants to watch Detroit iron go around in circles. You might as well stand above an L.A. highway and root for all the red cars. Stupid idea."

"I don't know," said Natalie. "It doesn't sound any more ridiculous than driving four hundred miles per hour across a desert."

"We've been all through this, Natalie. No one has ever done that before, and I'm going to be the first. I can't help being what I am."

Natalie reached over and touched his hand. "Let's go back to the hotel," she said. "It's going to be a long day tomorrow."

Dean nodded, and reached for his wallet to pay the check.

It was a cool morning for June in France, but James Dean didn't notice. He was driving first shift. If all went well, his co-driver, Mike Hawthorn, would relieve him in two or three hours.

The drivers lined up along the track, opposite their cars, for the traditional Le Mans start. James Dean was focused, for he knew it would be crowded and chaotic with all the cars accelerating at once. It was better if you got out first.

The signal was given. The drivers raced across the track for their cars. Dean had practiced this a hundred times. He vaulted into the open cockpit of the D-Jag, slapped the ignition, popped the clutch, and pulled out into the weaving traffic.

He was fourth into the first turn, behind another Jaguar and two Mercedes roadsters. As he tucked in behind Bob Immler and reached the apex of the turn, he got on the throttle. The Jaguar engine responded beautifully, and the car leaped out of the turn. Dean settled down to race.

He loved road courses, and this one was over eight miles of tight turns and long straights. It was a test of endurance, both for the cars and the drivers. At times he would be blasting along

at over 180 miles per hour and a few moments later he would have to slow down to 20 in order to negotiate a turn. It was a challenge to run on the edge for so long, but Dean was up to it, and he knew Mike Hawthorn would be, too. The biggest threats would come from the powerful Mercedes roadsters and the legendary Juan Fangio.

Being in fourth place did not particularly bother Dean. It was a long race. A lot could happen in twenty-four hours.

It happened just a few laps later. A Jaguar pulled sharply into the pits, causing an Austin-Healy to lock its brakes and spin. It developed very quickly. Pierre Levege never had a chance. He was going flat out at 185 miles an hour down the grandstand straight when the car skidded into his path. His Mercedes climbed the back of the Austin-Healy and was instantly airborne, clearing the fence and plowing into the crowded grandstands, cutting through the spectators like a deadly scythe.

Dean saw the tragedy unfold. A part of him locked down and as he concentrated on driving through the wreckage, he could feel the doors closing.

He expected them to bring out the red flag and stop the race, but instead they only brought out the yellow in the area of the accident. He continued driving around the course, but every time he passed the grandstands a part of him slipped back into that cold mansion and he watched the doors slam shut one at a time as he stood, invulnerable, in the middle. A few laps later he pitted, and Mike Hawthorn took over.

The sitting was the hard part; the waiting was far more difficult than the driving. He tried to rest, but couldn't. Mercedes had withdrawn all its cars. Much of the crowd had left following the accident. He and Mike were in the lead and adding to it with every lap.

It went that way through the afternoon and evening. Dean and Hawthorn rotated regularly. When he wasn't driving, Dean tried to sleep. It was impossible. Instead, he sat and stared at the lights of the cars weaving through the night like fireflies.

The next morning, Dean was driving as the clock ran down. The last lap was a madhouse. The stewards came out onto the track, waving all their flags at once in the traditional salute. At the finish he had to inch his way through the crowd, because Le Mans lets spectators on the track at the end. As expected, he and Mike went through the motions of spraying the gathering with a huge bottle of champagne. Neither of them were smiling.

As soon as he could get away, he found Natalie Wood.

"The reports are that almost a hundred people were killed," she said, anguish making her voice crack.

James Dean just nodded. He was wearing dark glasses and his face was hard and cold.

"We're catching the next plane out of here," he said.

"Sure, Jimmy," she said, slipping her arms around him. "I want to get away from this place, too."

"It's not that," said Dean, pulling away. "I've got a car waiting on the Bonneville Salt Flats."

Natalie shuddered. But she followed him.

She followed him all the way to Bonneville, where she stood under the merciless sun with Sal, watching Dean pose for the publicity pictures before his run.

"What do you think his chances are?" she asked. The car was a deep blue streamlined teardrop, flattened on top and incredibly low to the ground. It shimmered in the heat like a living creature.

"Pretty good," said Sal. "Those twin Rolls-Royce aircraft engines check out fine. There's no wind. I'd say he has a decent chance to break Cobb's three hundred and ninety-four run."

"That's not exactly what I meant, Sal," she said.

Sal looked embarrassed. "I know," he said, shaking his head. "Bad luck to talk like that."

They walked over together as Dean got ready to get into the car. Natalie gave him a kiss, and as he put on his helmet, she hugged him tightly. He looked over her head, already mentally halfway across the desert. When he climbed inside, Sal slapped him on the head, and said "SHAZAM" as always. Then they clamped the cockpit closed.

Dean was alone. He waited patiently as the technicians finished their last-minute adjustments and the spectators got a safe distance away. When he got the signal, he fired up the engines. He sat for a minute, watching the gauges and feeling the horsepower build. Then he eased the RPMs up, put it in gear, and started flying.

The acceleration was incredible, like nothing he had ever felt before. Pressed back into his seat by the g-forces, he floored the sucker, passing 100, 200, and 300 miles per hour. The car was a handful, but manageable. Unexpectedly, it tended to drift

left. He corrected and pressed on, tweaking every last bit of power out of the engines. He was so busy when he flew through the timing lights he didn't see how fast he was going. As he passed the end marker, he cut back on the engines and popped the chutes. He was thrown forward violently against his harness as the chutes caught, and he almost blacked out. He rolled to a stop and the team at the other end swarmed over the car.

"How'd we do?" he asked.

"Four hundred and seven, plus change," said a tech. "Back it up on the return and we're set."

Dean didn't get out as they turned the car around and got it ready for the return. He thought of nothing but the back-up run necessary for the world record. He integrated all he'd learned on the first run and when they signaled everything was ready, he nodded and fired the engines.

It was beautiful; couldn't have felt better. The crush of acceleration as he pulled away was like an old friend. He was convinced he was going to do it. He passed 200 mph, 300, 350.

At 375 miles per hour the car started getting loose. Like a boat skimming over waves, he was in a cycle where the nose of the car lifted and fell. When it lifted, he had no control at all, but regained it when the car touched down. He realized he had only two choices. He could shut down and lose everything they'd worked for, or he could hope that the next time the nose came down it would grab, and the application of more horsepower would keep it down. It floated up, and the next time it came down, he jammed the accelerator.

The nose of the car lifted even farther up, and as the air caught it, the car rose completely off the ground and did a slow backward flip in the air. Dean hit the chutes, but it was far too late.

There was nothing he could do now but play this game to the end. In the instant before the car hit the ground, he closed his eyes and imagined the mansion. The room was shaking, doors were falling from their hinges. He was on his knees in the middle of the room. The ceiling was falling in pieces all around him.

Then the car hit the ground and disintegrated.

Natalie Wood wanted to close her eyes, but couldn't. The horror etched itself in her brain as she watched.

"Jimmy!" she cried and found herself running with Sal across the hardpacked surface to what remained of the twisted car in the distance. A truck stopped to pick them up.

"Stay here, Natalie," said Sal. "You don't want to see this."

"I *have* to see this," she said firmly. Sal looked at her and nodded. They rode to the smoldering wreckage and when they got there, she wished with all her soul that she hadn't come. It was terrible.

For ten days, James Dean lay in a coma. His arms and legs were shattered, his skull was fractured. He had four cracked ribs, a broken pelvis, and internal injuries. He was not expected to live. As the nurses worked around him, they often talked as if he were already dead.

He drifted for those ten days. Unconscious to the outside world, he dwelled in the mansion, being careful to stay in the middle of the room and away from the doors. On the eleventh day, he opened his eyes and saw Natalie Wood standing at the foot of his bed.

"Jimmy," she said. "Jimmy."

He smiled at her, winked, and fell asleep.

Although the long-term prognosis looked grim, James Dean's strength, determination, and drive surprised everybody. A week later, as Natalie was coming by for a visit, she met Sal outside Dean's room. He was carrying the steering wheel from a racing car.

"No!" she cried, grabbing it from Sal's hands. "No!" She pushed open the door to Dean's room.

"What's this?" she shouted.

"A steering wheel," said Dean.

"The doctors said you'd never walk again. What do you need this for?"

"I don't care about walking, but I *need* to drive," he said. "They have to rebuild my arms and hands. I'm not going to have much motion when they're finished and I want to make sure they put me back together in a way that I can grip the wheel. I asked Sal to bring it in for measurements."

"You never give up, do you, Jimmy?"

"No," he said, smiling at her. "I never do."

It should have taken years, but it actually took only a couple of months. James Dean rented them a house outside of L.A. and hired a physical therapist to work with him every day. While he worked out with weights and in the swimming pool, Natalie tried to finish the article for *The Saturday Evening Post*.

She threw away twenty pages for every paragraph she saved. Sometimes she was too sad to write, but more often it was her anger that kept her from finishing the article. The day he took the Porsche over to the track at Riverside to run a few practice laps was the worst. They didn't speak for days following that. Then he dropped the bombshell.

"I'm taking the Porsche up to Monterey," he said casually over coffee that morning.

"Why?"

"I've entered a road race," he said. "I'm meeting Sal and the guys in Bakersfield."

"Jimmy!" She slammed her coffee cup down so hard it shattered the saucer. "You can't even walk without a cane! It's too soon."

"I have to do this," he said slowly. "Are you with me?"

She nodded, but her heart wasn't in it, and she had to fight back tears.

The Porsche Spyder that Dean was so proud of was a beautiful and powerful machine. As they headed north, Dean pushed it hard.

"Slow down, Jimmy," said Natalie. "We're going too fast."

"I know what I'm doing," he said.

"At least fasten your seat belt."

"I hate those damn things," he said. "I never wear them unless I have to. I'm safer without them. If anything happened, I'd be better off being thrown clear."

"Like at Bonneville?" she said. "At four hundred miles per hour?"

Dean shrugged. "The clock said I was only doing three hundred and seventy-eight when I flipped."

He would not back off, and seemed driven by demons that Natalie could only guess at.

On the outskirts of Bakersfield, they were pulled over by a cop. He walked to the driver's side and Dean flipped him his license.

"This isn't a racetrack, Mr. Dean," the policeman said.

"Is that right?" he said. "I never would have guessed."

"You were doing one hundred and ten miles per hour in a thirty-five mile zone."

"So?" Dean said.

"So you could have killed someone."

"If you're going to give me a ticket, just hand it over," he said. "Spare me the lecture."

"Damn right you're getting a ticket." He wrote it out and handed it to Dean. As he walked back to the patrol car, Dean crumpled it up and shoved it under the seat. Then he drove to the restaurant where they were meeting Sal and the rest of the crew.

When he turned off the ignition in the parking lot, Natalie got out and slammed the door.

"This is where I get off, Jimmy," she said.

"What?"

"I love you, but I don't want to watch you die. I can't take it anymore."

He looked up at her as she walked around to the driver's side. "You're serious, aren't you?" he asked.

"I'm afraid so." She bent over and kissed his cheek, then patted his head and said "SHAZAM."

He watched her walk away. Sal and the rest of the crew came out of the restaurant.

"What was that?" asked Sal.

"I'll never know," said Dean. "You want to ride up to Monterey with me? The other guys can follow."

Sal got in and they drove off.

The time passed awkwardly as they sped through the back roads. Finally Sal spoke up.

"I'll miss her," he said.

"I will, too," said Dean, drifting through a bend in the road. "But she has to be who she is, and I have to be me."

"Where are we?" asked Sal.

"About eighty miles south of Salinas. Coming into some burg named Cholame."

"Watch out!" cried Sal. A car was running though a stop sign in front of them.

"The guy's got to stop," said Dean. "He'll see us."

As Dean slammed the brakes and worked the wheel he flashed for one last time into the mansion. All the doors to the living room were closed. The floor tilted sharply and he tumbled to the downward side. Wilbur Shaw was there, as were Vucki and Pierre Levegh and so many others. They welcomed him with open arms.

* * *

The next morning Natalie Wood finished her article. With tears in her eyes she wrote the following words:

"Noted racecar driver James Dean died on September 30, 1955, in a tragic and senseless accident in Cholame, California. His chief mechanic, Sal Mineo, who was wearing a seat belt, survived with minor injuries. James Dean will be missed by all those who knew and loved him."

Loved him.
Loved him.
Loved him.

1955

D. E. Steward

When you found out the movie cuts out the whole first third of the big Steinbeck novel, all the juicy Connecticut double-brother-fuck, Old Testament, do-it-in-the-barn moralistic stuff, you shrugged and settled back for the action in California, but when his mother turns up in black running the whorehouse, and there is that climax scene when he first goes there, it becomes our nutty teenage *Iliad*. Salinas, Monterey. Lettuce on ice going back east, the good brother, not him, volunteering for World War One, trying to please the quixotic father and then displeasing him, Cain and Abel theme just like back in Connecticut, overbaked if you hadn't read the book. It had it all, good and evil, *sombra y sol*, eastern pussy and western wind, and as it starts to all bog down, you go rogue like him and hope that he ends up fucking everything and everybody—his mother, the lettuce, his brother's girlfriend, the camera. It's Natalie Wood in the other West Coast movie. Those two movies defined California from then on—one was Northern California and the other was the south, and in the Los Angeles one he was from out of town. After the headlights on the Palisades with Natalie Wood, who would die a lifetime later herself on that boat right across Santa Monica Bay there in the Gulf of Catalina, anybody who didn't understand the differences didn't have any business even thinking of ever going to California. We all knew through him, he was better and seemed younger than Kerouac, we understood everything because of him in 1955. And that was thirteen, fourteen years before the Haight and flowers in your hair; he probed all that and he defined what it was, what we were, all way back. Almost Robinson Jeffers and Henry Miller back. He was probably single-handedly responsible for

what California was from the end of the Korean War until he died.

The inevitable generational human sacrifice, still right out of *The Golden Bough*: kill the king and then the king is dead. Him, then Jimi Hendrix, and John Lennon, in turn, one at least for every minigeneration. In his Porsche, in the desert, quite a bit like it happened to Camus five years later. He would have ruled instead of Elvis if he hadn't died and maybe would have kept it epic and literary a little while longer and turned down the gain again on that new tumultuous jailhouse rock and roll. Because he made you think, he stood there on camera sticking it to everything, those shots of him walking away in the golden grass hills behind Salinas or across the oil patch in *Giant*, thinking, pissed off, going away somewhere to figure it all out, which was probably exactly what he was doing when he crashed his car.

James Dean and Audrey Hepburn; think of that, the fifties weren't so bad, certainly a lot more *corazón*, cool and style than Tom Cruise and Kim Basinger or whoever the the corporate yup-yup emblematic two are this month. There has been no equivalent to him since, and he laid it all out. Arguing with his parents in Los Angeles, he was already *The Graduate* ten years before the fact, and he upstaged Elizabeth Taylor and Rock Hudson, left them blowing in the prairie wind standing in the Texas drilling mud. *East of Eden* was a whole history of everything, what to do with your future, how to fuck up things and survive, how to get away. *Rebel Without a Cause* was the whole story if you were under twenty-five, the whole thing, open and shut. You didn't need anything more. *Giant* was good-bye. We didn't even want anything else except those three movies in 1955. He must have been awfully confusing for a lot of older people in the East who didn't know how to go out and drive in the desert, but they couldn't pin much on him, nothing like hair or music style, not even attitude, really, and so he could have been anything, could have gone all the way to somewhere even more immense than what he did in only a couple of years.

To put it in perspective, when he died a long generation ago, it was a different world, to say the least. There was the California dream and the open road. He lived one, died on the other. That's it, that's all. He could have been president.

No-Man's Land

Louisa Ermelino

We got to the border late. Too late to cross, they told us. Well, not exactly. They could let us out, but the Afghanis would not let us in because it was their dinnertime, and then they would have their coffee and a smoke, and probably even if we bribed them they wouldn't check us through. We would have to spend the rest of the night in the patch of no-man's land in the desert, and if they got angry at us for some reason—because we had disturbed their dinner or disturbed their coffee or their smoke—they might not let us in at all. We would have to come back here and that might not be possible because the Iranis were very sensitive about accepting people back that the Afghanis had rejected. We could understand, certainly.

I looked at James. He looked at me. We decided to stay. The border guard smiled. He shouldn't have, not with those black, smelly stubs that showed when he did, but who can control mirth? He told us that, conveniently enough, there was a hotel and restaurant just a furlong away with everything we could possibly need. James, of course, needed nothing, having been dead for some time now. I liked him that way. He was just as handsome as when he was alive. He wasn't burned or anything, which is amazing when you consider that terrible car crash. James didn't even resent that people paid money to see the wreck.

He had heard that they had rigged it up so that it smoked all the time, as though the crash had just happened, and this made people very excited. They felt like they were right there. There were plans to preserve his body and maybe have it thrown across the seat in such a way that you could see his face, which was perfectly fine, not a scratch. The studio discussed messing it

up a bit—some blood here, a cut there. One of the studio executives even suggested that they might remove an eye. That would really fascinate the crowd, he said (Jimmy did have such beautiful blue eyes). But in the end they thought it was too much trouble and went with just the smashed up car.

Well, was I glad. First off, I never would have met James, and second, if I had, he would have been a mess, and as much as I'm in love with his personality, it's his physical being that gets me, those beautiful blue eyes. He never explained to me how he got to Teheran. We found each other across the street from the Amir Kabir, in a coffee shop, an open-faced raised cement platform covered with rugs, where they served that thick, sweet coffee and tea in little glass cups. I had been sitting in there alone when he came in. I knew who he was right off. He sat down next to me. He said he doesn't know why.

The first thing I said to him was, "You're James Dean, aren't you?"

He had looked at me like I was crazy. "Are you crazy?" he'd said. "Do you know how long James Dean has been dead?"

"Maybe," I'd said. "Maybe not."

"But he died in that terrible car crash. The Porsche, remember?"

"I remember."

"Anyway, what would James Dean be doing here in Teheran?"

I'd shrugged. "What do I know? You should know. You're James Dean."

It had been his turn to shrug. We shared a pot of tea and left together. He had this great hotel room with a bathtub, and we stayed there until our visas were ready to run out and we had to move on.

So here we were at the border. The name on James's passport is Kevin Muldooney. Of course, he couldn't travel under his own name. I understood that. The first time I saw his passport, he started to say something about the name, but I'd put a finger to his lips. I didn't want to know anything. After all, some things you just don't question. His name didn't matter. I knew who he was.

The border hotel was cooler than I expected. James didn't have the same sort of expectations that I did. After all, we were more

than a generation apart even though he was as young as I. There is definitely an advantage to dying young, never ever having to grow old.

There were a lot of other travelers at the hotel. French, Dutch, German, even a couple of guys from South America . . . Argentina, I think it was. One of them was old but really well built and handsome and tan. He was half naked even though the desert was so cold at night. He had a pair of leather pants on and some kind of feather-and-bead necklace with a matching head-piece. He was telling a story of getting beat up in Turkey and his friend Paco had a black eye and cuts on his nose, as if to back up the story. I heard something about Pamploma and Hemingway and I went "Wow" like the rest of the travelers who could understand English but whispered to James that I wanted to get out of there.

The next morning we went to the coffee shop and tried to find out about the bus to the border, but no one could tell us anything. Everyone was sitting around drinking tea and coffee and smoking huge standing water pipes.

"Now what?" I said to James.

"Hey, what do we care?" he said. "Cool out. When a bus shows up, we'll leave."

"But we're on the edge of no-man's land. We could be here forever."

James shrugged, leaned over, gave me a kiss. I could see one of the Iranis watching us. Sometimes they cut holes in the walls or peered through the keyhole or just put their ear up against the door of the room where we slept. They thought we were all insatiable sexual animals and they wanted us desperately but were afraid to ask.

So the morning passed, and everyone started ordering lunch. I'd cooled out like James said. He was holding my hand under the table when this European man came into the café. He stuck out like a sore thumb. He was tall and very blond, almost white. I thought he was in his sixties, but it was hard to tell. We were all so young that everyone who wasn't as young as we were looked very old. I remember how dignified he was. His hair was short and smooth and parted to one side and he wore a suit, an expensive European suit, with a tie and gold cuff links. He came right over to our table and sat down.

"Please," he said, "I need your help."

He looked from me to James and back again. He leaned over the table. I was worried he would put the sleeve of that beautiful suit in one of the empty cups of coffee and stain it forever in the sticky syrup at the bottom of the cup, but he didn't. He leaned even closer, put his face next to ours, and folded his hands on the table.

"Will you help me?" he said.

"Who are you?"

"Shhh." He had an accent . . . Scandinavian, I thought, and I was right.

"I'm with the Swedish embassy in Kabul."

"Great, maybe you can get us out of here and across the border. . . . We got here last night and . . ."

James put a toothpick in his mouth and sat back, real slumped like he always did for his publicity photos. God, was I in love. I forgot all about the Swedish diplomat and just concentrated on James.

"I'm trying to save a girl, an American girl."

James was quiet and so was I, but James was watching the Swede. I was watching James, his beautiful blue eyes, his perfect hair. I was wondering how he got his hair to stay like that all the way out here in the desert. His hair looked exactly like it did in all his photos.

"I have to convince the authorities to let this girl go, or she'll spend the rest of her life in the insane asylum. Have you any idea what an insane asylum is like in Afghanistan?"

James held my hand against the muscle in his thigh.

"Imagine a dark pit dug into the ground," the Swede said.

"That's it?"

"That's it . . . and a bucket to do your business and the food, they throw it down at you—maggoty pieces of bread and lamb fat that dogs have chewed on." The Swede closed his eyes. "That poor girl." He opened his eyes. "She's from Long Island."

"Oh, my God," I said. "What can we do?"

"You can save her."

"How?"

"I can't go into details here. It's not safe. You have to trust me." His blue eyes bored into James's blue eyes. "Will you help me? Will you come?"

"Of course we will," I said, jumping up, upsetting a teapot already held together with silver staples. The Swede caught it before it could shatter, but the tea spilled out over the table. I

remember watching the puddle of tea form on the table when I heard the Swede say, "Not you . . . him."

"Why just him?" I said. The lamb kebab I'd had for lunch went sour in my stomach.

"Because . . . he's James Dean," the Swede whispered. "They'll listen to him."

"I don't know," I said. "I don't like it. We've been together since . . ."

The Swede ignored me. He put his hand, a very big hand with pink nails, on James's shoulder. "Will you come? Will you save the American girl?"

James stood up, took his comb out of his hip pocket, and ran it through his hair. "Let's go."

"James—"

"I'll be back in no time, sweetheart. Be cool."

I waved good-bye, but he didn't see me. The Swede had an arm around his shoulders; it was almost an embrace. "I'll wait right here," I said. "I'll be right here waiting."

When I walked to the door of the café and shouted out into the desert, I saw a black Volvo in the distance. I sat in the coffee shop until it was dark and they made me leave. I went back to the hotel. It was empty now because everyone else had somehow found the bus to the border. More travelers arrived the next night, caught in the wheel of no-man's land—Afghanistan closed, nice hotel and restaurant, you spend the night—and I sat along with them in the café until they, too, caught a bus to the border.

The manager at the hotel tried to convince me to share my room because there were so many travelers coming through, all trying to beat the summer season when typhoid and cholera would close the border, but I said I was waiting for James, and he'd be back in no time, and then he wouldn't have a place to stay.

Almost a month passed before I left the border hotel. The Iranis were starting to look at me funny. The boy who cleaned my room and watched me through the keyhole said it was time for me to leave. There was talk that I was working for SAVAK. I didn't want to disappear in no-man's land.

Before I left, I went into the café and asked everyone about the Swedish diplomat and the American girl from Long Island held prisoner in an Afghani insane asylum. News traveled

fast on the road. There were people in the café coming from both directions across the border, and I'd hoped someone might tell me something.

"He left in a black Volvo. He took James Dean with him." I said.

"Who?"

"James Dean. Jimmy. Jimmy Dean. You know. *Rebel Without a Cause*. Natalie Wood. *Giant*. The Porsche. 'Die young and leave a beautiful corpse.' "

"Far out . . . James Dean . . ." someone said. The smoke from the water pipes was so thick I could hardly see who was talking.

"You're crazy, man," I heard a voice say. "James Dean? He's dead."

"He's not," I told them. "He's just missing."

"I remember a girl, in Ezrum, in Turkey. She got off the bus and walked into the mountains, and no one ever saw her again."

"Cool," from the crowd.

"I heard about her. She was a French teacher from New Jersey."

"Wow!" from the crowd.

I took the bus to the border and asked about James and the Swede and the American girl as I passed through Herat and Kandahar and Peshawar and Rawalpindi. I even went to the Swedish embassy when I got to New Delhi. I spoke to a tall blond man who said they had no embassy in Afghanistan, and he was sorry about my boyfriend, but, after all, did we think we could go traipsing around the world with no money and no purpose and expect our embassies to bail us out when we got in trouble?

"No," I said. "Of course not, but you have to understand. This is not just my boyfriend. This is James Dean."

He got me a chair and a glass of water. "I think you should know," he said very gently. "James Dean is dead."

I sipped the water. My mouth was dry. "I know," I told him. "I hate to believe it, but you're probably right."

Son of Dean

David Plumb

Benjamin Dean Vose sang with her in the Calgary Baptist church. Those were the best times. His mother's long chestnut hair let down, her eyes a mist of awe and small smile, her rough hands suddenly soft along the pages of the hymnal, her voice slightly above alto, not quite soprano, maybe second soprano and him first soprano.

Those were the times he felt loved. When there was God, and he didn't think about dust and sometimes unbearable silence. He and Jimmy simply gazed at the stained glass window way up front, where the shepherd with the halo and the soft, blank eyes carried a lamb in one arm and a crook in the other. The sun streamed in. The mighty pipe organ pumped through it all, in a wail he thought would last forever.

Sam and Betty Vose lived in Dollar, Texas, a speck of a town just south of Greenville. Sam had a pale face longer than six generations and a stroke of work and worship driven right into the soles of his shoes. Asked in the dead of winter of 1953 why he had three jobs, Sam Vose said it was because he couldn't find another. Sam Vose didn't speak at all on Sundays.

When they picked Benjamin up at the agency on the second Sunday in November of 1954, Sam Vose told his wife that Benjamin looked like a boiled grasshopper. The agency said the boy came from good stock. Benjamin made howling faces without sounds.

Sam Vose worked for the Whitebird REDD EYE Cement over in Greenville. He wore navy blue coveralls with SAM woven in strong red thread above his left breast pocket. A battered blue baseball cap shaded a bald head and a pair of bland hazel eyes. Sam Vose brought home gray dust. Sam Vose planted green

beans, leaf lettuce, beets, radishes, tomatoes. The Barred Rock hens slipped under the fence and played hell with the green beans and lettuce. He planted cantaloupe between the corn out back. The melons grew half size. Sam Vose brought home dust, dust, dust. Benjamin's new brother, Jimmy, arrived the day before Christmas 1955. Sam Vose said the boy looked hungry.

Sam Vose wouldn't have a television in the house, so living began for Benjamin at the movies in Dollar, on Fridays, Saturdays, and Sundays. Horses raced into the foothills of California and emerged in Arizona. Houses burned. Audie Murphy took Korea for a few minutes. Lassie got help for the last time. Cleopatra married Richard Burton. Banks got robbed. Submarines dived. Dracula appeared in unfathomable, delicious disguises. Soldiers came home crying. Boxers went down for nine, got up, and won. Oils wells gushed. David met Lisa. Cattle got sick. Beautiful women with perfect skin drove hot cars and winked. Some were faithful, some weren't.

One afternoon, Benjamin Dean Vose discovered the back door of the drugstore next to the theater was unlocked. He stepped quietly inside the cool, dark storeroom. The old boards never creaked beneath his one hundred and thirty-four pounds. Stuck his right hand in the back safe and took a handful off the top just like he'd been doing it all his life.

When Benjamin Dean Vose came home, he pretended to be a ghost. He knew his chalky face blended with the light. The female marsh hawk preening herself atop the telephone pole at the end of the drive made him twinge. A single cricket chirped in the drainpipe at the left end of the porch roof. With luck, he tiptoed the warped wooden porch steps, eased past Daddy's creaking Boston rocker, slipped through the screen door, and on up to the room he shared with Jimmy at the back of the house.

Downstairs, his mother clanked dishes in the slow rhythm he was accustomed to. Benjamin Dean Vose's bed sank in the middle. It was too comfortable. Would he ever get the goddamn hell out of Dollar? Benjamin stood watch over the empty bed across the room. Jimmy'd come home and comb his hair a hundred times. He'd strike poses like some cowboy Benjamin saw in the movies. He'd hike his Penny's dungarees. He'd quick draw. He'd unbutton his top shirt button and stand in the shadow of the window with his arms folded and stare into the long orange sunset. Jimmy's froggy voice tore through Benjamin's head. Everytime Jimmy looked at him with those damp green eyes, Ben-

jamin Dean Vose saw the insanity just waiting to jump out and go to hell with itself.

He and Jimmy and Fat Elmer used to slip over to Love Field after dark. Fat Elmer rolled like Jell-O when he ran. Goddamn, he puffed so hard, Jimmy broke up everytime he looked at him. They'd sniff some glue and wait for a plane to start its descent, then run out on that runway and lie down. If they figured right, the plane would pass right over and a good way down the runway. The roar would flat tear your eardrums out. Elmer was terrified, but Jimmy ly back with his hands behind his head, his wavy blond hair flopped all over his face as if the whole thing was a joke. He didn't seem to have any fear at all.

One night, a 727 touched down early. The landing gear came at them like a monsterous eagle about to pick off a rabbit. No time to run or move. The goddamn glue went cold in Benjamin Dean Vose's nose, and the jet's belly was on them. Huge, big ol' claws about to tear out their guts. Smash their gizzards into the runway like so much dead cat for sure. Benjamin heard Elmer's scream disappear in the jet's scream. Benjamin Dean Vose felt its hot breath pass over. Then all he heard was Jimmy laughing and slapping his knees. Elmer lay there all sweaty with his eyeballs popping at the moon.

One morning Jimmy left without a word. Just walked down the narrow two-lane road leading to Greenville. The mist rose off the grasses, and the smell of lilacs and manure filled the air. A '64 Plymouth Barracuda slowed up, and the driver rolled the passenger window down to offer him a ride. Jimmy's grin curled down. The ice in his green eyes spooked the Plymouth straight on track, good-bye.

Sam Vose drove around after work for about a month and a half, thinking maybe Jimmy might turn up in a pool hall, or a bowling alley. Maybe Jimmy would go into Pete's for a bottle. Nobody in his family drank. Where did he go? At the end of his rounds, he'd park in front of the Calgary Baptist Church and wait. Sam kept it to himself. Never reported it, never told a soul at work. Told Benjamin and his wife the subject was closed.

Benjamin Dean Vose heard Jimmy was in Dallas. Somebody recognized him coming out of a movie. Said he was with a girl and two men. Told a friend of Greg Kellogg's, who ran Greg's Getty a block from the high school, who told Benjamin. Said he wouldn't talk. That was the end of that for six months.

In late August, when the heat cooked all sensibility out of

a rational person's mind. Jimmy appeared at the end of the drive. Matted dirty hair. Small hands dangling. Ashen faced. Eye sockets like empty teardrops. Summer dust churning around him. The marsh hawk on the overhead pole dropped off into the southwestern sky. As the blue Chevy pickup that brought him completed its turnaround, the rear right tire jammed a two-by-four hidden in the short brown grass, kicked it back another three inches, and rumbled back toward Dollar.

Jimmy weaved down the dirt drive. Benjamin ran out to help him. Jimmy held his hands away from his body like limp, irretrievably broken spiderlegs. Jimmy stumbled. Benjamin shivered in the heat. Jimmy tripped and fell on his face. Benjamin picked him up. Once they reached the porch, Jimmy seemed to know where he was. He slipped through the screen door, shuffled inside, went up to his room. Benjamin stood on the porch listening to the silence crackling in the sun.

For days Jimmy sat up there on his bed. Once Benjamin Dean Vose waved his hand in front of Jimmy's face to to see if he was alive. He wondered if Jimmy ate while the family was asleep.

A '68 white Ford with orange license plates and a couple of dark faces nobody could see from the porch began driving by the house. Not enough to stir any interest until the fourth or fifth pass, when Mamma raised an eyelid. Benjamin thought they were after him for the $97.12 he'd pulled out of a purse in a supermarket shopping cart over in Greenville.

Sam Vose pitched forward in the Boston rocker. "Jimmy, you come out here and tell me if you recognize that car," he said. He nudged the wooden railing with the heel of his hand and felt it give a hair. "Stick around long enough, you might help fix this thing. Got another couple months left 'fore it falls over in the yard. Are those friends of yours out there?"

Jimmy stood behind the screen door and never said a word. When the car was gone, he went back upstairs.

The following morning Jimmy's bed was empty. Benjamin Dean Vose wasn't surprised, but he was fearful, and he ran out front for some sign. He even hoped the strange car would drive by. Along about 11 A.M., while his mother shook the kitchen runner out back, a sheriff's deputy pulled in the drive, got out, hiked his pants up, and was about to spit, when he remembered why he came, so he took off the sunglasses, swallowed the rest, and walked toward the empty porch.

"We really don't know," he began. Betty watched his lips move through the words. "He must've fallen. I haven't any idea what he was doing up there in the middle of the night." The deputy caught his voice raising a question and dropped the pitch. "The sign is over in Greenville. He fell right off the end with the foam on the beer ad. You know the one." She didn't, but nodded. "Found some cigarette ashes and one of his shoes and a comb lying up there on the catwalk." He took a deep breath and glanced over at Benjamin standing by the wall telephone next to the kitchen door. Betty seemed to know what he was about to say, but she gave no indication that Benjamin shouldn't hear it.

He went on. "The boy fell on a wooden fence, Mrs. Vose. He fell right on the fence. It was his chest."

Betty Vose raised her hand, and the sheriff stopped.

Benjamin Dean Vose thought he'd throw up. He had an urge to grab the sheriff's gun, but it had a strap over the handle. Why wasn't the sheriff sweating? It pissed Benjamin Dean Vose off because he was sweating in his shoes, and they felt too big.

Drugs, the autopsy said. LSD. Amphetamines. Valium. Alcohol level .21. Something odd about the way he fell. Who were those men in the car?

Benjamin Dean Vose was terrified he'd end up like Jimmy. Worked part time after school at the Whitebird REDD EYE Cement. Came home at night. Went to church twice, sang with his mother once.

Went to junior college. Had to get away from Dollar, Texas. If only he could come up with a little more brain power. It amazed Benjamin Dean Vose that he actually sat still in a classroom long enough to finish. He felt like he was jumping out of his skin all day, every day. Living at home drove him crazy. Death and dust gathered around him. Original sin dogged his every move.

When Benjamin Dean Vose took his graduation scroll, his only response to the damp handshake and smile was his stomach, perverted by the consumption at 5 A.M. of one pint of gin, seven beers, and two leftover fried chicken thighs Fat Elmer left on the backseat of his 1954 faded green Plymouth sedan. What the audience heard coming over the sound system, resembled the low sucking echo of a pig being eviscerated.

For a few short seconds he felt free. The sky ran a big sheet of sweet life ahead of him, and he laughed out loud for the first time he could remember, just for the love of it, then for the

stillness it left behind. At once, a lark flew across his path and dipped into a shrub. Benjamin stopped laughing and listened to the lark's song. He heard faint whisperings of the heated life around and behind him. He smelled somewhere blackberries and an irrepressible swelter ahead.

Seven weeks after graduation, he commandeered a bicycle. Rode over to a gun shop in Greenville. Parked the bike out of sight at the side of the building.

"Can I take a look at that?" Benjamin said, pointing to the Walthers PPK 380.

Benjamin Dean Vose heard the big man's blood pounding through its heavy flesh. He smelled saliva punctured with tobacco juice and licorice as he turned the gun over in his palm. Asked to see a clip, took it, slapped it in very nicely. He produced one of his rare Benjamin smiles, a small mouth coming up a rash of teeth to stop God and a flush of cheek to match, the excitement building in his skinny body, almost six feet tall with a homemade haircut snipped here and there, patched and holey. A raggedy-assed cowlick tripped over his forehead. Sling and holster passed smoothly across the counter. Leather smelled just fine. Gun oil wafted everywhere, slick, dense . . . calm.

If you asked the gunsmith if he'd lived in Greenville all his life, he would have said, "Not yet." Known for honesty and an eye for good men, his gunsmith's ring finger flickered when the leather passed over the glass counter. Below, nineteen pistols in the back row, seventeen in front, more in the bottom case. Small tags attached to trigger guards by thin double strings. Marked by number, price.

Benjamin Dean Vose put the holster to the sling, adjusted the sling, tied the holster in place, dropped the barrel in right at the left armpit, then stood tall as the moment came. In the next instant he was out the door with a "Thanks" tacked in the air over the counter. By the time the gunsmith hit the street, there was no sign of Benjamin Dean Vose at all.

Stopped in the supermarket, lifted two wallets out of two purses, one in the cereal department, one in toilet paper for a grand total of $179 and change. A Ford station wagon in front of Neal's BY RITE gave up another purse worth $51. Eighty bucks from a friend of Fat Elmer's for the bike, and Benjamin never had to use the gun. Bought a pint of gin. Didn't even stop home. He felt wired. He felt dark and empty. The comfortable desire for his bed returned; the screen door slapped and slapped, but,

as always, the deafening silence took over. Words that didn't even have a shape sent him running to the bus terminal.

For the next thirteen years, Benjamin Dean Vose toured the Southwest and parts of California, hiding in his shadow, precisely on the run; various and sundry drugs boosted, swapped for guns, ingested, injected, popped, rubbed, snorted, with a trail of gin bottles and exhausted stolen cars jammed in ditches or driven into the sides of buildings. Sometimes he had a girl with him. Sometimes he had a boy. Most of the time he didn't know. Half the time he didn't care.

Drove a hot black Thunderbird across a hospital lawn and up the front of a commodities salesman's Buick Century in Coolidge, Arizona, while the man's son lay in the emergency room getting his right thumb sewn back on after playing tag with an aberrant hedge trimmer. Salesman's wallet gone. Mother furious and in tears. Benjamin Dean Vose en route to Seven Springs via Pheonix with someone named Priscilla. May have had a big plate of shrimp in mind. Maybe on his way home for a few days. One thing was certain: Benjamin never knew whether he was running away from silence or looking for it.

Five minutes after sunset. A bass thumped in the upholstery. Brushes on the cymbals—*tshussah tshussha tshussa* . . . Benjamin Dean Vose's mouth made a big hole—"WA, WA WAHHHHH! Whoochy whoochy whoochy . . ." Headlights, taillights, blinking brakes. Goddamn ELECTRIC string *gonnnnkk* off in a thunky rift . . . Beepy dumb horn beat everybody off at the intersection. WEEP WEEP WEEP! Hot night. Green light!

"See, it's all a bunch of shit, Benjamin," Priscilla said. "Family is all that matters. If you don't have that. If they don't care. Right? You know what I mean. I mean, you're beautiful, Benjamin. You're the first person who hasn't tried to rape me, rape my mind, tell me what to do. You just go! I like that. I want to go! You're stable, Benjamin. You just don't know it."

Benjamin raised his eyelids, and a glimmer of uncertainty raced past. She bounced up and down on the seat to the bass. Her little breasts jumped all tight in her bright yellow T-shirt. Benjamin Dean Vose was beside himself watching her.

"I mean, if you go to college, a woman's college, any college, you see how it's all falling apart. Benjamin, does going to college teach you how to live in the world? No. Did they tell you

how to keep from going crazy in a world you don't have any control over? That's because they don't know how. I mean, I hitched out here from New York. I'm gonna be an actress. A real actress. That place died years ago. It just doesn't know it. They haven't had a new idea in years. Everything that's worth a shit now has to come from the grass roots. We have to fight for love. They'll steal it Benjamin. They'll just switch you on like a new lightbulb and let you burn out. . . . They'd be right here if there was any reason. They'd stamp themselves all over the place. They got no idea what Albuquerque's about. Right? They'll build all kind of buildings, restaurants. First thing you know, they'll be talking about Albuquerque needs an identity. Right? They never come and embrace Albuquerque or any other place. They just take. Right? You know what I mean, Benjamin. You always say that America ate all the ice cream. That's right, Benjamin. How many people really know that? You let your guard down just for a second, and everything you ever wanted goes WHAP! You're more focused. I know you're crazy, but it's focused crazy. Know what I mean? Focused!''

The guitar ripped into the percussion, got lost, came out the other side. Benjamin Dean Vose slid the car off the street into cool darkness beside the building. Pulled the Walthers PPK out from under the seat. Took the nice red cloth off the nice leather holster. It looked just grand in the dark, with its shiny, oily smell and its gorgeous, deep metal heartless blue, lying cold in Benjamin Dean Vose's long Dean hand.

The CT Convenience sign blinked a red set of wheel spokes with clock numbers at the ends. COLD BEER alternated with ICE in mint green beneath the clock; 24 HOURS flashed in the side window.

Benjamin tapped his left temple with his index finger. ''Like there's a whole goddamn world running through a tunnel in your brain that never sees daylight.''

''That's why you need me!'' Priscilla shouted over the din of music. ''I like staying up nights!''

Benjamin stared at his long legs that didn't fit under the dash no matter how far back he pushed the seat. His knees looked goofy sticking in opposite directions, and his ankles seemed skinny jammed into the big white hightop sneakers that glowed in the dark. He beat the steering wheel lightly with the heels of his fists. ''My god, Priscilla, will I ever sleep?''

''It'll all work out,'' Priscilla sang over the music. She

stared straight out the front window where six teenage Mexican boys streamed out of the convenience store and into a black 1972 Ford Torino. "Because I'll give you what you want and what I want. That's all," she said kissing his cheek. They sat in the car gazing at each other for a full minute and a half until all Priscilla felt was the pulse of the bass on her skin, and the momentary softness that came across Benjamin's face and disappeared in a riff. "Maybe I should get a tan," she said. "We'll make one big bunch a money; then we can go the beach on our days off and get a tan."

The guitar faded into the cymbols. Priscilla and Benjamin waited until there was no music left; then Priscilla turned the radio off. They sat quietly with their hands folded in their laps for a full five seconds. Finally Benjamin Dean blew a big breath into the night. "WHAHAAA!"

He slid out the driver's side. Priscilla slid over smoothly and pulled herself erect with the steering wheel. Her beautiful red lips glowed in the streaming neon light. Priscilla revved the engine. Benjamin hopped into the air-conditioned store like a giant grasshopper.

A big heart banged like crazy all over the car. It was Priscilla's big heart scaring the shit out of her again. Shadows in the window. Rapid shadows. Right above the 24 HOUR sign. She cranked the shift in and out of drive while she held the brake. . . . Eased forward a hair . . . Neutral . . . More shadows. A pink Jeep bumped up to the front of the store. The grasshopper man leaped through the door. Priscilla had the car in reverse, holding off until the grasshopper man got in panting. Pebbles burped all over the bottom of the car. Priscilla spun it around, jammed it into drive, sending more pebbles ripping up the side of the store, across the glass, and along the right side of the jeep. Two pretty, pretty girls stood in the jeep seats in their white shorts and midi tops, all creamy and tan.

"Hey ASSHOLE!" one pretty, pretty girl screamed at them, but Benjamin and Priscilla were already swirled into Friday night, beautiful Friday night.

"See," Priscilla said, snapping the radio on. "See what you got." A sweet saxophone leak into the car. "OOOOOOOh God-awful sweet!" Priscilla punched some radio buttons while Benjamin wiped the pistol off and carefully placed it in the cloth. A nice paper bag sat on the dash. It was a number eight bag, and it was stuffed. Bruce Springsteen blew the speakers out all ends.

Priscilla felt like wrapping her legs around everything. The car ran like cool white wine.

One afternoon in July of '68 Benjamin and Priscilla stopped in front of a shack on Alvarado Street in L.A., thinking they were in Hollywood. Benjamin knocked on the door. A huge man with outrageous acne, a can of beer in one hand, and a fat woman's ass in the other, sent them to the movies. Benjamin Dean Vose and his Priscilla sat in the front row, drinking beer and belching. A man in the movie wore a cowboy hat and hung over fences. Benjamin Dean Vose thought he recognized him. He simply stared at the screen, cocking his head from one side to the other looking for a semblence of meaning in the young man's face. Once in a while the man tipped his hat or slapped it on his thigh. Often he merely shrugged. There were oil wells and dead cattle. An older woman in a farm kitchen talked to him in a raspy voice. Then Benjamin passed out.

Woke up three months later in a Dallas cell with four maniacs, yellow chipped paint on the walls, one toilet. Cold metal bunks murdered sleep; a half blanket kept him crazy. The noise never stopped. Somebody in another cell, somewhere—Benjamin never knew where—whistled day and night, off key, no discernable tune, just whistled. He got bored and plugged the toilet. Flooded the cell. Got everybody to stand on the bunks and sing "Yellow Submarine." Got a little solitary confinement. "Priscilla?" he said. Naked in the dark. One hole in the floor. Couldn't hear the whistler anymore, but this one guy, this one guy in the next cell . . . Benjamin Dean Vose could see him through an itty bitty crack. Writing on the walls in his own shit and singing "Ebb Tide," all verses. Next thing he knew, he was out in the streets in Dallas with no idea how long he'd been in, no idea where he was going. No money and no job. No Priscilla.

Benjamin Dean Vose no more than had his pants zipped up and his shoes tied when he began trying to figure out how to get a gun and what he might be willing to do to get it, and what he might do *with* it when he *did* get it, stepping out under the empty streetlights of Dallas, where everything went right on by like it didn't care. "America has eaten all the ice cream," he said.

Seventeen months, later Benjamin Dean Vose left Los Angeles at five past noon. Smack! He'd been riding the Beverly Rodeo Drive hotel elevators in his red basketball sneakers and his

yellow plaid Goodwill sports jacket, trying to get up the cash to buy smack. Couldn't find Priscilla. Couldn't find anybody. His blue '64 Ford had no left front fender, and the water pump was on the fritz, but he could fix that if he could get to San Bernadino.

It came down to punching a little old lady in the face for her purse. Just your basic, purple-haired 5 foot 1 inch grandmother with a pink sweatsuit on and a little sequined purse on a chain, her perfume filling the elevator, thick pink-framed glasses making her brown eyes big and fishy. She went down in a heap just above the fourth floor. Blood all over the elevator. Teeth broken. The poor thing couldn't even scream. Benjamin Dean Vose wanted to cry. Benjamin Dean Vose wanted to pick her up and take her to the doctor. And all Benjamin Dean Vose wanted was more.

Other people made it. They left their little towns all over America and did okay. They seemed to be in better shape than Benjamin Dean Vose. It was killing him. He needed a rest. He needed more. He thought about calling home, but the notion fled before he could remember the phone number. Where to run. Where to stop? Benjamin Dean Vose checked the gas gauge. It read three quarters. "Pomona! Maybe Pomona!"

FROM Come Back to the Five and Dime, Jimmy Dean, Jimmy Dean

Ed Graczyk

(JOANNE *enters.* SHE *is very classy in a lightweight pants suit.* SHE *wears large sunglasses.*)

JUANITA. Hello.

JOANNE. Hello.

JUANITA. We was just lookin' at that funny lookin' car you're drivin'.

MONA. It's a sports car, Juanita.

JUANITA. I know. I know . . . still funny lookin' to me . . . don't know how you can squeeze yourself all up inside it. (*Laughs.*) Must make you feel like a sardine in a can.

JOANNE. (*Giving her a half smile.*) Don't see many dime stores like this around anymore.

JUANITA. Still a few of us left hangin' on. Is there somethin' I can help you to find?

JOANNE. (*Caught off guard.*) Umm . . . (*Removes her sunglasses.*) Sunglasses . . . One of the lenses on these is cracked, and it's become very irritating to look through.

JUANITA. There's a few pair left hangin' on the wall over there. (*Gestures to a spot near the shrine.*)

JOANNE. Thank you. (SHE *goes to it.*)

MONA. Are you just passin' through?

JOANNE. You might say.

MONA. Not many people do, anymore . . . what with the super highway ignorin' us the way it did.

JOANNE. (*Looking up at the photos of Dean.*) I used to be a fan of his, too.

MONA. Not anymore?

JOANNE. (*Bluntly.*) He died . . . didn't you know?

MONA. Well, of course, I know . . . but he lives on in his movies and . . . did you happen to see *Giant?* It was filmed not far from here, in Marfa. I don't mean to sound boastful, but I was in that picture. Only in the crowd scenes, but my face does appear on the screen distinctly in one segment.

JOANNE. That must have been very exciting for you.

MONA. It was *the* most exciting time of my whole entire life. (*Curious.*) Your voice . . . it sounds so very familiar.

JOANNE. (*Going to the counter and mirror with several pair of glasses to check out how they look.*) People have said it's unusual. I've heard it all my life so it sounds perfectly normal to me.

MONA. (*Laughs.*) Well, yes . . . I suppose it would.

JOANNE. Are you the mother of his son? (*Gestures back to the photos.*)

MONA. (*Feigned surprise.*) How on earth did you know about that?

JOANNE. I saw one of your signs down by the highway . . . "See the son of James Dean, visit Kressmont's five-and-dime, nine miles ahead."

MONA. (*Embarrassed laugh.*) We never bothered to take them down because the words became so faded from the sun they couldn't be read anymore.

JOANNE. (*To* JUANITA.) I believe I'll take these.

(*Removes money from her purse.*)

JUANITA. Will there be anythin' else?

JOANNE. Yes, could I have a glass of water?

JUANITA. (*Embarrassed.*) We seem to be temporarily out of water. Would you settle for an Orange Crush instead?

JOANNE. As long as it's cold and wet.

MONA. When little Jimmy Dean was first born, nearly three thousand people swarmed into town over a one week period, just to see the son of James Dean. He really put McCarthy, Texas, on the roadmap for a brief but glorious period of time. We were the busiest, most prosperous Kressmont store in all of Texas.

JUANITA. They gave us a plaque . . . see it on the wall over there.

MONA. Juanita's husband, Sidney, was the manager at the time. He has passed away since.

JOANNE. And were the signs *his* idea?

MONA. Why, yes . . . he had the whole thing planned out perfect. There were newspaper an' magazine people here takin' pictures an' writin' down everythin' I would say . . . I was quite a celebrity. People bought up everythin' they could get their hands on thinkin' little Jimmy Dean had touched it. He was on display on a platform over there by the window. Sidney had to hire two policemen just to protect him from possible molesters an' kidnappers. It wasn't only the five-an'-dime, neither . . . the entire town went through a period of immense prosperity.

JUANITA. They even elected Sidney mayor after that.

MONA. You really should have seen this town before . . . it really was quite active for one its size, but now most everybody has been drawn away to greener an' *damper* pastures. (*A small laughter.*)

JOANNE. And you?

MONA. (*Surprised at the question.*) Me? . . . Why, I'm quite content to remain where I am.

JOANNE. There's not much chance of any growth here in all this dust, is there?

MONA. (*Amused.*) That seems to be rather an extremely personal question comin' from a stranger. (SHE *is becoming very nervous.*) Juanita, do you think that water pressure has risen enough by now? (SHE *turns to see* JOE *again outside the door.*) There he is again! (HE *runs off.*)

JUANITA. I didn't see anyone.

MONA. It looked like he was hurt an' bleedin' . . . an' he wanted to come in.

JUANITA. You sure it wasn't just Jimmy Dean?

MONA. Hurt an' bleedin? (*Goes out the door.*) Jimmy Dean, you out there?!

(SISSY *approaches her outside.*)

SISSY. Mona . . . Mona, I wanna talk to you about—

MONA. I don't wanna talk to you. (SHE *re-enters the store.*) Juanita, you don't suppose somethin's happened to him. (*A car horn is heard blaring down the street.*)

SISSY. (*Outside.*) Here comes Stella an' Edna Louise!

JOANNE. (*Nervously wanting an escape. To* JUANITA.) Excuse me, could I use your ladies' room?

JUANITA. Right through them curtains there, an' straight ahead. (JOANNE *exits.* MONA *is drawn to her momentarily.*)

STELLA. (*Outside.*) Sissy! . . . Sissy, honey is that you?

SISSY. (*To* STELLA.) It ain't my aunt Sally . . . Park that thing you're drivin' an' come on in. (SHE *enters the store.*) Shit, would you get a look at the size of that car she's drivin'!

JUANITA. (*To* SISSY.) You've been drinkin', haven't you?

SISSY. Drinkin' what?

JUANITA. Alcohol. I can smell it on your breath.

SISSY. There ain't no water. I had to drink me somethin' or die of thirst.

(STELLA MAY *and* EDNA LOUISE *appear at the door. There is much squeeling and yelling as they all converge on each other with hugs and kisses. STELLA is the same age as the others. EDNA is several years younger. STELLA is loud, boisterous and obnoxious, a small-town girl who married into money SHE wasn't prepared for. SHE is dressed to the hilt in the best of everything, and then some. Over her dress, SHE now wears a red windbreaker. Across the back in script is written DISCIPLES OF JAMES DEAN. EDNA LOUISE is plain and simple. SHE wears a white, stained beautician's uniform, which is pulled tight across her obviously pregnant front. Her stringy hair is pulled back into an attempted ponytail. SHE wears beat-up saddle shoes and white anklets and carries a clear-plastic cleaning bag, which contains a party dress.*)

SISSY. (*As they enter.*) Stella May, you old shitkicker, how the hell are you?

EDNA. I didn't have time to change after work 'cause Stella May was in such a hurry to get here. . . . I feel so embarrassed.

SISSY. Edna, you got somethin' cookin' there in your oven?

EDNA. (*Dumbly.*) I beg your pardon? (SHE *suddenly realizes the joke and holds her pregnancy.*) Oh! (*Giggles.*) Yes . . . my seventh.

STELLA. Seven kids! Can you imagine anythin' more horrible! (SHE *models the jacket.*) Hey! . . . Hey, everybody, look what I found up in my attic. (SHE *laughs . . .* SHE *always laughs.*) Ain't it a hoot?!

MONA. The old club jacket.

EDNA. (*Frantically trying to pull hers out of her bag.*) I have mine, too . . . it seems to be stuck here in my bag, but . . . I do have it!

SISSY. Jeezus, can you believe we used to wear them things?

STELLA. Sissy, my God it's so good to see you. . . . Last I heard of you was a Christmas card from Oklahoma City 'bout five years ago.

SISSY. Lived there ten years. . . . I'm back here now, goin' on three . . . been workin' over at the "Flyin' 'H' Truck

Stop'' down by the highway. Got me plans for movin' on though . . . real soon.

STELLA. From the looks of things out there, you'd better start movin' on quick. Christ, what's happened to this town, anyway? I've seen dead dogs layin' out 'long the side of the road with more life than this town's got.

JUANITA. Lack of rain's just about dried us all up.

EDNA. (*To* JUANITA.) I will have to use your bathroom to change. (SHE *wanders around the store, looking.*)

STELLA. Mona, you ain't changed a day . . . hell, none of you has. (*Laughs.*) Hey, what about me? (*Twirls around.*) Think I've changed, huh?

SISSY. Honey, you look like a million bucks.

STELLA. Million an' a half. (*Laughs.*) My Merle just brought him in another one. That man can smell oil, I swear.

EDNA. (*Who has put a penny in the gumball machine and holds up the gumball.*) Look! . . . Look, everybody. . . . Red, my favorite color. My fortune in the newspaper said today would be my lucky day . . . (*Pops it in her mouth.*) an' it is.

STELLA. Ain't she a dip though? (*Looks around.*) Anybody else show up yet? (JOANNE *enters through the curtains.* STELLA *sees her.*) Don't tell me now, let me guess.

MONA. Stella, that's not—

STELLA. No! . . . No, let me guess. (*Quickly.*) Alice Ann Johnson!

MONA. Stella, she's not—

STELLA. I said don't tell me, for Chrissake! (SHE *sees the group picture on the table.*) Oh, my God . . . the old group photograph . . . aw! (*Goes to* SISSY *with it*) My God, tell me that's not me.

SISSY. It ain't. . . . (*Points to opposite side.*) You're over there with your tongue stickin' out. (EDNA *rushes over to look.*)

STELLA. My God, would ya get a look at that outfit I'm wearin'? (*Laughs.*) If any of the girls at the country club got their hands on this, I'd be blackballed.

EDNA. I have a party dress here in the bag. I haven't worn it in so long it smelled like moth balls, so I sent it to the dry cleaners, which is why it's—

STELLA. Oh Edna, quit bellyachin' about the way you look. She's been harpin' about that damn dress all the damn day. Go put it on an' shut up. (*To* JOANNE.) As if it would make any difference.

JUANITA. The bathroom's right where it always was, Edna.

EDNA. I won't take very long, I promise. (SHE *exits.*)

SISSY. (*Calling after her.*) Don't flush the toilet, whatever you do. It's the only water left in this whole damn town.

STELLA. (*Looking at* JOANNE *and then the picture.*) I just love to try an' guess at people from old photographs.

SISSY. (*Quietly to* JUANITA.) Who the hell is she?

JUANITA. Just someone passin' through.

STELLA. Hey, Mona, is that fancy yellow sports car parked out front one of the purchases you made with all that money you raked in off Jimmy Dean?

MONA. There was no charge to see Jimmy Dean.

STELLA. There wasn't? You sure did miss out on a golden opportunity to cash in on a craze. (*To* JOANNE.) Then, it's gotta be yours then. . . . You look like you've done pretty good for yourself.

JOANNE. I managed to do all right. (*A glance to* MONA.)

STELLA. You sure you're in this picture?

MONA. (*Very unnerved by* JOANNE's *continuous stares; quietly to* SISSY.) Did you see Jimmy Dean out there anywhere?

SISSY. Nope.

MONA. (*Goes to the door.*) Then where is he? . . . He couldn't have just disappeared into nowhere. (SHE *starts to wheeze and gasp for breath.*) . . . Some . . . some . . . thing's . . . ha . . . happened . . . I . . . I can't catch my breath. (SHE *grabs on to the door frame for support.*)

STELLA. Get her some ice water. She's gonna faint for Chrissake.

SISSY. There ain't no water. (JUANITA *helps* MONA *to a seat.*)

JOANNE. Give her a swallow of whiskey.

JUANITA. There is no alcohol in this store an' there never will be.

JOANNE. What about that bottle Sidney used to keep hidden under the hardware counter?

JUANITA. (*Stunned.*) What do you—?

STELLA. (*Quickly.*) Martha Jane Gibbons!

JUANITA. Sidney did not drink!

JOANNE. Then how did he die from it?

SISSY. Who the hell are you?

JOANNE. He died from a decayed liver . . . he was eaten up by alcohol.

SISSY. You can't go talkin' like that to her.

JUANITA. Sidney was a saint and he's in heaven now with God.

JOANNE. The only time he was ever in heaven is when he had a bottle in his hand.

JUANITA. Lies! . . . All lies!

(JOE *appears at the screen door.*)

MONA. (*Seeing* JOE *at the door in her memory.*) I think I know! . . . I think I know.

(SISSY (THEN) *enters from the back room with magazines for the rack.*)

STELLA. Christ, I named everybody in the picture it could be.

JOANNE. I'd find him collapsed in a corner, hiding from you and God . . . every Wednesday night when I came to put another layer of oil on the floor.

(MONA (THEN) *comes through the curtain.*)

134

JOE. (*Opening the door*.) MONA!

MONA. Oh my God . . . it's Joe!

MONA (THEN). (*Rushing to him at the door*.) Joe! . . . Sissy, it's Joe an' he's hurt an' bleedin'.

SISSY. Holy shit! . . . The McGuire Sisters are reunited!

(*The lights black and quickly*.)

Jimmy

Michael Hemmingson

I. CASCADE

Tammi's room was, as her roommate, Quinna, put it, an obelisk to James Dean.

She was prancing for James Dean, getting ready for the gig. She was naked in her room, the many faces of Dean on the wall studying her. She was going through her closet, trying to decide what to wear for the show. She held out various skirts, blouses, asked the posters, "What do you think of this?" Most of what she had was basic black, mixed with some whites and purples—like her hair. She'd kept her hair purple long after the fad went the way of camp; besides, it worked well being a singer in a band of the neopsychedelic-goth mode.

James Dean would have approved of such hair color, had he lived. This was something she knew. She *knew* Dean: his soul, his desires and fears. It was *there*, in his movies, the TV shows he'd done; she'd read every book written about him . . . *every-thing* was so clear and present, Dean naked before the world, the display of the perfect person. This was the reason for her connection, as others had and have made a link: he was a real human being, in a world where there are so few real human beings.

At eight, Lee came by in his Mustang. He was the drummer in her band, Crash Digital. His Mustang was vintage but needed work. It would be a great car if he ever got around to fixing it. Like herself, Lee was a poor artist barely making rent. He was in basic jeans and black T-shirt, his drum kit—acoustic and electric—crammed into the back of the car. He had a goatee and wore granny shades. He grinned at her. They never spoke

much—well, Lee wasn't a talker. What did they have to talk about? They made music, that's all that mattered.

Annette and Davie, the other two members in her band, were in the club parking lot, leaning against Davie's van with some friends. The sound of another band on stage poured out from the club's interior. They were too metal for Tammi's taste. Clubs seldom booked like bands on the same night, hoping for a diversity of people. Often that just led to trouble. Tammi liked trouble now and then. She wasn't in the mood for much tonight. She didn't really feel like getting on stage—one of those weeks.

People were drinking. Lee took a beer offered to him. Tammi didn't feel like drinking. Christ, she wasn't in the mood for anything—*great way to be when you have a gig*. She clutched the locket around her neck; inside was a photo of James Dean. It had been given to her by a friend, a gift, when she first became obsessed with the dead man. That had been when everyone thought it was just another one of her passing phases. She knew they whispered about it now—she talked too much about Dean, watched his movies over and over, knew the films line by line, scene by scene, cut by cut; she carried his biographies around with her and had written four songs about Dean. *Let them whisper*. She'd always been weird. What the hell did they expect?

Quinna's car pulled up, a VW. Tammi smiled. Her roommate always came to the gigs, a Crash Digital regular. Quinna was in leather tonight, hair bunched up in a top hat. Quinna was a tall mulatta in quasi-dreads with a strange accent she never bothered to explain. She gave Tammi a quick hug.

"Got some fry." Quinna said softly. "Wanna drop?"

Tammi smiled. She twirled her mirror shades, thinking. Maybe this was what she needed to get out of the doldrums. She considered the possibility of a bad trip. "Sure."

Davie and Lee pulled their vehicles up to the back of the club. Tammi watched them unload the equipment. She seldom helped; there were always enough tag-along friends happy to play the part of roadie. All Tammi needed was her microphone plugged into the sound system and she was ready to go.

She was feeling the acid start to hit her, and it was rather good—until she saw Gary, her ex-boyfriend, approach the Crash Digital entourage. She had nowhere to hide. Quinna

was talking to a couple of guys. Gary wore a long overcoat, torn jeans. He smiled but didn't look happy. She didn't want to see him right now. She'd broken up with him two weeks ago. He'd called but she'd never talk. It was *over*, and it should've never begun in the first place. She'd been attracted to him physically, but there wasn't much substance to the guy, and he wasn't willing to let go. She knew he thought it cool to be with a girl who sang in a band, and more and more he'd attempted to control what she sang about, how she acted on stage (at times she could get wild and erotic), and once he pushed a friend's lyrics on her and said she should make them into songs. No, no, *no*, Gary was bad *news*, and why the hell was he here just as this fry was getting into her brain and they were getting ready to do their set? This sucked.

"Tammi."

"Gary."

Nods.

"I've called," he said.

"You left messages," she said.

"You haven't answered."

She put on her shades. "No."

He looked around. "What the hell."

She sighed, wished she hadn't. "I don't want to get into it. I have a gig."

"I know," Gary said.

"You shouldn't have come," Tammi told him, "*really*."

"What? This isn't a private party. I can pay to get in and see the show." He smirked.

"Go ahead and pay and see the show." She tried to sound as cold as she could. *You're not getting in with the band, that's for sure, buddy.*

She turned and he grabbed her arm. He was starting to piss her off. He said, "We should talk."

"About what?"

"About *what?*"

She pulled her arm away. "I'm not in the mood for shit."

"Shit." He laughed.

" 'Bye."

He stepped in her way. Now she *was* pissed off, and this was giving her a bad trip. He snagged the locket around her neck. "Who you going to have for a man?" he asked. "James *Dean?*"

He gave her locket a slight tug. If he tore it off, she knew she'd murder him. "Let go of it."

He did.

She went around him and joined her bandmates.

The acid was hitting her *too* hard. She was sitting on a crate backstage and watching Lee set up his drums. He was hooking midi cables from the Roland drum pads to sound modules. Davie was tuning his two Fenders, and Annette was stringing a new B string on her five-string Ibanez bass. There was a decent crowd tonight, maybe a hundred or so people, half band regulars who went to every gig. Tammi wondered what it would be like to make it big time, with hit songs, playing to full auditoriums, stadiums, thousands and *thousands* of faces and souls concentrated in her direction. The thought was scary. She wasn't even sure if she wanted to go that far in this band. The others did, of course. Sometimes she didn't know why she did this; it would be a lot simpler to be a recluse and write down her feelings in the form of poems or stories.

Annette looked at her, chewing on bubble gum. It was getting close to time. Tammi clutched her Shure microphone a little too hard, sweat on her palms. Maybe it wasn't such a good idea to have dropped. Too late for regrets. She was certain she could ride it out; the set was only an hour, an hour and fifteen minutes. She could do it. Maybe she'd keep her back to the audience. Christ, did James Dean ever drop acid? Was acid around in his time? He probably would've been right out there with Leary and Kesey.

Dean. A good James Dean song to start the set would be nice—"The Spyder," an eerie song that started slow then suddenly went fast and ended with a crash.

Tammi was doing okay. She concentrated on her lyrics and went into the world of her words, psychotic riffs and feedback coming from Davie's guitar and Ampeg stack, thick swampy bass notes with flange effect from Annette's instrument. She was having difficulty hearing her own voice, uncertain if it were the sound system or the drug. Bodies were pressed to the stage, eyes on her, moving to the beat of each song. When the urge came, she shrieked, high-pitched—a scream her regulars always expected from her—with the accompanying look of anguish she was good at, a mien she practiced before the mirror, to arrive at a cross-

roads between ecstasy and pain. More than once guys had expected to see that visage in bed and more than once were disappointed. Who she was on stage was not who she was in life or bed or elsewhere. *Didn't these fools understand?* No one could understand. James Dean would understand: there was the existence on stage, life on celluloid, and life in real time. She could see his face on her bedroom wall. She'd rather be in her room, alone, watching TV or writing on her Macintosh, than out here. She told herself not to think this way. She was drifting. She had to keep with the band, the songs, the feelings she was transmitting. Did anyone really feel the stasis and despair she wrote of, or was it fashionable again to be gloomy and dark, put on the face but shut off the emotion? Did it matter? She saw Gary out there in the audience. He was glaring at her. She was caught in his gaze, almost missed a beat, then turned, going back into the chorus of the song she was on right now. *That ass.* Why did he come here? Why was he bugging her? Like the others, when it first began, she thought there was something there. She often fooled herself. How many men had she gone through the past year? Three—*five.* Gary was the fifth. It was always the same: they bored her, they had nothing to offer, and they never wanted to let go. For once she wished she felt that way about a man: the attachment, the obsession. She hadn't felt such a thing since . . . since she was sixteen, seventeen. A long time by her standards. This was depressing. She missed a few words in the next song, standing stonelike on the stage, but got back into the rhythm. Annette gave her a look, strumming on the E string of her bass, heavy phase shifting and slight delay. The music was getting too deep in her head. She wanted this gig to end. She wanted to get out of here. She wanted something desperately and didn't know what the fuck it was. . . .

Things were falling apart. She was crying and trying not to show it. She was indeed having a bad trip; this was hell. Annette tried to comfort her, but she told the bassist she'd dosed and it was going the wrong way. Annette nodded, having been there herself. Everyone was back in the parking lot. There were more people than before. She accepted a beer, hoping it might help. No one paid much attention to her tears and streaked black makeup as she feared they might. Maybe they thought she'd sweated a storm on stage, maybe they thought crying in public was part of her conduct. The worse thing was, she had no idea why she was cry-

ing. It was a combination of a lot of things. Life sucked, that was plain and simple. She was going nowhere, she had nobody, she had no reasonable explanation for the things she did. She yearned for when this drug would fade off, and these simple things wouldn't seem so megalithic.

There were too many voices around her. People told her how great the gig was, how nice and haunting a voice she had, how cool the lyrics were. She nodded and nodded. Another voice: "We have to talk," and she was being led away. Gary. She was like a puppet. No one moved to help her. Didn't they know she was in danger?

"Go away, Gary," she said weakly.

"No," he said, and he was pushing her now.

She tried to call out. His hand was on her mouth . . .

. . . she was in his car. He was driving. How did she get here? He had a bottle of Southern Comfort with him. Her favorite. Did he plan this? He drank from it, offered it to her. She took a drink, then spit it at him.

"Let me out," she said.

"*What's your prob?!*"

"I can't stand you," she said, "I can't stand the sight of you. You're boring, you're lousy in bed, you're an idiot, that's why I broke up with you. I'm *not* being nice about it, I'm letting it all out, so take it or leave it, kiss it, suck it, bite it, *and let me out of this car!*"

He was on a side road, going fast. He always drove fast. She wished he'd slow down.

"You bitch," he muttered.

She laughed.

He was quick—hitting her in the face. "Bitch!"

She smashed the Southern Comfort bottle against his head. He cried out, blood from around his ear going down his neck. The car swerved. She looked up and saw that they were going to hit another car. Tammi reached for the wheel, jerked it, and then they were heading straight for a tree.

I'm going to die just like James Dean. . . .

II. GREEN FINGERS

there was a portal

 voices •

there was light • *more voices* *and*
 then there •
 was darkness
fear •
screams
pain
 blood . . . •

So many faces, old faces, wise faces, staring at her. She tried
to talk to them but they would not
 answer
 they would not
listen
• to her pleas. . . .

She screamed to God, the same scream she used on stage
to cry out her hate for everything God had given her in the
world. . . .

This is life in the TV movies, Tammi mused.

She came to in a hospital room, in a bed, bandages on her
body and face. Her arm was in a cast. She felt pain everywhere.

Just like on TV, when people wake up after accidents . . .

She remembered the accident. She remembered the im-
pact into the tree, Gary flying through the windshield, glass
everywhere; she'd covered her face, body slamming into the
dashboard.

Pain.

Numbness.

—people looking down at her. People pulling her from the
car. Paramedics. Flashing lights.

The lights had become a tunnel.

The tunnel had become darkness.

Now she was here.

I'm still alive.

They sedated her. She returned to dreams. Dreams were always
nice. She envisioned herself on a windy hill, a sunny day, wearing
a white dress, just standing and waiting. She didn't know who
she was waiting for. She was content in her tarry. She could stand
on this hill forever.

The other dreams were about the ancient faces, and
worse: the ugly hulking black things with red eyes. They moved
close to her. They smelled bad. They wanted to do bad things to

her, of this she was certain. She tried to run away from them, but she couldn't go anywhere, couldn't move. The hulks got closer, smelling worse. . . .

Everyone came to visit; made her feel odd. The room was stuffed with flowers. She was worried about Quinna—how would the girl meet the rent? Well, Tammi had some in the bank; she'd give Quinna the number to get what was needed.

She'd been in the hospital for a week now. Gary, she learned, had died. She didn't know how to feel. She didn't feel anything.

She didn't have insurance, and she dreaded the bill she was running up. She told the nurse who filled out the paperwork that her parents were dead. This wasn't true, they were quite alive. Tammi didn't want to have anything to do with them, hadn't since she'd turned eighteen and was able to leave. She wondered how much they'd care if they heard about her accident, or even her death had she gone to the great beyond with Gary.

Gary . . .

What happened that night? She was on acid, yes, she was frying hard, and then she was in his car . . .

Her locket.

It wasn't around her neck.

She asked everyone who came in if they knew where it was. No one did.

"Trying to ruin our chances at fame and fortune, were you?" Annette said, smiling. She wore cut-offs and a T-shirt, hands on hips, chewing gum, baseball cap on her head. Davie was with her.

"Yeah, I know," Tammi said, "I'm supposed to get killed after we have a hit album or two."

"Then become an idol and a myth"—Davie nodded—"you know, like Jim Morrison."

"Janis Joplin," Annette said.

Dean, Tammi thought.

She woke up in the middle of the night and knew one of the dark hulking things in her dream was in the hospital room with her. She almost screamed. *She remembered a lot of light.* The room was green at first. She held up her hands against the green around the hulking ghost. Her eyes adjusted, the apparition went away. She relaxed. She hated shit like this.

* * *

She had a visitor the next morning, like none other. She opened her eyes and he walked in. He looked so much like him, she knew this was another one of those reveries.

He wore jeans, rolled up at the bottom, a white T-shirt, and a red windbreaker. He was leaning against the wall, observing her, a slight boyish smirk on his face. His thumbs hooked into the front pockets of his jeans, his head slightly tilted, his blond hair smoothly slicked back in a ducktail. He was gorgeous, there was no doubt. *Truly the man of my dreams?*

He moved to her. She could smell him . . . slightly sweet . . . not cologne . . . she didn't know what. Tammi sat up, realized she wasn't asleep.

"How are ya?" he said. Even the voice matched.

"I get it now," she smiled. "You're one of those hired actors. Celebrity look-alikes. Sent here to . . . cheer me up. Okay, who sent you? Was it Annette? Lee? The whole band? Quinna?" Quinna couldn't afford to hire someone like this, nor could her bandmates.

"Don't know any of those folks," he said, standing next to her now.

It was like a video image come to life, or in 3-D. She thought if she reached out to touch him, her hand would go through his nonexistent flesh.

"Come to think of it," he added, "I don't know anyone, I just know you. . . ." His grin widened. "Tammi. Tammi Aaron."

"Cut the gag," she said, "who sent you?"

"I came here on my own," he said. "Well, I hitched a ride. If anyone'd sent me where I was—it wouldn't be nice."

"Hitched a ride? What, you don't have a car?"

He seemed to think on that. "I used to. I don't right now." Back to his grin. "That'll change. A lot of things are going to change. For both you and me."

"Oh, I see." Tammi nodded. "Okay, I'll play the game."

"Hey, this is no game." And he took her hand in his. Something went up her spine . . . a sense of—what? . . . it was almost like a goddamn orgasm, and it scared the hell out of her. His hand was real, warm and smooth, just as she imagined it might've been. She withdrew from him, too abruptly she thought, but this was *weird*.

"Sorry," he said.

"Hey," she said, looking at the hand he touched, "what's your name?"

"Call me Jimmy."

"Jimmy what?"

"Jimmy Dean. What the hell do you think?"

"I mean your real name, *Jimmy*."

He shrugged. "Hey, that is my real name."

"Yeah, and every Elvis and Marilyn impersonator is also Elvis and Marilyn, right?"

"Marilyn?" He frowned. "Monroe?"

"Monroe, sure."

"She was nothing. Thought she was something hot. I never did like blonds. One night, after the screening of Brando's *On the Waterfront*, I scared the hell out of her and Shelley Winters. I was on my motorbike, see, and I kept getting in front of them, hitting the breaks—I looked back and could see the terror on that bimbo's face. It was pretty funny."

"I read about that," Tammi said. "It's in books. Anyone can read about that."

"Bet they never put the time I slept with her in the books." He smacked his thigh, shaking his head. "She acted like she detested me only because she really wanted me. I let her have me one night; then I ignored her. What was the big deal with her, anyway? She was and always will be nothing. That's why she continued to hate me. Well, she's gotten hers down there. She's down there with some guy who used to be president, and it's no Sunday picnic at the park, let me tell ya."

"Down where?"

His face seemed to pale for a moment. "The bad place."

"Why are you here?" she asked. "Aren't you supposed to do some act? Something to cheer me up? What, no balloons?"

"Cheering up takes time. I still have to reconcile." He turned away, adjusting his windbreaker. "Look, I gotta go. Just for a while. I'll be back."

"When? I want to prepare myself this time."

"I don't know when," he said distantly. He turned. "We're attached now. We're in this world together."

"*What?*"

"I'll return," he said and left.

A few minutes later a nurse came with breakfast. Tammi asked the nurse if she'd seen the James Dean imitator who came in.

"Visiting hours haven't started yet," the nurse said.

* * *

She was taken for a CAT scan again, and this time she talked to an old doctor who asked her a lot of questions. It was then that she found out she had died in the car crash. The paramedics had started her heart up again. This was news.

III. SHE'S A CARNIVAL

He came back that night. He was sitting on the edge of the bed. Now she was caught up between what was in her head and what was real. She'd been dreaming of James Dean, an erotic dream. Now his look-alike was by her; he reached to touch her face. She felt the same sensation go up her spine; this time she did not flinch or move away. His touch became a caress.

"I know what you have been dreaming," he said, "I know what's in your mind and your soul: I became a part of it."

She still had no idea what this mumbo jumbo was all about, but in the darkness she didn't care. She looked at the clock: two in the morning. She wanted to ask how he got in. His mouth was on hers. She didn't fight him. This very well could have been an extension of her dream, and the hell with it, let it. His breath and tongue were warm and sweet. She closed her eyes, but she could still see him. He was in the bed with her, his hands reaching under her gown. She felt her nipples grow aroused under his graze. She had to place her casted arm on his shoulder, gently; he seemed aware of it, cautious not to hurt her. She spread her legs open as his hand wandered there. "I must be mad," she whispered when he released the kiss from this dreamhouse of desire.

"We're all mad," he told her. "That's what ultimately keeps us sane."

He sat up, stripped out of his shoes, jeans, jacket and shirt. His skin was somewhat pale, but not like hers. She adored his slight musculature in the dim light of the room. Yes, he not only had the face and clothes, but the exact physique as well. *Was this part paid for?* She was too far into this, and still in a dreamish state to ponder rejecting him. He returned to her, kissing her again, moving on top, pushing her gown up, spreading her legs wider.

* * *

I'm a dangerous fool.

But she always had been, hadn't she? Being where she was now proved it. Her life was a carnival of mad acts.

Despite her shock at what had happened last night—and how he'd slipped out of the room as quickly and smoothly as he'd come in, again with his promise to return—she couldn't remember when sex had been so . . . *exacting* . . . perfect, as she'd always hoped it might be, as consummate in its degree of hope and helplessness coupled with joy and despair as the songs of sex she sometimes pushed out of her like tiny births. Music and sex, sex and death, life and love, art and breath—Jesus Christ, she needed to get out of here. What was she doing in this hospital room?

She called everyone she knew, asked who it was who'd sent the actor. No one knew what she was talking about.

He didn't come that night; well, he didn't say he would. He only promised he'd return with no set date or time. She wondered how many women chased him for whom he looked like.

He came the next night, though.

He was on the edge of her bed again. She reached for him, wanting his sex.

"I know I'm crazy," she said, "but why not?"

"Ssshhhh," he said, putting a single finger to her lips.

She licked his finger. She wanted to lick him whole.

"We have to go," he said.

"Go where?"

"Out of this place."

"Where to?"

"You have a home, right?"

"Well, yes."

"I'm going to take you there."

"You didn't come here to—like the other night?" Dammit, she sounded too hopeful; she never liked to sound that way with men, it gave them too much leverage.

He smiled, leaning to kiss her. "We have all of eternity for that, my sweet Tammi."

She had to laugh, only softly. "You're good at this. But you're an *actor*." She pronounced it "act-ORRR."

"I'm not in role right now." He sat up, holding her hand. "I'm me. That's all I've ever really wanted to be: me."

"We all have roles." She didn't want to ever let go of his hand. "Aren't we always playing at some scene or another?"

"I'm just happy being human again," he said.

"Why do you say weird shit like that?"

"You don't like it?"

Her voice was mocking. "Oh, I love it. Do more."

"You don't understand."

"I don't understand nuttin'." She sighed.

"We need to go."

"Why are you in such a hurry?"

"I'm only thinking of you. I know you can't pay the hospital bill. I know how much you want to leave. You called out to me for it, like you've called out to me these many months. So I'm here to take you away."

"Sweep me off my feet?" She squeezed his hand. "What, take the princess off in her magic carriage?"

"If you wish, yes."

"I thought you didn't have a car."

"I do now," Jimmy said.

He literally snuck her out. She put on a robe and slippers; none of her clothes were here yet. Quinna was supposed to bring some tomorrow. First, he stuck his head out to make sure no nurses were around. "It's just an old lady asleep at the desk," he said softly. He still held her hand. She felt like a heroine in some movie, and he was the star who would, in the end, after some discourse and adventure, save the day.

"Let's go."

They scampered down the hall. Tammi fought the urge to giggle. This was too much. Jimmy led her out a back entrance. She saw a sign:

EMERGENCY EXIT
ALARM WILL SOUND

"Look," she said, stopping him.

He turned, grinning. "You gotta live dangerously sometimes."

"Sure," she grinned back.

He kicked open the door. There was an alarm, only faint. "Quickly!"

They ran out to the parking lot. He opened the passenger door to a black Chevy. Vintage. Circa fifties. Not in the best

condition. Like Lee's Mustang, it would be a beauty with some work.

"Your car?" she asked.

"Yup." He rolled across the hood, with ease and grace. She admired his agility. She wondered how old he was. Mid to late twenties, close again to the real thing. He got in and put the key into the ignition.

It didn't start.

Tammi looked at the hospital. She couldn't hear an alarm. She expected an army of security guards to storm after them. She wasn't a prisoner, and she wasn't really running away from any hospital bill: they had her address and social security number.

The engine turned over.

"There!" He shifted the gear to drive and floored the pedal.

"How long've you had this car?" she asked.

"Hmmm." He looked in the rearview, then at her. "Not long. A few hours."

"Right. What, did you steal it?"

"Don't ask so many questions." He smirked. "You'll take the fun out of it all."

She still felt like a spy even when they quietly snuck into her apartment. It was late and she didn't want to wake Quinna. Wouldn't the girl be surprised to find her here in the morning, with—? What was "Jimmy" going to do? She wanted him, no doubt of that. All this running around like being in a film made her excited. During the drive home, she'd kissed him several times, grabbed his leg, and squeezed. "Now, that's what I like," he'd said.

Once in her room, she turned on the light and looked around, sighing. Felt like she'd been gone for months. Everything was still in place.

Jimmy glanced around, tilting his head at the purple curtains, purple bed sheets, the posters of famous musicians and bands and writers on her wall—but mostly at all the posters of faces and figures that were his resemblance.

"You're different," he said.

"What?"

Shook his head. "Nothing."

"Do you . . . do you want something to drink or eat?" Tammi gestured at the wall. "I don't know wh—"

He went to her, swift, taking her in his arms. "Eat, drink? Why think of such trivial things when a whole big life is before us?"

"You get hungry sometimes," she said.

"Then I'll have you." That irresistible dangerous grin.

"Tammi?"

Quinna was standing in the doorway, in shorts and a tee, rubbing sleep from her eyes.

Tammi sat up, happy that she wasn't in the hospital room. She patted the bed around her. What the hell. She was alone.

"What are you doing here?" Quinna said.

"Ha ha, isn't this my home anymore?"

"You know what I mean. . . ."

"I escaped." Tammi smiled. "I got away from them."

"When did you come in?"

"Late. I didn't want to wake you. I—"

"You think it's a good idea?" Quinna said. "Leaving like that?"

Tammi lay back. "Why not."

"Are you okay?"

"Hey . . . is there, uh, anyone else in the apartment?"

"What?"

"Nothing."

"Tammi?"

"It's nuttin'."

IV. OBSESSION

This was driving her crazy. On the third day, she told herself she wasn't going to think about it anymore. The hell with him. And maybe it was all a dream anyway.

She was sitting on the couch, angry that her arm was in this stupid cast, when someone rang the doorbell.

It was him.

"You."

He walked in, thumbs in jeans pocket, still in the same clothes, still with that look.

"I didn't invite you in." She tried to sound like a bitch, but it didn't work.

He turned around. "Yeah, I know."

"Where . . ."

Silence.

He sat down, where she was. "Television. I see it's improved over the years, in certain ways."

It just came out: *"Where have you been?"*

"Me?" Shrug. "Around."

Tammi stomped to the TV, turned it off, and glared. "What is it? You just come and go as you please?"

He nodded. "Of course. This is America."

"I mean, I mean . . ."

He leaned forward on the couch, eyebrows arched, staring at her with his big blues. "What do you mean, Tammi?"

"You left that night."

"Morning."

"You left me."

"You were sleeping a deep sleep. How could I wake you? Sleep is important, and so are dreams."

She was feeling dizzy. This was not like her at all. She hated this. "You could've called me."

"I don't have your number."

Pause.

"You took your sweet time to come around," she said.

He nodded. "I sure did. Still trying to reorient myself."

"What? Look, you just can't . . . can't . . ."

He stood up. "I can't what?"

She turned away, shaking. She hated herself. "Forget it."

"Hey." He reached out to touch her. "What are you so angry about?"

She fell into him.

They were in bed, and when she'd had what she'd been craving these few days past, she asked him:

"Who the hell are you?"

"Who do you think?" He pointed to the posters of his image. "I'm right there, captured on the camera. I used to be good with a camera myself, you know. Now I'm here, captured in the flesh. Or should I say 'released'?"

"Look"—she touched his chest—"you were born with a gift and a curse, okay? You look like someone famous, and you've

used that to your advantage. I don't know who sent you or why you're hanging around, and I'll admit I'm not complaining, but the fantasy can only go so far, you know? You're not James Dean."

"Famous?" he said distantly. "I used to be. In memory I am. Now I'm just like . . . I'm just here, trying to get by. I need your help. I should've come back sooner. I was . . . confused. And scared. But I need your help to return to this world."

She hit his chest. He winced. "Stop talking nonsense!"

"Nonsense?" He mulled on this. "I guess you really don't know. I've been too caught up in my own dilemma. You don't understand."

She grabbed him, her face to his neck. "I don't understand this. I don't understand any of this shit. I just know I want you here and I never want you to leave but . . . *it's too weird.* . . ."

He touched her hair, stringing it through his fingers. "I guess it is, for you. Weirder than you can imagine. You were in a car accident, right?"

She hesitated. "Yes."

"You died."

"For like sixty seconds my heart stopped, that's what I was told, and they started it again."

"But you died."

She didn't reply.

"Do you remember dying?"

"I barely remember the accident," she whispered.

"It may have been sixty seconds here, but elsewhere . . . a small infinity." He laughed; the laugh was hollow.

Silence.

"Tammi, I have been feeling you for some time. I have always felt those beset with me. There used to be a lot more, and it was—hellish? When someone's mind is always on you, their thoughts . . . *you feel them.* I knew about you. When you died and passed through—"

"Passed what?" She looked up.

His face was pasty; he was quite serious. "You passed through Hell, Tammi, but it wasn't your time. We all knew this. The—call them demons—knew, and they paid no real attention. I saw my chance. Even in death, you were thinking about me. I used this to latch on. I hitched a ride out of death when you came back."

She said, "You expect me to believe that?"

"Well . . . no."

Jimmy came and went; when he wasn't there, Tammi ached for him. She no longer bullied herself about these new feelings for a guy. Wasn't it these exacting sensations that she had been yearning for, the lack of which made her bored with the men in the past? Like Gary . . . dead Gary. She tried not to think of Gary. The accident was his fault. He shouldn't have dragged her into his car. Why didn't he *let go* when she told him to let go? He was too ob—

Obsessions: they did more harm than good, this was the proof.

Jimmy, Jimmy, goddamn Jimmy and his bizarre tales of what hell was like and how he had escaped with her help. Crazy or not, she couldn't get enough of him. And she knew nothing about him except stories he told that were the past of the real James Dean, and he'd tell them until she demanded he shut up because she already *knew* those stories by heart. There were some she'd never heard before—but they sounded right out of the life of James Dean.

Who Jimmy really was, where he came from, what he did when he left her for a night, several days, she tried not to think about. When she attempted to get information, he would put on his act, look at her with his blues, move to kiss her, lure her into bed, and from there all was lost. . . .

My obsession . . .

The sex was incredible.

She wanted to eat him alive.

She'd gone back to work, at the shoe store, despite her broken arm. Dreams and sex and life from death notwithstanding, she still had to make money to survive in this world.

Where Jimmy got his cash, she had no idea. She still assumed he worked as a celebrity impersonator, doing whatever job he was sent on. She still hadn't learned who had hired him in the first place. She didn't care. She was going with the flow. . . .

But when he wasn't around, she felt empty. Like something was missing. She could *feel* him out there—didn't know where, but he was out there, as she'd once felt about the real James Dean: he was no longer alive, but his soul was . . . was *out there*, somewhere, anywhere.

She couldn't get enough—his taste, his sex, his closeness, his soft words, lies or not. She would know his truth one day; she wondered if that'd ruin things.

"We're bonded forever," he'd say, "it's unavoidable now," and she questioned if these were endearments that mean nothing—the usual—but he said it with such graveness that it made her almost feel ill—

Ill with lust.

Ill with love.

She refused to believe she was in love.

V. THE PAINTED BIRD

Once her cast was off, she was more than ready to go back on stage with her band. She needed it, and she wanted to show Jimmy this part of her life.

Her cuts had healed, leaving some light scars. Her death-white makeup and black rings around her eyes hid this well. She experienced some pain in her lower back when rehearsing with the band only when she got physically active. It was something she could learn to live with.

Suffering for my art?

Quinna, the band, her friends at work—they had all come to accept Jimmy's presence in her life. Just as he didn't speak much to her friends, she didn't supply any straight answers when they asked about him.

"Where did you meet him, Tammi?"

"Oh, around."

"What does he do for work?"

"This and that, you know."

"He sure as hell *looks* like James Dean."

"I know—it's cool, eh?"

Jimmy was spending the nights with her more often, rather than disappearing while she slept. Sometimes he had breakfast, and he would drive her to work in the now-fixed jalopy; where he went after that she didn't know. Once in a while he'd pick her up from work, but she usually took the bus home or got a ride, and then she'd have to wait for him to come over—which was either later that night, or the next. He didn't stay away for more than one night. Being without him even one night drove her batty.

She was frightened of this newfound compulsion. It just wasn't the sex. He was right: there was some bizarre connection, as if they were one. Was it love? She wasn't about to buy the story that he'd grabbed onto her soul when she left Hell. He didn't bring *that* up anymore.

He usually had money. Not a lot, but enough so they could enjoy themselves. He liked to go to the movies, he liked to watch TV, but he refused to see any Dean films. He asked Tammi if she'd take down the posters from her walls. One by one, she was rolling them up, sticking them in the closet. It pleased him. Why did she need to stare at posters when she had his look-alike in her bed?

She missed her locket.

Tammi started to wonder if Jimmy had a home. He said once, "Hey, the world is my home." When he stayed away, the thought of him sleeping in that car hurt her. *This* could be his home, and in fact was, now that he slept here a lot. She wasn't certain, but she had a feeling that Quinna didn't like him. Jimmy and Quinna seldom spoke—Quinna was hardly around; she came in late, got up early, having her own life with her own friends— but Tammi was sensing some tension. She wanted to ask Quinna, didn't know how to approach it. They'd both had men stay here in the time they'd been roomies, but not to the extent of Jimmy.

Once when Jimmy took a shower he left his jeans on the floor. He always had the same clothes, but they never stank. Maybe he had several sets of the same gear. She fished through his pockets, feeling guilty for doing so, hoping for secrets or information. He had a wallet, but no ID. Shit, what if he got stopped by the cops? Maybe he had his license somewhere else. He had a roll of money, about seventy dollars in tens and ones. Change, lint, and that was that.

Jimmy didn't want to attend her rehearsals with her. He said he wanted to be surprised when he saw Crash Digital on stage. She planned on giving him her best show.

She was nervous that night of the show, Crash Digital's first in the three months since the accident. It was like when she first started playing in a band: exciting and frightening, so self-aware of each move and gesture. The club was packed, and somewhere out there was Jimmy. There were too many lights on her face for her to get a good look. She was wearing a black suit jacket, only

two buttons, braless underneath, quite aware that her breasts were nearly hanging out but that's the way she wanted it. She had on a black skirt slit high on the side, lace nylons, Doc Martens. Her hair was done in a bun, and she wore a hat with a veil. She had a few new songs, slow and gothic with the psychedelic overtones in her band's vein, about her accident and scrape with death:

> I passed through the inferno
> like a babe from a bloody womb
> finding my love
> among devils and the tomb
> love from evil
> love from the fire
> kiss me again
> you fucking liar.

She knew it was time. The band had to go on to bigger and better things, seriously get some demo tapes to record companies, perhaps go up to L.A. and try to book shows where A&R people might be. They were only one hundred miles south of Los Angeles, there was no excuse for delaying. True, the prospect of failure was scary, and even scarier was the notion of success. She didn't want to work in a goddamn shoe store for the rest of her life. She wanted it ALL, and she wanted Jimmy to be there at her side.

Things were going smoothly, it was good to be back. A few people stage dived during their faster, punk-style songs. What was Jimmy thinking? During their slow erotic tune, Tammi unbuttoned her jacket and let it fall. She was topless before two hundred-plus people. She unfastened the skirt. No underwear. This was nothing new to Crash Digital's audience: when they first formed, she often stripped at every show. She was hardly the bashful type. On stage was a bucket of purple-dyed water. She picked it up, and splashed it on her body, her white skin becoming purple now, dripping down her like alien blood. She ran hands up from her belly to her small bosom, spreading the dye about her. She was a painted thing. The audience loved it. She wondered how Jimmy felt. This was her: true and unveiled before the world, in her art.

Backstage, she held her clothes up to her, still nude, dreading the long bath she'd have to take to get this dye off. There weren't

many people here, and they'd all seen her naked before. She turned around and there stood Jimmy, grinning his grin.

"Ohh," she said.

He touched her hair, then her neck, gazed her up and down.

"I better dress," she said softly.

"No," he said. "I love you like that."

"What . . . what did you think of the set?"

He grabbed her hard, pulling her close, kissing. His hands clutched her buttocks, and next a hand was parting her legs. She tried to tell him no, this wasn't the place, but she felt drugged, felt in a dream state again, and didn't care. They stumbled into the wall. His jeans fell down. They got onto the floor and frantically fucked. She saw the people around her turn away, or leave. Jesus, the last time she'd had sex in a public place where people could see . . . it was backstage after the third time Crash Digital ever played a show, with some old boyfriend—she didn't even recall his name, didn't care.

After, he held her face in his hands, nose to nose, breath sweet, eyes hungry. "Now I know what I truly want," he said.

Jimmy screamed, the first time he'd ever really been so—what was the word?—loud when reaching orgasm, as if he had suddenly lost control. They were parked in his car, the gig three hours past, and she was going down on him. Tammi had always thought herself good at oral sex, but Jimmy was acting like his soul had been torn in half, his nails grinding into her scalp when he came, his rear rising from the seat, crying like he was in pain, and finally relaxing, loosening his grip from her, which had been painful. She liked the pain. She got up. He was staring out the window. He pulled his jeans up. His semen dribbled down her chin. She wiped it away, the taste of his essence full in her mouth. Even his seed was sweet, which was odd.

"Jimmy?"

He still stared out the window.

"What's wrong?" She reached to touch him.

"Nothing, nothing." He turned to her, first glib, then going back to his grin.

She leaned back, hair falling into her eyes.

"I guess I . . ." he started.

"What, baby?"

"It truly was meant to be, when I grabbed onto you in the

abyss," his voice was almost a whisper. "Tonight, I knew what was missing. I knew what my mission has to be. It was all so clear."

"What's that?"

Silence.

"Jimmy?"

"I'd rather wait and show you," he said, "than tell you."

"I have a few hits of acid that Quinna scored for me. Have you ever dropped? It's usually my favorite form of entertainment. I haven't since . . . well, in a while. Do you like acid?"

"What's acid?"

"LSD."

"A drug?"

"Yes, but a cool one. A mind trip. Like going to a movie and you're the star."

"I've been the star before. I don't want the movies. I want *another* limelight. I can see that now."

She moved against him, her head at his shoulder. "I love you so goddamn much it scares me."

Silence.

"Jimmy."

"I know," he said.

"And how . . . how do you feel?"

He took her hand and said, "What do you think?"

The dreams were more frequent, and they were the same: the ancient faces (old looking but what made her think *ancient?*—it was something she just knew), and the dark, hulking, slow things with the red eyes. Sometimes they spoke to her; she didn't understand what they were saying, a language she never heard of, more like garbled mumbo jumbo, dream speak that was never supposed to make sense, the tongue of a strange subconscious. She once mentioned these dreams to Jimmy, and he got white, moved away from her, staring off into nothingness like he was doing more and more lately.

What she didn't like was that he was spending less time with her the past few weeks. His leaves of absence were two days now, enough to make her pull at her hair and bite her nails. She was afraid he had another woman. The thought of that made her blood go into overdrive.

She asked him if there was another in his life.

"Of course not," he laughed, "that would be like sacri-

lege—you saved me from the depths, you and I are . . . *one*. How could I do such a thing to you?"

"The real James Dean would," she said. "He was a free soul when it came to such matters."

"That was the old me; I'm reborn, remember? In more ways than one, as you'll soon see."

"You keep saying that! 'You'll soon see' and 'Wait until I show you my surprise'—*what is it?!*"

"You'll know soon," he said with that goddamn grin!

"Where are you going lately? Why have you stopped coming by as much as you used to?"

"I have to." He moved to hold her. "I don't like it, but for now I have to. Soon we'll be spending the same amount time together, if not more. Just be patient."

She didn't want to be patient. She wanted to know what the hell he was doing when he wasn't with her. He didn't have a *right* to a private life. *She owned him.*

He told her it was time. He told her to dress for a club. This was different: he never felt like going to public places much, other than the movie theater where it was dark and safe. Tammi wore purple velvet pants, matching her hair, and frilled white shirt, lace gloves, and boots and an overcoat. Jimmy had a leather jacket this time. It was a bit used. She didn't ask him where he got it.

They went to a small club where local bands played. Crash Digital hadn't played this club in months, having since graduated to bigger and better venues. She felt nostalgic for the place—it was small and intimate. Maybe they should come back for a gig.

A neo-punk band was on stage, unintelligible lyrics and three chord riffs with distortion. The place was filled with punks, and they were giving her looks. A goth didn't fit in well with such, but she had Jimmy on her arm to protect her. He left her at a table and went to talk to three guys in a corner. They also had leather jackets and jeans, and hair much like Jimmy's. This was interesting. She didn't know he had any friends—he never talked of any.

Jimmy returned with two beers.

"Who're your buddies?" she asked.

"Buddies."

"Can I meet them?"

"Later."

"Known them long?"

"Long enough."

"Shit," she said, taking a drink, "I'll never get you to talk, will I?"

He grinned.

Things swiftly took a shift to the bizarre. Tammi felt like everything was fuzzy around the edges, again the dream state, more intense. She wasn't ready for this: when the punk band finished, Jimmy joined his three friends in setting up on stage. Basic guitar/bass/three-piece drum band, and Jimmy was the lead singer.

"For you," he said, looking at her, and the band jumped into the first song, which sounded like a train coming straight at her.

They were loud, but not so loud that she couldn't make out the lyrics and the changes. The words were simple, spoke of fires and cars and movies and girls, but the way Jimmy sang: so intense, guttural, yet beautiful. Tammi was having a hard time breathing; she was in shock. *This was her Jimmy?* She's told herself long ago she'd never get involved with another musician—especially another singer—foreseeing jealousy and competition. She didn't know how to take this. The band was good, damn good. The music was elementary, but it had style and a lot of odd changes that you wouldn't expect, specially from an unknown band out of the misty blue. It was a combination of garage rock, grunge, and a touch of goth.

Tammi stumbled to the bar, needed a strong drink. She had a shot of tequila. She spotted a crumpled sheet that listed the line-up of bands. The first was Shitspit, obviously the punkers, and the second: Jimmy and the Giant Rebels. The audience was rowdy, but they seemed to be getting into the music. A mosh pit went into full force.

Their set was short, only six songs. When Jimmy came to her, she felt faint. She leaned into him. He asked what she thought, she didn't know what to say. She felt like crying.

VI. MELT . . .

Jimmy brought up the idea of his band playing a show sometime with Crash Digital. Tammi said, "No." He didn't

ask why. Since that night she saw their debut—two weeks ago—she felt like something had been broken, like one of the tendrils that kept them together had been severed. She wasn't angry, at least not admittedly, and her feelings were the same, if not more so: she was afraid of losing him. She didn't want him to be in a band, and these conflicting emotions confused her.

The dreams of the faces and the hulks were becoming a lot more vivid, and in between these dreams were visions of Jimmy and the Giant Rebels, hard distortion, slamming drums, angry lyrics. . . .

Things were going too fast, like Gary's car. . . .

Too fast, too fast. Tammi was starting to feel dizzy. This was going from dream to nightmare. Jimmy came over and said, "Come see my new car."

He grabbed her hand, pulling her, full of life and joy. He was like a little kid. They could have been siblings or cousins, hand in hand, running outside, going to a carousel.

Parked on the street was a silver Porsche Spyder, vintage, in perfect condition.

"You're kidding me," she said.

"Nope," Jimmy said, "those are my new wheels."

"This is a gag, right? You're doing one of your Dean impersonator jobs, and they gave you this car to use."

"It's all mine. Want to go for a drive?"

It was a small inside, but the Spyder was everything she had imagined and had written about in the song. Jimmy was about to start it—and she stopped him.

"What's going on?" she said. "If this is really yours, where the hell did you get the money to buy it?"

"It was a gift." He grinned at her. "Well, part of the deal."

"Deal?"

He nodded, kissing her quickly. "That's my great surprise for you, baby. My band just signed a major deal with Phoenix Records."

Of course she wasn't hearing right. "What?"

"Two record contract—they love us."

"Signed to a label?"

"Yes!"

"*Impossible!*" she spat. "Jimmy and the Giant Rebels has only been around—what? A *month?* And you've done all of five gigs?"

"The right person was at the fifth gig, the one you didn't want to go to," he told her, clapping his hands. "And of course we just finished doing our demo and had the tape right there to give to the guy."

"What guy?"

"A rep from Phoenix, combing San Diego's clubs for bands."

"You're lying to me."

He opened the glove compartment, pulling out a bundle of sheets. "Here."

It was a record contract. For three million dollars.

Tammi gave him the papers back.

She got out of the Spyder.

She ran to her apartment.

She cried into her pillow. This was fucking insanity. Crash Digital had been around now . . . eighteen months, nineteen, almost two years, and nothing. Just a slow cult following and plenty of good write-ups in the local fan press, and this sonofabitch puts a band together and makes a mega deal in less than two months?! Of course, she'd read of such things, they weren't impossible, had dreamed of them herself—

"Tammi?"

Jimmy came into the room.

"Go away," she told him, "just go."

He sat on the bed. "What's wrong?"

She wasn't going to turn, wasn't going to let him see her tears, wasn't going to admit to anymore weaknesses. Things had changed now, and they were on a continual modification. So be it.

"Don't fucking touch me," she hissed.

"What's the matter with you?"

"Just go away."

"Tammi, are you—"

"GET OUT OF MY ROOM!!"

He stood, not saying word. She heard him walk away and go out the door.

"Come back, goddamn you!"

She heard the Porsche Spyder start outside.

Quinna was eating yogurt and watching the TV when Jimmy knocked on the door. She didn't want to let him in, but he walked past her. He started for Tammi's room.

"She's not here," Quinna said.

Jimmy stopped. "She's not at work."

"Nopers."

He looked at her. There was something strange. He seemed different. He was unshaven, his eyes bloodshot. "Where is she?"

"I don't know. And you know, you upset her. I don't know about what. But I know you did. I've never seen her like this. Did you guys break up?"

"We'll never break up. We're forever."

Quinna sucked down a spoonful of yogurt. "You know, I think you're bad news."

He grinned, licking his lips. "You bet I am, bitch."

Quinna raised a brow. "You should probably go."

"You never did like me."

"To be honest—no. You're not real."

"I'm too real," he said, stepping forward.

"How can you go through life masquerading as someone famous and dead?"

He nodded. "I've asked myself that before—a long time ago."

He was quick. He was all over her. Quinna tried to scream, but his hand was on her mouth.

Quinna kept drifting in and out of consciousness, always aware of the pain. She became lucid enough to realize she was naked and bound on the floor, bleeding in several areas. She remembered the violations, saw a piece of ear that had been bitten off and left near her face. She tried again to scream. She was gagged.

Jimmy stood naked next to her, his urine streaming down, cascading on her face. He was laughing. He walked away.

Tammi. She had to warn Tammi. This guy was a lunatic.

He came back. He had a kitchen knife, was giggling, drool and blood coming out of his mouth. There was something wrong. He looked green, his skin scaly, his eyes glowing red. . . .

Tammi was at the park, walking around, frying on a hit of LSD. She hadn't been able to sleep all night, thinking of Jimmy and his record contract and the way she'd treated him. She thought a good acid trip would give her some insights; it had before— she'd made several major decisions on it, like deciding to form a band two years ago. She was riding the fry well, out in the park,

by the lake where the ducks swam. Communing with nature was a good thing.

She thought she saw a black hulk moving toward her. No. Something from her dream tunneling out in the dose. She didn't want this to be another bad trip.

Something snapped in her head. She fell to her knees, dizzy. Something was wrong. At first she thought it might be a strychnine attack, that she'd gotten bogus fry, but this was different. Memories were flooding into her. The old faces were clearer now. They still spoke in a language she didn't comprehend. But clearer were the ugly black hulks who smelled bad. She remembered! *All the cries, the pain, the vast plains and hills of fire and the smell of death, strange creatures flying in the blood-colored sky. She'd been so afraid, calling out to God. Gary was there, falling into a pit. Then she was flying, going through a portal of white, but she wasn't alone. Someone was hanging on to her, two, three, four arms were at her, coming for the ride. . . .*

VII. SLOW DIVE

It was almost night when she got back to the apartment. She'd slowly walked, dazed, like someone who had received electroshock therapy, her brain numb; uncertain who she was. If anyone spoke to her, she wouldn't know how to form the words to reply.

She started up the stairs, and a voice said, "Tammi, no."

She turned.

Jimmy stood there. He looked terrible. He was dead white, his clothes rumpled, scratches on his face. Spittle was at his lips.

"Jimmy?" she said, voice hoarse.

"Don't go up there, please. . . ."

He was crying. What the hell?

"What—what is it?" she said.

"I did something terrible. I—it wasn't me. It was me . . . *but it wasn't me.* You . . . you wouldn't understand."

She started toward him. He stepped back, holding up his hand. It hurt her when he did this.

"Jimmy?"

"I don't know what might happen!" he cried, "I don't

want to hurt you. Not you. *It could have been you,* what happened to Quinna, and . . . and—"

"*Quinna?* Jimmy—"

"Oh, my God!" He fell to his knees, grabbing at his head. "The fucker came along, too! He's been hiding up here all along waiting for the right moment!"

"Jimmy, I remember now," Tammi said, and this was all like a movie, Jimmy this way, "*I remember what happened when I died.* I passed through . . . the bad place . . . and I left, and you were with me. I didn't see you, but I could feel you."

He nodded, looking at the ground.

"I could feel you and someone else, too."

"I didn't know there was a third party," Jimmy said softly. "I had no idea. This isn't my doing."

"Jimmy, what's going on?!"

He glared up, eyes red, skin green now. He held out his hands as if for an embrace. "When you rejected me, it gave it the power to come out. As long as your love kept us together, it was trapped inside. But your hate released it."

"*Released what?*"

"The fucking demon that hitched onto me as I hitched onto you!" Jimmy's voice was horrorstruck; it was not his voice. Blood and something white flew from his mouth.

"*Get away, Tammi! . . . Run and hide. . . .*"

"Jimmy?" She started for him.

"NO!" He fell back, tried to crawl, then stood up and turned her way. His face had split open, revealing a green skull and—

From the darkness they came, a dozen of them: the black hulks of her nightmares. They moved fast, their stink permeating the immediate air. The things converged on Jimmy, mouths opening, baring yellowed fangs. They tore him limb by limb, gouging out his guts. Jimmy's body splattered in the air, on the ground, as the dark hulks piled on him like a football offensive on a runner.

Tammi couldn't scream. She couldn't move—then she did, running up the stairs, knowing very well she would be trapped in her apartment but wanting the comfort of familiar surroundings. The apartment door was unlocked; there was a mess in the living room similar to what she had seen outside. Quinna was on the floor, body shredded, her head severed and sitting on the couch.

Tammi stumbled back, feeling bile in her mouth. She nearly fell down the stairs, scraping her left knee. The black hulks were nowhere to be seen, nor was the carnage that had been Jimmy.

His Porsche Spyder was still parked by the curb. She went to it, got in. The keys were in the ignition. She was crying, not thinking straight. She started the car, having some trouble with the gearshift. She never had been a good driver. She floored the pedal.

Tears in her eyes, still the taste of vomit coming from her throat. *Jimmy and Quinna.* She was going fast, driving mad like Gary.

She lay on the ground, a gash in her forehead bleeding. It took a moment to recall what had happened—jumping out of the Spyder before it ran into the side of a building. The Spyder was smashed, the engine coughing, smoke rising up. There was music coming from the radio. She didn't remember having the radio on. The song was familiar—it was a Crash Digital song, which slowly faded into one from Jimmy and the Giant Rebels.

"You almost did it this time," his voice said above her. "You've escaped death twice—you're not always going to be so lucky."

She looked up, blood flowing into her eyes. Jimmy was there, wispy and transparent. He was naked; there were wounds all over his body.

She reached up. He moved to her and knelt, grinning. "It was worth a try; I had to try. I almost tricked them—if that imp hadn't come along, it could've worked."

"What . . . happened to you?"

"I'm still fighting them but losing, Tammi," he said, a pained expression on face. "I have to go back."

"To the bad place?"

He looked away.

"Goddamn you, don't leave me!"

"What happened to Quinna. That was not me. Don't ever think that. I tried to stop it but . . ."

"We can trick them again! I'll—"

"It's silly to think there can ever be second chances." He was fading more, his voice an echo.

She managed to get up, falling toward him.

"JIMMY!"

166

He caught her, helping her to the ground. Her own grasp went through him, like a 3-D image that wasn't really there. He stared at her for a moment that she knew would be an eternity's worth of songs to write about, and before going back to where he was mandated, he ran his hand along her face, a final caress in the dream of nature.

Rebel With a
Cause

Chuck Taylor

It's a beautiful morning, clear and cool. I just start hoofing in a direction my nose tells me to go. It's through a neighborhood of nice old houses and old apartment buildings that looks like East Dallas where the store is located. I love East Dallas. It is eccentric and seedy, not impoverished or decadent like some unfortunate parts of town south that are downright dangerous. As I walk along, the moist air begins warmin' up quickly, which suggests another scorching July afternoon. I'm pleased to be able to spend the day inside at the bookstore with the air-conditioning.

Suddenly I remember, walking along enjoying the sights, that I used to be, a long time ago, the famous actor James Dean. Sometimes I forget for weeks at a time. How many years ago was it that I faked the car accident? Everybody runs around saying Elvis isn't dead, that Elvis is in hiding somewhere and still alive. Reporters do investigating and check out sightings and write articles and books. No one says James Dean is alive. If some reporter checked my "accident" they'd see through it real quick. Standards weren't high back then; people were more trusting and believed what you said.

I disappeared because I had made enough money to live on from my movies for the rest of my life, and I wanted to be free to live a normal life and free to do other things. I was sick of reporters always following me everywhere taking pictures and telling everyone what I did. "James Dean has a bad cold this week. James Dean stubbed his right small toe on a fire hydrant in front of MGM!" They never said anything that was true.

I'd always been interested in painting, photography, poetry—stuff like that—even before my art school days in New

York. I got tired of the bad boy thing that Brando and I were milking, got sick of pouting and putting grease on my hair. I thought I would have a much better chance doing normal things, getting happily married, raising a family, if I dropped the James Dean routine, all that phony Hollywood baloney.

But sometimes I wonder. Last night at that party, if I had shown I was James Dean, it wouldn't have mattered how old I was, I could have gotten laid. No drunk cowboy would give me a hard time like that Ted Buffalo did for not knowing much about contemporary music. They'd all be crowding the kitchen, worshiping my every burp. Mr. Mustache, the KRUB station's manager, he'd say, "Mr. Dean, I know you're busy. We can't pay much, but could you see a way to tape a few station promos? It would really help a good cause."

Yes, I could go back to being James Dean. I could write the definitive book myself that would show exactly how I faked the accident, faked the medical and police reports. They could run a blood test or do a test on my chromosomes. I could get plastic surgery, a face-lift, liposuction around the waist, and I could be as big as I ever was—and look almost as good. Maybe the James Dean mystique would last for a long time; maybe it wouldn't. Whatever, I could get laid and start again all over.

I am mulling these thoughts through when I spot the shopping strip where the bookstore is located down at the end of the street. I do this kind of mulling maybe once or twice a year. No star has ever come back from the dead. My old buddy from the *Rebel Without A Cause* days, Dennis Hopper, he came back from twenty years living in Taos on drugs; but coming back from the dead, well, that's the big one, what this civilization is built on. The Jesus thing.

I get to the store, fish in my pocket for the keys, go in and turn on the lights. I go to the main counter and turn on the answering machine to see if there are any messages from the owner. He's got about twelve used bookstores stores all around Texas and after a lot of years of hard work is doing pretty good.

A lot of people will think I'm nuts if I come out as James Dean. My ol'lady, Media, this will give her the perfect opportunity to have me locked up for good, to divorce me, take the house and all we own. She didn't believe me when I explained the James Dean thing on our first dates. She looked at me real funny with those marijuana dilated blue eyes of hers, so I dropped it, never talking about it again. When was that—ten or fifteen years ago?

It has been so long, sometimes I wonder myself if I am James Dean. I have to go and take a good long stare in the mirror; I have to think back to when I was making *Giant* with the Rock and Elizabeth Taylor. That's when I fell in love with the wide spaces and big sky of Texas.

The money I got from *Giant* and the other movies, first I did all right through my investors, but then they gave me a bum steer. We put it all in electronics, which, unfortunately, the Japanese took over in the sixties and seventies. I still get a couple of hundred a month, but that's not enough to live on. Media and I, we've had to work. I've got this false social security card under the name James Harris and a whole ream of false papers—a birth certificate, credit cards, library cards—you name it. The stuff wasn't hard to get. Compared to a lot of folks, I don't have much of an education, but still we've worked some interesting jobs, Media and I, that have broadened our lives and given us a real education. Deaf school superintendent, hospital animal label caretaker, tour guide for Inner Space Caverns. . . . I like working in this bookstore right now because I like books, and I get a twenty-five percent discount on anything I want.

I can't just walk into a hospital and ask for a blood and chromosome test to prove I am James Dean. I have to go to a private clinic, and that will cost a bundle of dollars. I've saved in the past, but things have always come up, and I never have been able to get much money together. Nobody ever believed that Anna Anderson woman who claimed to be Anastasia, the daughter of Czar Nicholas of Russia.

I always wonder, when I start thinking over things, do I really want to go back to the Hollywood life? I like writing poetry, publishing it in little magazines, doing a reading every once and a while. I did one here in Dallas last month on Greenville at a little theater. Sometimes I worry if someone in the audience might recognize me, but few poetry-reading types watch old Hollywood movies. I get my drama fix hamming it up reciting poetry I wrote myself, not somebody else's script.

The clock in the store says I've got more than an hour before it's time to open. Plenty of time for a good breakfast of hash browns over at Huts, a read of the *Morning News*, and a jaw with the old waitress Virginia, whose been working there since the late forties, before I even hit Hollywood. You know, all in all, I like my life, and I got a good feeling today. I found my way back to the store just by following my nose. I do not know

what's coming up ahead, don't know what I am going to do about all of my troubles. The woman I love doesn't love me anymore. That really hurts. I guess it's a good thing we never had kids.

Still—not that you ever talk much about such things— I've got this good feeling set deep in the bones. It's always been there. You won't find me complaining much. The universe, she's a rose, a real beauty, and she is with us. She's always been with us—I am more sure of that than anything—and that's what keeps me up and going.

Day in the Life

Hilary Howard

I saw James Dean walking down the street today. In the throws of my usual annoyed five minutes late to work pace, I was getting pissed off at people whose mosying and milling about reflected they'd gotten up on time. It was a pretty average early spring day—gray, rainy—the kind of day that warranted a morning off from work and an extra cup of coffee.

Just when I was overtaking the stride of this unbearably slow, hunched over meanderer, a stale puff of smoke powdered my acid-rained-on, nonsmoking face. I could no longer tolerate sharing this city with all the idiots who made my daily walk to work a friggin' obstacle course. That smoke puff threw me over civility's deep end. I burst around to commit possibly my first public offense when I realized who my target was: James Dean, alive and kickin' in '94. He looked just like that famous poster where he's walking down the street on an ugly New York day, protecting his body with his trenchcoat and his soul with a cigarette. The rebel. Right there on Fifth Avenue and Eighteenth.

My punch stopped in midair as I subtly attempted to convert it from a public offense to to an "Ooh! I got a crick in my shoulder. . . ." James approached me as I pretended to wiggle and roll my shoulder back into place. The closer he approached, the faster my heart beat and the more spasmodic my shoulder became. It was as if all the lust and intrigue I'd ever felt for James Dean had concentrated itself into one particular nerve of my right shoulder. He walked up to me and planted his left hand on my right twitchiness. Melt. Melt. Melt.

I looked into his eyes. Purples and navy—premature smoker wrinkles around the edges. Keeping his hand on my shoulder, his eyes spoke to me: "Whatever you do, don't make

a big hoopla out of my being here. You're the only one who could possibly see me, and if you start jumping up and down with a twitchy shoulder and screaming that James Dean is looking into your eyes and blowing smoke into your face, well . . ." He grinned and slid another cigarette into his mouth.

All of the sudden the most important issues in my life—career, love, money, health—were washed down the nearest Fifth Avenue gutter with everyone else's waste. I was with the rebel. Things just didn't matter anymore. I mean, this was my personal, pop-cultural Buddha, my own personified pillar of spiritual content. He seemed to know this about me. Maybe it was because I couldn't say anything to him and my shoulder was possessed—or maybe, I began to think, he had interrupted my walk to work on purpose. Like he was sent or something. I couldn't believe how much in shock I was; I mean, I really couldn't talk. But then again, what do you say to James Dean? "Hi, I'm a really big fan. . . ." or even worse, "I thought you were dead!" just didn't cut it. So instead, I stood, twitching . . . thanking God for the rain to camouflage the drool pouring from my paralyzed mouth.

I guess James finally felt sorry for me and knew he had to take the initiative, so he motioned—without words—to a nearby diner. The walking was good; it finally got me talking and it soothed my shoulder. He remained speechless.

We both took black coffee—I usually take mine with milk but I wanted to impress James with as many cool coincidences as possible—and I had to order his side order of hash browns and grapefruit juice because, of course, he didn't want to draw attention to himself. He just sat there across from me, slouched over, head down, hair hiding his eyes. When he wanted to say something to me, he would subtly peer out from between his hair and mutter what he wanted to share. At first we talked about petty things—Michael Jordan's baseball career, where to get the coolest leather jackets, Jackie O's recent demise—but most of the time we just stared into each other's eyes, like adolescent soul mates.

By the time we'd asked for the check, James told me why he'd visited me: "I am your new guardian angel, Hilary. God decided that Benjamin Franklin was making you take yourself a bit too seriously with all that self-reliant crap. He practically forced Ben to go on a Caribbean hiatus to loosen up a little. So, here I am. You are hereby free of all of your neurotic hang-ups. Have a cigarette."

And have a cigarette I did. Then James took me into his arms and gave me the roughest, most passionate kiss I'd ever experienced. He took off his trench coat and handed it to me. It smelled like Maine and Arizona in there: dusty, dirty, lived in. As we left the diner hand in hand, I ran smack into my boss on her lunch break. I quivered in fear at the harangue I was about to be subjected to—but instead of yelling, she just looked right past me, as if she didn't know who I was. I turned around to give James another passionate kiss out of gratitude for my new, cool life—but he'd disappeared. And the rain hardened. And the day grayed. And I threw my umbrella down the gutter and let the acid rain bathe my smoking face in all its liberated glory.

Sausage King

James Finney Boylan

He's already waiting for us as we arrive. The years have not been kind.

"I know what you're thinking," he says, shaking our hand, and escorting us up towards the factory. " 'He's gone to seed. Lost his fire.' "

He looks up at the black clouds spewing from the smoke-stacks that bear his name. "Well you can say I've put on weight, I mean sausages—that's not exactly nuts and berries, am I right? But you show me the man who says I've lost my fire, you show him to me. I'll explain some things to him. Is that what you're saying?"

No, we explain, we are saying nothing of the kind. We just want to know why he's coming out into the open now, after all these years.

For a moment longer he gazes at the thick smoke. There is a smell of onions hanging in the air. "A man can't live a lie," he says, mopping his bald head with a huge pink bandanna. "Tell me what's not true in that. Enlighten me."

He puts his hands into his pockets and walks into the factory. Inside there is a receptionist who looks at him with longing. We go past her down a long hallway. Halfway down we see a long glass window that overlooks the factory floor. To the left we see a half a ton of chopped pork moving forward on a conveyor belt. Giant knives plummet down upon the moving pork like a series of guillotines. At the end of the belt the chopped pork drops into a lazy susan of oversized skillets, each one the size of a satellite dish. A mechanical hand whips the pork around so it doesn't burn. Stainless steel canisters shake in onions and pepper and salt. One canister is marked with a red question mark.

"You see that?" he says.

We tell him we do.

"Those are my secret spices. Nobody knows what's in there. Not even me."

The concoction is dumped onto another conveyor belt by a rotating spatula, then moves down toward the stuffer. Underneath, the casings are hanging down loosely like udders. Great cylinders press the pork mixture down into the casings. As each one fills, it looks like a balloon inflating. A knife descends again and the trail of sausages is sucked into the stryofoam shrink wrapper. Each one is imprinted with the legend: JIMMY DEAN PORK SAUSAGES.

"Mm-hm," he says. "You know what that smells like?"

Sausages? we suggest.

"No sir," he says. "That there smells like money."

We follow him down the corridor to his office. It's only slightly surprising to find that it is a relatively small chamber, containing a desk, some file cabinets, and a phone.

"So," he says. "You want some coffee?"

No thanks, we reply.

"Well, then."

Well. First of all let us say that it is an honor to be the one to break the story.

"Well, I was always a fan of yours, Mister Brolin. I thought you were really good on that show, what was it called, *Emergency!* I think it was. And *Marcus Welby*, too. I sure liked that."

Uh-oh. Mr. Dean, you ought to know that's James Brolin you're thinking of. I'm James *Boylan*. A writer. I got a couple of novels you might have heard of.

"Boylan?" he says, wrinkling his forehead.

Yes.

"Well." He looks disappointed. The hell with that.

There's a few moments of awkward silence. He picks up a pencil and taps it on the desk.

Do you mind if we follow up on something you mentioned earlier?

"What?" He doesn't seem to be paying attention. He's going through some papers on his desk.

You said you didn't want to live a lie. Is that what it felt like?

He rolls the yellow pencil in his hands, reading the words on the side.

"You lose yourself," he says. "It's not a pleasant thing. When you get projected on a screen it's like you get magnified. Stretched thin. There was this one guy named Fred who had plastic surgery so he could look like me, practiced talking the way I talk, even stole my clothes. That guy could do me better than I could."

A guy named Fred, we say.

"I used to make him drive around while I sat in the passenger seat, wearing flannel. All these girls used to think he was me. No one ever thought I'd wear flannel. To me, flannel was like disappearing fluid."

We tell him that strictly speaking, flannel is not a fluid.

"The night of the accident I got thrown clear up into a palm tree, and I just sat up there among the coconuts while the cops circled round. They carried off that Fred, and a tow truck hauled away the car. The moon went down, the sun came up. Me, I stayed up there drinking coconuts, just thinking. I decided I wouldn't come down out of that palm tree until I could think of something worth coming down for."

We try to imagine him getting the coconuts open to drink the milk. Maybe he had a Swiss Army knife or something.

"Well," he says. "I mean, it warn't pussy, I can tell you that. I wasn't coming down out of no palm tree for more pussy. I'd had enough a that. And it wasn't going to be for no whiskey bottle, and it wasn't going to be for any pile of money. I just sat up there trying to think of the one good thing in life I could bring to people. The one thing people need. The one thing that each man shares."

And that's when you thought sausages.

"Well, first I thought brassieres. I mean, for a long time I was thinking brassieres." His cheeks redden slightly. "But then I thought, no, sausages would be better."

And that's when you came out here.

"Well, it wasn't like this when I started. No sir. It took a long time building this place up from the ground. When I started it was just a little stand. You hear me, a stand! I mean, imagine me, *Jimmy Dean*, starting over with a little stand, spearing the sausages out of the steamer with a fork. But a little elbow grease, a little perseverance and a little help from—and I am not afraid

to admit this—God the Almighty, and you have the current situation."

We ask him exactly how many kinds of sausages he makes, and he explains. Breakfast sausages, dinner sausages, Lil' Satisfiers. Sizzlers. Half-Smokeys. Kosher Dogs. Frankfurters. Canadian Bacon Patties.

We ask him if he ever made chicken hot dogs.

His face turns pale, then deep red.

"That's enough, Mr. Broylan," he says, and stands up.

What? Did we say something?

"This interview is concluded."

We apologize rapidly, even as he hauls us down the corridor pinching our ear. Our apologies are not effective. We are sorry we mentioned chicken hot dogs. If we had known that this was an area of sensitivity we would not have brought it up.

"Well, it's a little late for that now, pal," he says, opening the door and booting us out into the bright sunshine.

We are filled with regret for the pain we have inadvertently caused by mentioning chicken hot dogs.

"You know who eats chicken hot dogs," he says, hot tears pouring down his cheeks. "I'll tell you who. Whiners and complainers. People who are always looking for breaks. People who are afraid of doing a little hard work. Phonies. Hollywood big shots. I'd like to take them all on if I had the chance. Throw a little weight around."

Why don't you do it, we ask. The country needs someone like that.

He shrugs, and some of the anger seems to pass from him. "Too old," he says. "That's somebody else's job now. Anyway"—he looks up at the smokestack, breathes in the smell—"anyway I guess I like sausages too much now. You know." He looks like a man who could be described as satisfied. "They're tasty."

We shake his hand again, and he apologizes for flying off the handle like that. "Sometimes the memories are a little too real," he says.

We are about to leave when he says, "You know who I think about some times?"

We ask him who.

"Jim Backus. You know how he played my dad in *Rebel Without a Cause?* Later he was Mr. Howell on *Gilligan's Island.*

A sweet man, and a great actor. But you know what they said about him when he was gone?"

What?

"Mister Magoo. Dan Rather said that he was dead, and a few seconds later they're showing Mister Magoo on the *CBS Evening News*, and everybody's shedding a little tear for this penny-pinching blind guy. It was like Mister Magoo was the one dead. Jim Backus was just an afterthought, the shadow of a cartoon."

We nod.

"Well," he says. "You take care now."

We head toward the car and notice that he is walking away from the factory, down toward the town where the people live.

You want a ride, we ask. We're headed that way.

"Naw," he says, and opens his hands. "I don't ride in cars."

We drive away from the factory and he waves. As we leave him far behind, we hear the voice of Jim Backus, whispering in our ears.

Oh, Magoo. You've done it again.

A Strange Occurrence

Sparrow

James Dean once lived in my apartment. I learned this from my neighbor Rosalie. "That actor used to live in 4G, where you live. What's his name? Dean . . . Dean . . . The one in *Rebel Without a Car*."

I looked up the rent checks for 1949, and there was his frail, wavering signature: James Dean.

I scoured the walls for a scratch he had made in anger or in whimsy, but there was none. He was a 'burnt seed,' as they say in the *Upanishads*—gone without a trace.

Then one afternoon, sitting in the northeast corner of my living room, next to the heat pipe, I felt an extraordinary melancholia—a sadness so deep I had to dance. I half closed my eyes, pursed my lips, and glided around the room. When I came to the mirror, I froze. There was the final frame of *Giant*.

Little Red and the Hood

Miranda Schwartz

Luke Perry's hair is getting dusty. James adjusts his tiny red
corduroy windbreaker and runs a finger over his head. He half
smiles, pulls an American Spirit from the pack, leans back in the
driver's seat of his Chevy Nova. The car is a '55, black and
convertible. He got Luke on clearance at K-Mart. He was the last
one, the cardboard package, although dynamic and exuding
youthful jism, was frayed and dented. The plastic over his tender
face plastered with orange reduction stickers. Luke was an idol
once, a smirking sad and bad presence in the twelve-inch action
figure world. James gets a kick out of thinking of himself as a
doll, starts the car and heads down Route 66 in Virginia. He
doesn't have a map, sensible shoes, a magic marker, or even
honey-roasted peanuts. He has a sense of direction and a vague
memory that California is at the end of 66. "I am a star that has
just exploded," he tells Luke, "but not quite a black hole. And
the memory of that light isn't as strong as the pull of the Nova."
When his Porsche crashed on September 30, 1955, when he was
twenty-four years old, he survived. He flew through the infinite
black hole of his own belly button. He traveled through the im-
plosion of his own flesh turned inside out, exposing tendons,
sinew, veins, gristle, watermelon plants, a grilled-cheese sand-
wich and Coke, mucus, the beginning of an ulcer until he was
completely sucked back into himself, smelling like fish, smokey
and a little taller.

Meanwhile: Pee Wee wears a paisley brocade bathrobe with black
silk lapels and a tassled belt. He puts his feet up on an antique
wooden and black-iron chair in the high-ceilinged kitchen of the

old farm house, lights a cigarette, and peers into his coffee cup. He rubs his razor-stubbley cheek and looks at Daisy. She wears a white terry-cloth robe with huge daisy appliques she knows isn't hers. She accepts a cup of coffee from him, even though she usually drinks 7-Up in the morning. His eyes are red. Pee Wee pushes the sugar bowl her way. It is shaped like a fire hydrant. The creamer is a one and a half inch dog, leg raised. She fixes up her coffee. She looks for a spoon, but instead finds a swizzle stick, atop of which there is a tiny lady spinning by her teeth, like in the circus. She spins and reflects the lemon bars sprinkled with powdered sugar sunshine that foams all over the kitchen. It is nearly a yellow fog.

He gets up and goes out the back door. Before the screen door slams, Pee Wee pauses. "I'm a loner, Daisy, a rebel. There are things about me you don't know, you don't want to know. I'm going to rotate the fulcrum." Daisy wakes up peaceful, but a little itchy.

Cut to dusky highway: "You have to watch out for false stars, Luke." Jimmy drives about 85 mph. He finds early November in the South to be very much like a virus. The late afternoon air rushes into his open window, evaporating the sweat from the noonday sun, making him chilly and hot at the same time. He feels exactly like a nostril afflicted with postnasal drip. "Luke," James says, "there's strength in numbers, and I feel a number of things. I am humid with contentment, Luke. I need a tissue."

Luke removes an embroidered hanky from his pocket. James blows his nose, rolls up the window and heads towards the Potomac.

Zoom in: Daisy plans to attend a dog-grooming seminar in New Jersey. Daisy dresses like Lucille Ball meets Marsha Brady. She packs up some extra sodas, chocolate frosted doughnuts, lip balm, Hello Kitty toothbrush and tiny flashlight, Barbie Band-Aids, miniphone, and visor. Daisy never made it to New Jersey. At Grand Central Station she bought a one-way ticket to Washington, D.C. "Oh, Lordy," Daisy thinks, "PMS is taking me south this month."

Fade to dashboard: "When matter collapses, the body is sucked into itself, into its center of gravity, and in collapsing recreates itself," says the man on the radio. James shifts his denim-

covered ass on the car seat. He wishes Luke could drive for a while. Somehow it got to be 2:00 A.M., and somehow they ended up in Fairfax, Virginia, off the beaten track and about twenty miles farther away from California. He pulls over at a Day's Inn and asks directions. He buys a travel sewing kit, a keychain puzzle, and some Pep-o-mint Life Savers. Heading for the highway, he spots a figure standing on the side of the road. A slow-motion liquid response happens between his eyes and his brain, and for a second she, illuminated by headlights, is superimposed with the ghost of a dead costar. It is a girl, in a polka-dot dress. He stops.

She takes her time walking to the car. Daisy leans toward the window and takes out her Hello Kitty flashlight. "Can I see some ID, buddy?"

James looks up at her and squints (insert your favorite memory of James Dean looking squintily endearing here). "I don't have any," he mumbles.

"Okay," she says, "then I'll get in." Daisy walks around to the passenger side, flings herself into the car, buckles up, and takes off her shoes. "So I say to myself, 'Daisy, you are all dressed up and nowhere.' Nowhere is the lounge of a Greek restaurant in a suburb of a suburb of Virginia, next to a Holiday Inn. There was a $4 cover charge at nowhere. Iced tea is $2. People steal your cigarettes. You want to do something outrageous, like flash your panties at the band, but just being there is weird enough. You say to yourself, 'I'm nowhere, here I am, I finally made it. At least I look nice.' You watch a band you've seen a lot before. You dig it, it's cool finally, but near the end it gets too loud. You try to leave, but you're already nowhere. You're nowhere with somewhere to go. You get lost when you leave. I go to the bathroom and someone is smoking my cigarettes when you get back. I must be invisible. Am I invisible?"

"I don't know," Jimmy says.

"California? I hope he's going to California," Daisy says to Luke. "I've been feeling really invisible lately, like I'm fading or disintegrating. So the band is getting louder and louder, and I decide the drummer is cute enough to be a drummer. Did you know there's a $5 cover charge when you're nowhere?" Jimmy says he didn't know. Daisy asks him, "Where are you going?"

"Let me tell you about where I was," Jimmy says, lighting a cigarette, starting the car and pulling onto the highway. "Approaching Love, I took a wrong turn into Obsession. I ended up

at the corner of Crush and Misery where Low Self-esteem was hitchhiking through to Depression. I picked her up, and the car stalled. I tried to start it, and it sputtered and choked and Low Self-esteem sobbed. I opened the window, leaned out, and looked under the hood. I tried the engine again. It started. Low Self-esteem wanted out at the dead end of True Love, but I wouldn't let her. Beyond the overpass of Rejection was Hope. She could backtrack from there for all I cared, but I couldn't leave her behind. When I came out of the tunnel of Self-deception, I looked for a rest stop."

The silence between them lay heavy with the smell of vanilla lip gloss and Life Savers.

"And you?"

"I'm lost," Daisy says. "I fell into the Gap."

"Where are you going?" Jimmy asks.

"Jimmy? Does Burger King own the Gap? The Gap always says, 'Do you want socks with that?' Burger King says, 'Do you want fries with that?' I bought yellow socks because I was hungry."

Luke tumbles off the dashboard. Daisy removes him from her shoe where he has fallen. She brings him close to her face, and he holds his breath. "Lordy," she says, "look at him. He's like a migraine version of James Dean."

Luke coughs.

Daisy says to him, "Just because I can read your mind, it doesn't mean we have anything in common." She starts crying. They are finally on the right road heading west.

"Where are you going, Daisy?"

She picks at her fragile skin when he asks her about her future. Around her fingernails are scabs like garnets set in flesh. She rips them off, and the stunned fresh skin beads with blood. "I have PMS." she says. "I'm not an actress, but I play one on TV. I don't have a dog. Concha Alonza Venetia Velveeta Von Cha Cha does."

"Who?" Luke asks.

"I was going to be a hairdresser in next week's episodes of my soap opera. I have been very happy with my job and know I am very lucky to be one of the most adored psychopaths on TV. I have been kidnapped, lost my memory, doubled, buried alive, and starred in a made-for-TV-movie about my life. At least my character on *Revolving Passage of Time* did, but I had a dream

last night. Jimmy, what if one day there's nothing left but the image of me on TV, and I really disappear?"

A Life Saver sparks in the dark of the Nova.

"Well," Jimmy says, "what if you do?"

Daisy is quiet for a minute. She feels feverish. Her blood heats up from the inside like a tea kettle on high. There is nowhere for the steam to go. She thinks that it's the steam from the inside that ejected her from her apartment, that made her buy the wrong train ticket and made her order the *Greatest Hits of the '70s* last month. Daisy feels better after she cries. Jimmy hands her a hanky. She wipes her eyes and looks at the Pennsylvania countryside in the dark, at the shimmering stars, at the pop-up book of her future. She rolls down the window. Luke jumps off the dashboard, floating down next to Daisy on a handkerchief parachute. Daisy's brain is clouded momentarily as he passes by her head. Jimmy drives. Jimmy smokes. Jimmy drums his fingers on the seat, the steering wheel, on Daisy. His fingers are very hot, and when they leave Daisy's arm, the spot where he touched goes cold.

"My soap opera character is dying next month. But I don't know if it will be a real death or a fake death. Amnesia, coma—fake death." Luke munches on a peanut butter cracker snack.

"I thought I heard the earth grind to a moaning halt. I saw the light and I saw it chased by the night," Jimmy says.

Daisy puts Luke on her shoulder and with the quiet hum of his channel in her ear, goes to sleep.

Cut to the Continental Divide. Jimmy changes the windshield wipers. It's somewhere around 5:30 A.M. The sun is shifting like a squirmy baby over the Rocky Mountains. Daisy sees pink: it's coral pink, Pepto pink, pink Nova Scotia salmon flesh. Luke sings "London Bridge Is Falling Down" to Daisy in French. She feels like her skin is trying to crawl off of her. She itches at the hot spots and wipes sweat from the cold spots.

"I'm a little teapot, short and stout," Daisy sings, "Stop the car Jimmy, my insides are coming out." Daisy heaves into the snow. Jimmy politely shaves with his electric razor.

"Daisy," Luke drawls, "half of that is going to the Pacific, and half is going to the Atlantic."

Daisy smiles a blurry smile and feels the postvomit burn

in the back of her throat. Luke hands her a butterscotch Life Saver. "Sorry, Daisy, no more peppermint."

"Jimmy?" Daisy says, "can we get popsicles?" Jimmy looks at Daisy long and hard. In the hibiscus glow of sunrise Daisy appears to be fading. He runs a hand through his hair (*Rebel Without a Cause*). The hushed rose-gold of sunrise and Daisy's translucence has him a little concerned.

"Daisy," he gently says, "please get in the car." She squints up at him and sees a light-red halo around his head. They get in the car. Luke busies himself lacing and unlacing Daisy's purple shoes.

"Jimmy?" she says. "I think I'm really sick. I think I have a fever." He turns on the radio. "A star near the end of its life ejects its outer atmosphere. Thermal pulse convulsions cause the outer layers of the star to separate from the burned-out core. They float into space, revealing a stellar corpse."

"Once upon a time, Daisy" Jimmy begins, "we were all stars. When stars die, they burn out. Sometimes they come back. Remember *Love Boat?*"

Daisy starts crying. In a split-infinate moment, she understands. "Oh no, oh no," she sobs, "not *Murder She Wrote.*"

"Infomercials," Luke intones. "Each show could be considered a different level of hell."

Daisy cries harder.

Jimmy squints at Luke. Luke squints back. "Or heaven," Luke adds.

She finally hiccups her way into sleep. She wakes up hours later, crossing the Colorado-Utah state border and sighs in relief.

"Jimmy? You got any beef jerky?" Daisy clips her nails with her Hello Kitty nail clipper. He looks at her. Her skin is mottled, like a second degree burn. A rush of fatherly tenderness (Plato) overcomes Jimmy. He lights a cigarette. Daisy asks for one.

"I never smoked before in my life." The black Nova surges forward, toward California.

A small sign tells them they are in Nevada. Daisy feels at home in the cool desert. "Stop the car. I want to bury myself in the sand."

Luke pats her cheek. His plastic fingers soften a bit.

Daisy: "What if you have an accident before we get to California. Lot's of people die in cars, Jimmy."

Jimmy: "Isadora Duncan."

Luke: "Jayne Mansfield."

Daisy: "Patsy Cline."

Jimmy: "That was a plane."

Daisy: "That guy from Def Leppard."

Luke: "He lost his arm."

Daisy: "Oh." She watches the dark outside go by. Luke feeds her goldfish-shaped crackers. Jimmy squints at the road ahead, eyes watering. "Christa McAuliffe," Daisy says.

Daisy, sleeping, dreams about the end of a star's life. She is so hot. It is so hot inside a star. Then she is part of a planetarium show, smeared on the ceiling like some fleshy raspberry jam bruise of a Milky Way. The announcer says, "A white dwarf is a dead star. The red giant is a dying star. They are companions. The double stars have small orbits, and some are actually touching each other. The hydrogen-laden gases from the cooler red giant can build up on and ignite its companion. Thermonuclear reactions make the white dwarf increase its brightness ten thousand-fold. The white dwarf is now a nova." The announcer's voice turns into Jimmy's voice. Luke stands on her shoulder and brushes her hair. ". . . hydrogen burning shuts off. With no more outpouring of energy, the star's core loses stability against the influence of gravity. . . ." He says, "Daisy? We're in California."

"The lilacs came and went like a bruise that year," Daisy answers. He puts a hand on her arm. He feels as cold as a New England ocean in June. Daisy's core is compressing. Her temperature rises to a volcanic state. Hydrogen between her skin and muscle fuels the burning inside. She finally ignites under her skin.

"Jimmy?" They are crossing the state border. Luke wears a tiny parachute and goggles and white silk scarf. The sun comes up again. Jimmy's red halo stands out above his fully three-dimensional wavy golden-brown hair. Daisy opens her eyes. He's fading. As he fades, a crushing sensation attacks her chest, and intense pain sears her muscles, stings her joints like a thousand bee stings. Her veins unravel like a hand-knit sweater.

"Luke," Jimmy says, "she's got the bends."

She looks at Jimmy for help. She opens her mouth. Luke parachutes in. Jimmy slows down. He carefully pulls over onto a dusty shoulder. He gets out of the car, stretches, breathes deep, lights a smoke, flips open a soda, and slowly leans himself against the door. He enters the February California morning where the dew has just burned off and the evaporation of predawn clouds

his heart for a moment. "My will is stronger than child-proof caps," he says to himself. "My will is stronger than wallpaper glue." He is relieved to be at sea level.

Daisy feels soft, sinewy, downy arms that remind her of how frog skin slides over frog bellies. She wonders if frogs have belly buttons. She opens her eyes. She looks at the face belonging to the arms. "River?"

Habits of Total Immersion

Terence Winch

Don't talk to me about what might have been—
today I would leave you in your glory days when
the smell of the road and the errata of career
defined your planet, hovering then so near.

Like Brando, who never apologized to his mother,
I don't want to talk to you. I would much rather
eat steak with my son and rebel again no more,
for I have no time to be knocking at your door.

When we canonized you, we cursed the curse
of young men living on, but dying first.
We were mad with anger, fear, grief:
your disappearance triggered disbelief.

Help yourself to the dead flowers in my backyard.
They remind me of Indiana, of the simple, hard
life of the private image, where no persona could
ever penetrate the beautiful chaos of Hollywood.

But then there was that road, the one taken, the one
 we all
take. Joan and George and Frank wept when they
 got the call
and babbled about their sorrow, their love
 unfulfilled.
But I have never cried for you and never
 will.

Contributors

AI is a native of the American Southwest and currently lives in Tempe, Arizona. Her fifth book of poems is *Greed*.

JAMES FINNEY BOYLAN was born in 1958 and holds degrees from Wesleyan University and Johns Hopkins. He is the author of a short story collection, *Remind Me to Murder You Later*, and two novels, *The Planets*, and *The Constellations*. He teaches English at Colby College and lives in Belgrade Lakes, Maine, with his wife, Deirdre, and son, Zach.

EDWIN CORLEY was a novelist whose books included *Siege, Acapulco Gold, Shadows, The Genesis Rock, Long Shots, Farewell My Slightly Tarnished Hero, The Jesus Factor*, and *Air Force One*. He lived with his family for many years in Pass Christian, Mississippi.

JANICE EIDUS is the author of the novels *Urban Bliss*, and *Faithful Rebecca*, and of the short story collection *Vito Loves Geraldine*. A two-time O. Henry Prize winner, her work has been published abroad in Britain, Japan, Greece, South America, and elsewhere.

LOUISA ERMELINO has published several short stories and a novel, *Joey Dee Gets Wise*, with St. Martin's Press. She currently works at *People* magazine in New York City.

ED GRACZYK's comedy-drama *Come Back to the Five and Dime, Jimmy Dean, Jimmy Dean* was first produced by Players Theatre of Columbus, Ohio in September, 1976, and directed by

the author. It was subsequently produced in Atlanta, Georgia, and directed by Fred Chappell. The Broadway production, directed by Robert Altman, opened February 18, 1982, at the Martin Beck Theatre. Altman directed the movie version in 1982.

JACK C. HALDEMAN II. was born in 1941 and currently lives in Gainesville, Florida. He went to Johns Hopkins University and is the author of eight novels including *There Is No Darkness*, a collaboration with his brother Joe Haldeman. Other books include *High Steel* (with Jack Dann), *Vector Analysis*, and *Perry's Planet*.

STEPHANIE HART lives in New York City. She's been writing poetry and children's stories for years. Stephanie has published a young adult novel, *Is There Any Way Out of the Sixth Grade?*

MICHAEL HEMMINGSON is twenty-seven and lives in San Diego, California, and is the author of *The Naughty Yard*, a short novel, a collection of s.s., *Nice Little Stories Jam-Packed with Depraved Sex & Violence*, and several poetry chapbooks. His play *Driving Somewhere* is forthcoming from the West Coast Play Series, plus he edited the anthology *Metacritical Overdrive*, forthcoming from SUNY Press.

HILARY HOWARD, who's been told she looks like James Dean with long hair and hips, is a native North Carolinian, who's currently persuing an acting career in New York City.

REUBEN JACKSON lives in Washington, D.C., where he is an archivist with the Smithsonian Institution's Duke Ellington Collection. His book of poems is *Fingering the Keys*.

BENTLEY LITTLE's short fiction has appeared in dozens of magazines and anthologies, including *Hottest Blood* and the Borderlands series. He is the author of *The Summoning*, *Death Instinct*, *The Mailman*, and the Bram Stoker Award-winning *The Revelation*. Bentley and his brother Judson have searched Griffith Park for James Dean's tire iron.

MICHAEL MARTONE is the author of four books of short stories, *Alive and Dead in Indiana*, *Safety Patrol*, *Fort Wayne Is Seventh on Hitler's List*, and *Seeing Eye*. He has also edited and

contributed to two collections of essays about the Midwest, *A Place of Sense* and *Townships*. He lives in Syracuse, New York, where he edits Story County Books with his wife, Theresa Pappas.

DAVID PLUMB, the former editor of Smoking Mirror Press and *journal 31*, lives in Florida where he writes, teaches, and keeps finches. He has published three books of fiction including *The Music Stopped and Your Monkey's on Fire*. Recent work appears in *The Miami Herald* and *Santa Barbara Review*. He's working on a novel called *Flamingo Heaven*.

ROBERT READY lives in New York City and teaches at Drew University. His stories have appeared in *Antaeus*, *West Branch*, and *Gargoyle*.

MIRANDA SCHWARTZ has been an intern at *Sassy*, where she's published some work. Her favorite writer is Anaïs Nin. Having an Incomplete in Existentialism pretty much defines her life.

LEWIS SHINER is the author of the novels, *Glimpses*, *Slam*, *The Edges of Things*, *Deserted Cities of the Heart*, and *Frontera*. He edited the benefit anthology *When the Music's Over* and lives in San Antonio, Texas.

SPARROW sings with the group Foamola and writes regularly for *Reptiles of the Mind*.

D. E. STEWARD, has one trade novel, *Contact Inhibition*, and recently has been publishing parts of a new book called *Chroma* in *Conjunctions*, *Sulfur*, *Temblor*, *Minnesota Review*, *Chelsea*, *Central Park*, *Fiction International*, *North Dakota Review*, *Southwest Review*, *Puerto del Sol*, *Epoch*, etc. *Chroma* is made up of nearly a hundred month-long sections, thirty-eight of which are published so far.

CHUCK TAYLOR was born in Minneapolis, Minnesota, but has achieved legendary status after more than twenty-five years in Austin, Texas. His books of poetry, fiction, and photographs include *Always Clear and Simple*, *When the Land Is Taken*, *Nothing's Impossible*, *Everything's Impossible*, *Lights of the City*,

Amerryka!, *Ordinary Life*, *Drinking in a Dry County*, and *Only a Poet*.

TINO VILLANUEVA was born in San Marcos, Texas. He is a poet/painter/teacher and editor of *Imagine: International Chicano Poetry Journal*. His books of poems include *Scene from the Movie Giant*, *Hay Otra Voz Poems*, *Shaking Off the Dark*, and *Cronica de Mis Anos Peores*.

TERENCE WINCH makes his living playing traditional Irish music in the Baltimore-Washington area with a group called Celtic Thunder. His books include *Irish Musicians/American Friends*, *The Great Indoors*, (poetry) and *Ancestors* (short stories). His work has been included in *Out of This World: Poetry Project at St. Mark's: Anthology*, *Before Columbus Foundation Poetry Anthology*, and *None of the Above*.